Painting Flowers
– a creative approach

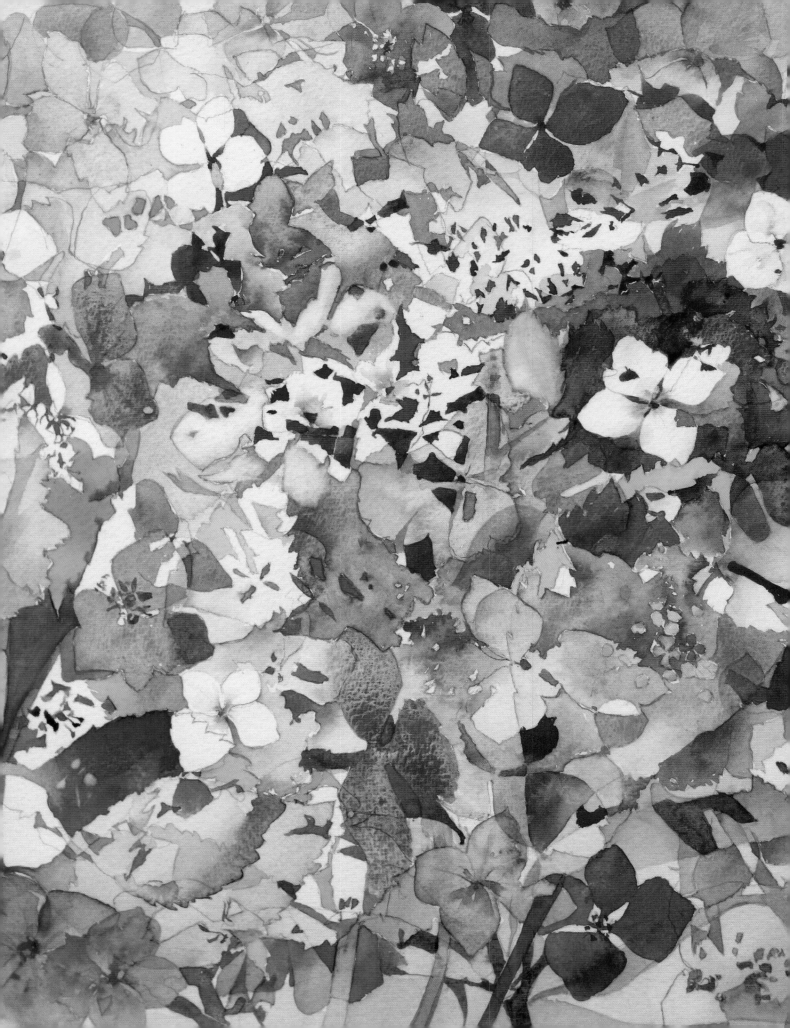

Painting Flowers

– a creative approach

SIÂN DUDLEY

THE CROWOOD PRESS

First published in 2018 by
The Crowood Press Ltd
Ramsbury, Marlborough
Wiltshire SN8 2HR

www.crowood.com

British Library Cataloguing-in-Publication Data
A catalogue record for this book is available from the British Library.

ISBN 978 1 78500 371 4

Dedication
For Rob, for Purple Pansy Sunday and for your patient and loving encouragement in the many years since.

Graphic design and layout by Peggy & Co. Design Inc.
Printed and bound in India by Replika Press Pvt Ltd

Contents

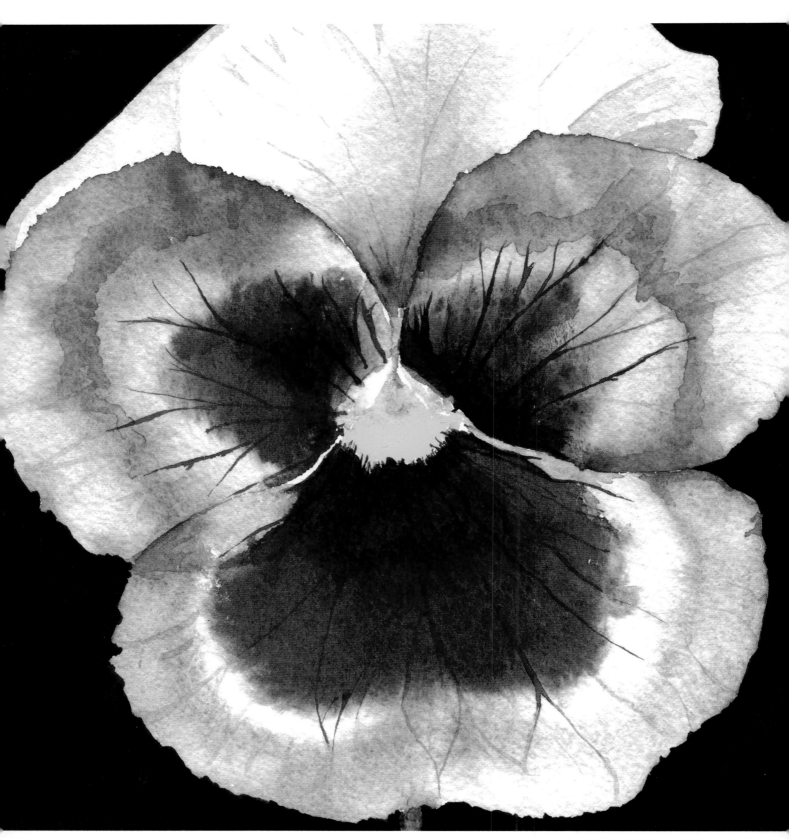

The Purple Pansy; a life changing painting.

Introduction

I knew I had found my ideal medium the very first time I painted with Artists Quality watercolours. I was painting a deep purple pansy, freshly picked from my garden. I mixed the colour on my palette, and carefully placed it onto a dampened area of paper. What happened next quite literally took my breath away. As the colour flooded across the paper I gasped, and my knees went weak. I knew instantly that this was the medium I had been looking for. That was many years ago now, and I can scarcely believe that I still have the same reaction. Watching paint move with a will of its own, and the brilliance and clarity of bright fresh colours, still causes an involuntary intake of breath. Sometimes when I am demonstrating I have to concentrate hard to stop my knees buckling.

Like many artists, I can genuinely say I have always drawn and painted. It is an impulse which I have found impossible to ignore; it just has to be done. The day just doesn't feel complete without creating something, and the best days are when that something is a painting or drawing.

Growing up in a science-based household, my artistic nature was encouraged, but not fully understood. Art was considered a hobby, not a need, and despite my father's valiant attempts to aid me in my interest, the finer points of art and art materials were missed. Science 'won' and my fascination with detail and wanting to know how things work finally led me to a degree in Microbiology. Thankfully this involved hours and hours of drawing. These were very precise, descriptive diagrams, focussing on tiny details and an accurate representation of the plant or animal we were studying. It called for intense observation, but any form of artistic expression was strictly forbidden. In spite of this I enjoyed every moment of making these drawings, from developing an ability to notice each tiny feature of my subject to learning to control my pencil to join two lines so that the join was invisible. This of course is the basis of botanical illustration, the purpose of which is to record a plant carefully and accurately in order that the illustration could be reliably used for identification purposes.

And so to the plants. I love flowers! I love the colours, the shapes, the way they move, the architectural qualities, the softness, the play of light on and through petals and the kinetic qualities of their shadows.

Oh, and the scents. The wonderful scents! There is a saying that you can hear an excellent landscape painting, because you are transported into it; imagining yourself standing there, you can hear the sounds that would be present. Wouldn't it be wonderful to similarly transport the viewer of a floral painting to imagining themselves picking up the flower and being able to breathe in the delicious scent?

When I acquired my first garden, it was quite natural for me to draw and paint the flowers I grew, and very natural to continue in the botanical illustrative style I that I had already developed to quite a high standard. But now I could add colour, which was very exciting. I experimented with all sorts of materials, some very interesting, but none that thrilled me.

The afternoon I painted the pansy quite literally transformed my life. I had discovered a medium that gave me the opportunity to mix the exact colour I wanted, very easily. More than that, the watercolour seemed to have a life of its own, which was very exciting. It did unexpected

things at unexpected times. Frustrating, of course, but I saw that as an exciting challenge. My initial interest in colouring the illustrations quickly developed into an exploration of the medium itself. The more I experimented and explored, the more exciting it became, until I realized that I had reached a point where it was the medium, not the subject matter, that was leading my decision-making when I painted. My paintings were no longer tight botanical illustrations, but much looser flower paintings. The subject matter was still recognizable, but the painting was now also about the paint and the painting process, not just the flower. My paintings were no longer a celebration of flowers in paint, but a celebration of flowers and paint.

In my very brief time as a scientist, I was trained to design experiments and analyze the results, and I think when my painting started to evolve from a tight illustrative style to a looser, freer style, I was instinctively adopting this same approach. That degree had to be useful for something as I never worked as a scientist, instead becoming a teacher, and very quickly finding myself teaching art.

I have often heard artists who paint detailed figurative work expressing the idea that they would like to paint more loosely, but have no idea how to go about it. Further questions establish that the person I am speaking to has attempted to make a leap from figurative painting to a much looser style. Experience has shown me that leaps of this kind, without a thorough understanding of techniques, rarely results in success. I have also discovered that many people feel that they ought to paint in a loose style; not only do they not know how, they are not even really sure that they want to. It saddens me to see enthusiastic artists embark on an exciting voyage of discovery, only to be thwarted by either dogma or an ill-considered approach.

I realized that through the evolution of my own work, I had developed an approach to painting that readily allowed transition from one painting style to another, whether in the usual direction from tight to loose, or the other way around. Having an analytical mind means that I have developed a considered approach to design, which has helped enormously in making decisions about style and freed me creatively. Taking time to think before and during painting actually speeds up productivity, because the chances of success are so much higher.

This book will guide you through this approach. The approach laid out here is for anyone who would like develop their own painting, whether you wish to change your style, or you are comfortable with your choice of style but would like to improve your painting ability. Obviously in this book I will be sharing my passions for watercolour and painting flowers, but you will find that the approach itself is applicable to any subject matter and any medium.

Much of it will be familiar; as you will see in Chapter 1, I do not believe it could be otherwise. What I think might be different is that rather than simply list a set of techniques for you to practise, or exercises for you to follow, you will be asked questions that will help you to consider your choices and decisions when you paint. Often solutions are found by knowing which questions to ask.

I have also noticed over my years of teaching art that it is often a lack of confidence, not a lack of ability, that holds people back. The desire to paint flows from somewhere inside of you; it is very personal. Keep this in mind as you go through the book. The right answers to the questions are your answers; trust them. You will be painting your paintings, not mine. I hope that you will find my approach helpful in building your confidence in your own work, so that you enjoy the process more and are happier with the results.

There will be techniques, exercises and examples too. You will also find demonstration pieces that you can work through. These should be used as stepping stones for your own work. You will also find lots of general tips for making painting easier. Whether you work through the book, or dip into the bits that are most useful to you, I hope it will help you to enjoy your painting more.

My own work continues to evolve, and I hope it always will. For me, the process of experimentation and discovery is endlessly exciting. I hope to be able to help you along your own path of thoughtful experimentation and discovery, and that for you also the process will become just as enjoyable and important as the finished image, if not more so.

Green Globes.

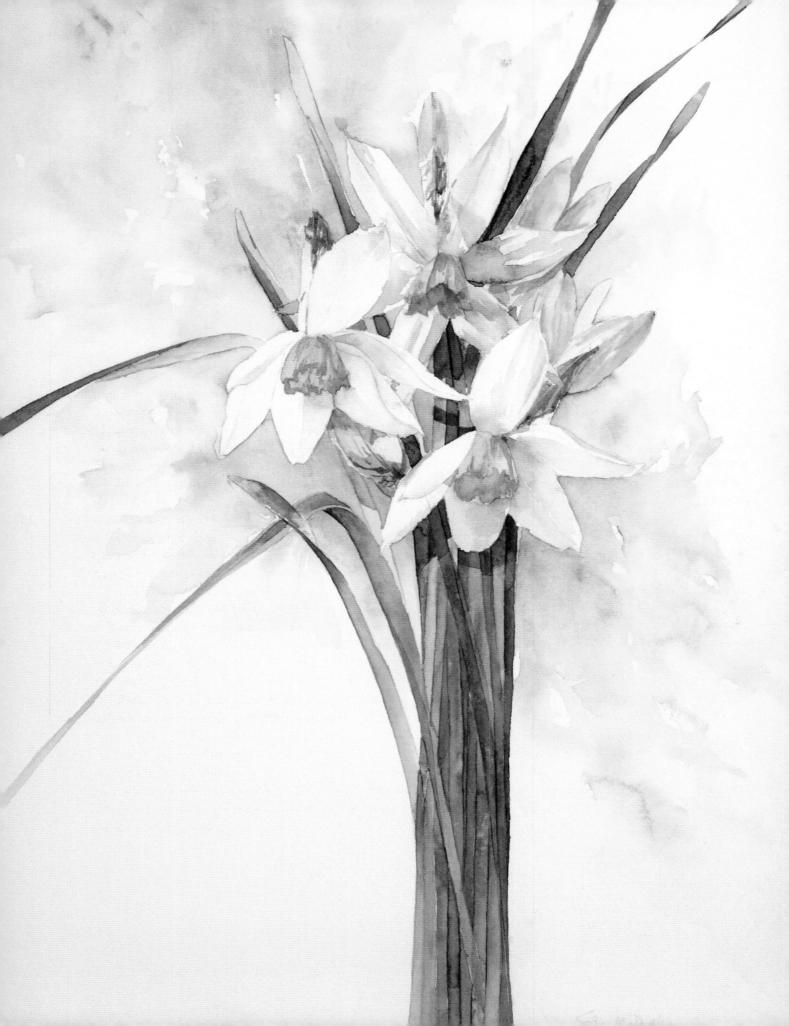

Creativity in flower painting

Imagine for a moment the excitement of finding an inspiring subject that you are passionate about, and that surge of enthusiasm to begin painting immediately. How wonderful it would be to do just that! To paint freely, expressively, sensitively, with a sense of purpose and unadulterated joy. To allow your personality to show through in your paintings. To have the freedom to develop your own style. To paint the painting you want to look at. Are you smiling?

Every year since 1769, the Royal Academy of Arts has held an open exhibition in London. The RA Summer Exhibition aims to show contemporary art in painting, drawing, sculpture, printmaking, architectural models, film making and installations in one exhibition. Each year, thousands of hopeful artists submit their work, and over a thousand works are selected for exhibition.

What makes this exhibition so remarkable is the huge diversity in subject matter and variety of style and genres in the artwork exhibited. Ethereal figurative work is juxtapositioned with loud splashy abstracts, bold sculptures in strange materials are exhibited alongside delicately constructed architectural models. There is nowhere else on earth where it is possible to experience such a potpourri of artwork in one venue on the same day.

That is why, as an artist, one should visit this exhibition, and with an open mind. Walking through the galleries can be an adventure, a voyage of discovery. The number of paintings on display can be initially overwhelming, but you will very quickly find your eyes resting on the images that interest or excite you. But, do you like them? Could you live with them? Do you find yourself seeking out the familiar, or looking for surprises? Are they good? Do you question the selection committee's choices? Why? What do you learn about your developing tastes in art?

For me, the most remarkable thread that runs through this exhibition every year, the one thing that every piece has in common, is confidence. The level of confidence on display at the RA Summer exhibition is encouraging, and freeing. The artist had the confidence to choose their subject matter and style, and to design the image they presented. The works themselves are confident in their execution. A whole committee of people liked it enough to confidently select it for exhibition. And a whole bunch of visitors will like it too. Some will not, but everyone is entitled to their personal taste.

Each time I visit, I leave with my own confidence boosted, because I am reminded that there is no right or wrong way to create a piece of art. There are as many ways as there are artists. There is my way. And there is your way, which is as valid as anybody else's way. And that is exhilarating.

Escaping Daffodils. Painted in response to seeing daffodils held in bunches by rubber bands and squashed into boxes in a supermarket. I painted this picture to express a desire to see them escape captivity and dance in the breeze under a spring sky.

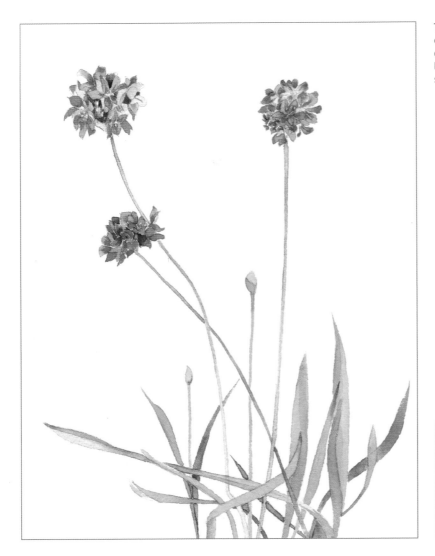

These pretty flowers were in a small pot on a garden table, where I was sitting drinking coffee. They fascinated me and I knew I needed to paint them, just for the sheer pleasure of it.

> What has been will be again, what has been done will be done again, there is nothing new under the sun. Is there anything of which one can say, 'Look! This is something new'? It was here already, long ago; it was here before our time.
>
> Ecclesiastes 1: 9-10

VALUING YOUR CREATIVITY

Do you see a flower and just feel like you want to paint it? Is it as simple as that, the need to make an image of it? Or do you need to explore the medium, and you do that through painting a flower? Is it an inner feeling that you want to use your hands to make something? Or a desire to play with paint?

Nothing comes from nothing

Many people question their own creativity. A rather old fashioned but annoyingly prevalent and persistent definition of creativity implies that something is made out of nothing, and that the something created is completely new. It requires a good imagination, and the ability to come up with completely original ideas. This definition is so inaccurate it should be reclassified as a myth. Fledgling artists are often inhibited by this definition, feeling that unless they come up with something completely new, they are not being creative. We are all influenced by what has come before, by what has happened before, in art, and in our lives. It is impossible not to be. The lyrics from one of the songs in *The Sound of Music* are a lovely reminder: 'Nothing comes from nothing, nothing ever could...', and a lovely little tune to hum in a moment of doubt.

A kinder and more accurate way of defining creativity is to see it as the ability to perceive the world in new ways, to notice patterns that others have missed, or to make new connections between apparently disparate sources, and in doing so to form something new. In the world of ideas, the something may be intangible, but in the world of art it could be a painting.

A mature artist will not only be aware that nothing comes from nothing, but will readily share the sources of

their influences. The reality is that we build on what we know, because we cannot do otherwise. Do not overcomplicate the term 'creative'. Instead, tune into your need to make something without worrying about it being completely new. Embrace the things that have influenced you, and learn from them.

If it has all been done before, why bother? You bother because *you* haven't done it before. Your interpretation of it is as important as anyone else's. There are few artists interested in painting flowers that have not attempted to paint a rose. Imagine the loss to our experience if Charles Rennie Mackintosh decided not to paint roses because Redouté had beaten him to it.

There is no one else quite like you. No-one else with your thoughts, who will make connections in the same way as you. No-one else with your hands, and your eyes; no-one else who can use them. So when you do that, when you co-ordinate your mind, your eyes, your hands and your heart, you are being original. *You* are the originality in the image, not the paint, not the techniques used to apply it, and not the subject matter. You have a desire to make a painting of what you find to be an inspirational subject. You *are* being creative.

Luckily there is a long history of floral art for us to draw on to inspire us and aid us in our creativity.

VARIETY IN FLOWER PAINTING

It is rather an obvious statement to make that flowers play an integral part in our lives; so do lots of other things, but few commonplace things hold such a special place in people's hearts as flowers. For beyond their usefulness in nature and their inherent beauty, the perfumes and the messages they convey have long played a part in cultures all around the globe. Little wonder then that flowers have provided inspiration for so many different artists, for so many different reasons.

Paintings of flowers display the same variety as the flowers themselves: intimate descriptive portraits recording every tiny detail of a plant; beautiful figurative paintings that transport you to a corner of a room filled with a vase of fragrant roses; soft gentle gardens full of fresh air and sunshine; bold energetic abstracts of bright red poppies; delicate portrayals of softly coloured primroses…

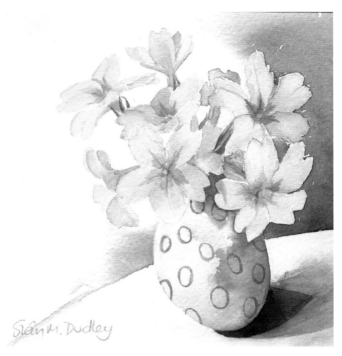

A tiny pot of delicate primroses.

When asked what type of flower paintings you do, it can be difficult to describe the general style or genre of your paintings. Flower paintings seem to fall into categories, but beyond the well-defined genre of botanical illustration, the boundaries become blurred. It is far better described as a spectrum, with a gradual transition from one style to the next, and often considerable overlap between the different genres. For ease of communication in this book, I have come up with loose definitions of categories of flower painting.

Botanical art
Botanical art includes paintings which are intended to describe or record the morphological features of a flower or plant; these are essentially paintings *of* flowers. At one end of this category, the strong link with botanical illustration is evident, although the rules are relaxed as scientific accuracy is not a requirement. Stylistically botanical art is detailed and figurative. As botanical art moves along the spectrum of flower painting, there is room to explore the medium too, as long as it does not detract from the flower itself.

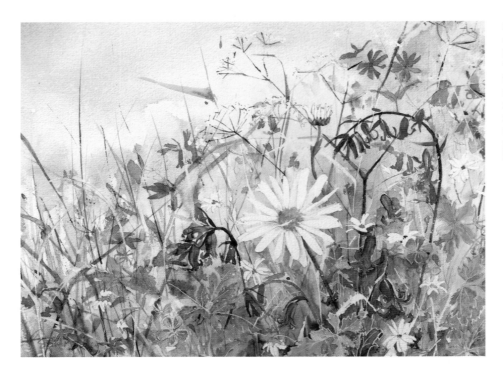

Spring Hedgerow. In this painting of a spring hedgerow, the flowers are instantly recognizable, despite the lack of 'botanical accuracy'. The painting is about the abundance of life and energy in a spring hedgerow, the use of the medium reflecting this is in the energetic mark-making and vibrant colours. This image contains both figurative and abstract passages, with the medium being as important as the subject matter.

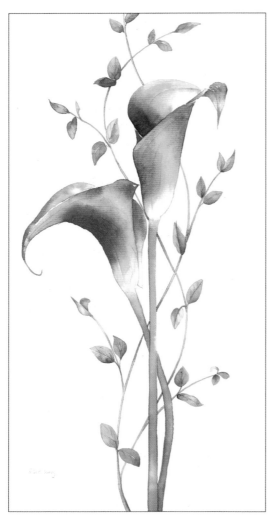

Calla Lilies. This painting of Calla lilies could be described as botanical art. It is clearly a painting *of* the flowers, encouraging the viewer to enjoy the colours and shapes, and drawing them in to discover detail they might have not noticed before.

Floral art

Floral art includes paintings that are *about* the flower. There is something about the flower that inspires a painting: it may be a physical attribute such as the colour, or the shape of the petals. It may be another characteristic, such as the way it moves in a breeze. It could be that the flower plays a role in a narrative; the painting is of a flower but there is a message or story involved. The medium itself plays a far greater role than in botanical art, and may even be the source of inspiration for a flower painting. Stylistically floral art is still quite figurative, but may also include elements of abstraction.

Floral abstracts

These paintings are inspired by flowers, sitting in a grey area between figurative painting and the abstract. The paintings are recognizably inspired by flowers, but are not representational of the flower itself.

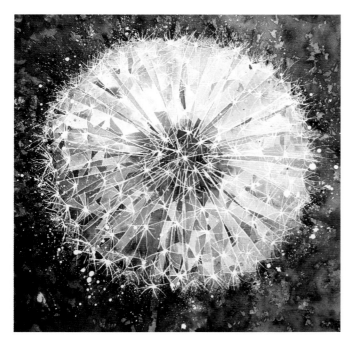

This image falls into the category of Floral Abstracts. In this case, the inspiration is clear, as it is obviously inspired by a dandelion clock. It uses the spherical shape of the fluffy seedhead and the arrangement of the individual seeds, to the extent that the dandelion clock is recognizable, but that is where the resemblance ends. Closer inspection reveals that the motif of the dandelion clock is little more than a structure on which to base painterly marks, and to play with a variety of techniques. Glazing, salt and masking fluid techniques have all been explored to create a feeling of fluffiness, movement and energy. The pooling of paint within boundaries created by masking fluid are more suggestive of stained glass windows than a dandelion clock, and the choice of colours may bring to mind a starlit night sky. The viewer is invited to wander away from the obvious inspiration to an interpretation of their own.

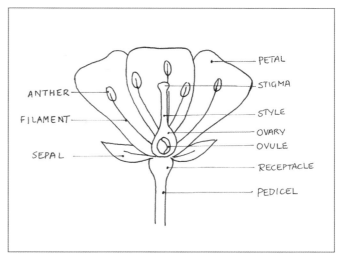

This diagram of a dissection of a stylized flower shows the botanical names for the parts of a flower. Botanical illustrations include this type of detail for each specimen, painted with extreme accuracy. Although not needing to understand plant structure to this degree, flower painters will find their powers of observation improved and their enjoyment of painting enhanced by gaining a basic knowledge of botany.

Each category is of equal importance. Each has its own purpose. As you go through the book, please keep in mind that each of these falls somewhere along the spectrum of flower painting. There are paintings that fit neatly in a particular category, but also many that would be difficult to place in one category rather than another. Where a painting sits often depends on the perspective of the viewer; a painting that the artist describes as floral art might be perceived as botanical art by someone who paints in an abstract style, but as abstract art by someone who paints in a botanical style. Equally important is the intent of the artist; do they intend to make a painting of the flower, about the flower, or inspired by the flower?

All of this is not a matter of learning to define your art, which sounds restrictive and might inhibit creativity. It is more a matter of understanding what you are trying to achieve, and using that knowledge to free your creativity.

A note on botanical illustration

Botanical illustration has firm roots in science, and is subject to strict rules enabling these illustrations to be part of an international scientific language. The purpose of botanical illustration is to ensure accuracy of identification to species level (which, let's face it, could be life-saving). The illustrations have to be botanically accurate, recording all aspects of the life cycle, and may include drawings of dissections, or illustrations of the plant in its natural habitat. The plant is depicted in a generalized form, ignoring any imperfections of individual specimens.

The best botanical illustrations can be very beautiful, giving considerable thought to composition so that they are visually appealing. It is impossible not to be in awe of the artist's dedication to fine detail and technical skill. Just as the plants must be portrayed in a generalized form, there is no room at all for artistic expression or for the personality of the artist to show through. Botanical illustration is very much about the plant; the image itself is of secondary importance. For an artist with an interest in botany and fascinated by details, making botanical illustrations can be absorbing and deeply satisfying.

Despite botanical illustration being carried out by highly skilled artists, and its worthy and lasting influence over the way flowers and plants are painted, its purposes are science based rather than creative. This book is

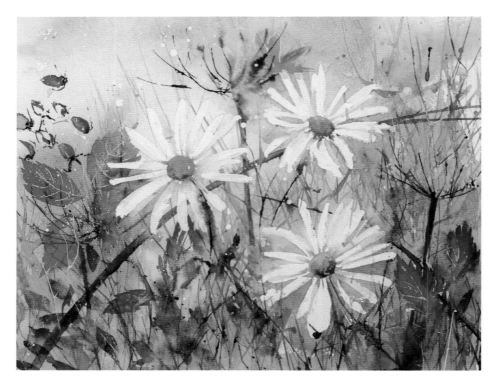

Second Flush. This painting captures the warmth and glow of an autumnal day, when a second flush of ox-eye daisies dance amongst the red and oranges of the changing colours in the hedgerow. Only the daisies and the veins in the leaves (left) were drawn in pencil first. The daisies were masked before applying paint with loose, fluid, confident marks, taking full advantage of the way watercolour blends and moves on the page. Although an experienced artist can make this look easy, it requires a thorough understanding of both the subject matter and the materials being used.

essentially about an artist developing their creativity, so it will be considering only the other forms of floral paintings. If you should decide that botanical illustration is for you then there are many excellent books which will guide you.

FIRST STEPS TO CREATIVE FREEDOM

When starting out, there is a need for the beginner to 'copy' what they see, a need to make an accurate representation of the flower in front of them; it has to be 'right'. Watercolour, the usual choice for flower painters, and the medium on which this book focusses, is a challenging medium, and there is a lot to learn about the handling of the paint. Powers of observation too need to be developed. If a beginner were to be placed somewhere on the continuum described above, it would probably be right in the middle, between floral art and botanical art, simply because the level of skill does not allow for the accuracy of botanical art, or the expressiveness of floral art.

As a tutor, it is not unusual for me to come across many people who have been painting flowers for many years, but who are frustrated at not having progressed beyond this stage. A common complaint is that the paintings they are making are too figurative, when they want to paint more

loosely. My usual response is 'Why?', which often causes a raised eyebrow. The answer usually goes something like 'Because I ought to be more creative by now', or even 'Because I can't draw; if I paint loosely it won't matter'. Often, problems are caused by an overenthusiasm to begin a painting with a new, as yet untried, technique, because '… Joe Bloggs made it look easy and the effect was stunning!' In discussion, I discovered they have tried all sorts of things; clearly a lack of motivation to try something new is not the problem.

These comments and complaints are common across the art world, whatever the choice of subject matter. When people start painting, capturing a likeness is often of prime importance. This may be rightly so; there is a typical path that artists follow, beginning with the figurative and gradually, as they become more experienced, moving towards the abstract.

One often hears 'I want to paint more loosely' but one rarely hears 'How do I tighten up my paintings?'. In the world of painting flowers, it translates into a feeling that after starting with attempts at botanical art, progression then involves loosening up to make freer floral art, and then later to be able to paint floral abstracts. However, abstract art is not the epitome of art, the end point for which we should all aim. There are very many beautiful, highly detailed figurative paintings.

If each genre of flower painting is as important as the others, describing progress as a move towards floral abstracts doesn't make sense. Some people may be happier to move in the other direction, and progress towards botanical illustration. Instead, progression should be described as a deepening understanding of which type of image you want to make, learning the appropriate skill set for that style, and then getting better at it. You may find you prefer to paint in a particular way so that your work settles at one point along the spectrum, falling into a style that suggests it belongs in a particular category. Alternatively, you may decide that you prefer to choose flower by flower, or painting by painting, how you want to make the image; with sound technical skills at your disposal, you have a choice where on the spectrum of flower painting each painting will sit, and you can happily choose whether a painting is to be precise and descriptive, loose and abstract or somewhere in between.

The later chapters in this book take another look at each of the categories of flower painting. There are projects which are intended to give further insight into the reasons behind each of the paintings, including step-by-step demonstrations which you can follow to learn or practise watercolour techniques. In reading the thought process behind each of my paintings, and seeing the effect it has on the design and execution of the paintings in the projects, you may gain insight into your own working method. Simply by beginning to question your intentions for your own paintings, you will be taking a step on the road to greater freedom and creativity in your work. 'Loosening up' is not just about how the paint is applied. It can also mean refusing to be beholden to how you think you *ought* to be painting, and developing confidence in your own purpose and abilities.

Creativity is not undisciplined

The word discipline often rings alarm bells for those wishing to be creative. Creativity is often associated with a splashy, exuberant 'fling-it-at the-paper-and-see-what happens' attitude. Unfortunately, this approach ends in failure and tears far more often than it ends in success. In reality creativity involves proper hard work. When Joe Bloggs made that stunning effect look easy, that was due to a depth of knowledge and understanding borne of experience; they didn't just get lucky, nor were they born with an extra large helping of magical talent. Of course talent can help, but the rest is down to endeavour and determination.

Discipline in this context is about developing efficient methods of working that enable you to discern how you want to paint, what you want to achieve and to acquire the skills to do those things. It involves learning how to combine an explorative and experimental attitude to your art with a practical analysis of your successes and failures, so that you can build on your experience. It involves time, practice, and lots of concentration. Proper preparation on every level (practical and intellectual) is essential if you want to begin a painting anticipating success rather than failure.

Contrary to expectations, a disciplined approach can lead to greater freedom. A useful analogy is to consider what it is like to learn to drive. When you first sit in the car, you are overwhelmed by the need to co-ordinate pedals, levers and gears, while watching the speedometer, the fuel gauge, reading road signs and, horror of horrors, other motorists. Yet within a short space of time, the handling of the car becomes automatic; you can focus on the journey and safely navigate from A to B.

In this book, I would like to encourage you to acquire a sound grasp of the essential practical tools of producing paintings, and that will require discipline. The tools are:

- Observational skills
- Understanding your materials and equipment
- Design skills
- The thoughtful application of these to implement any ideas you have.

A note on 'failure'

Very much part of a creative approach to painting is a pragmatic, non-judgemental attitude to the success or failure of each painting. Every painter has paintings that do not turn out the way they had intended, especially if you are painting in a medium like watercolour which has a mind of its own. Learn to think of each one as part of the process of learning to paint. When a painting fails, take a step back and put it into perspective. It is just one painting. Don't throw it away (yet). Analyze it: what went wrong? What can you learn from it? Do the same when a painting succeeds. Celebrate first, of course, then ask yourself what made it successful.

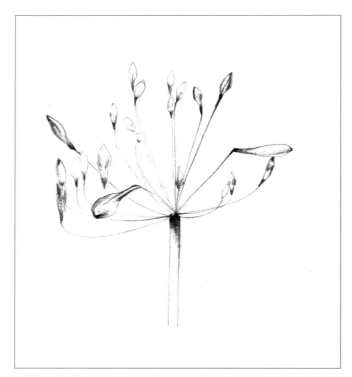

Draw often! Drawing causes you to see actively rather than passively, and will greatly enhance your observational skills and your visual understanding of the world around you. Draw as often as you can. Making this sketch of an agapanthus in bud forced me to make an accurate observation of the shapes of the buds in various stages of development, and how the angles change as they ripen. Although incomplete (there were more buds) it provides very useful information for future paintings; whether I choose to paint figuratively, or loosely through drawing, I have observed essential features of the essence of an agapanthus.

SEEING LIKE AN ARTIST

If you want to learn to paint, you need to learn to see the way an artist does. Artists genuinely notice more than other people. They are more aware of the play of light, colours and shapes, and more able to spot inspiring subjects.

Without any doubt, the most effective method to learn to see this way is to draw. Drawing does this through active observation. Strangely it is the act of drawing, rather than what appears on the paper, that is most important. It forces you to look much harder at your subject than you would normally. With practice, what appears on the paper improves, providing you with more visual information for your paintings. You learn to look differently, seeing things in a new way; the world itself becomes more visually interesting even when you are not drawing, and you find inspiration in the most unexpected places. Different methods of drawing, and the different ways those drawings are

used are discussed in detail in Chapter 5, but why not take a short break now, pick up a pencil and draw something?

There are good reasons to use all the technology available to us, and in Chapter 5 we will be considering how to use photography and other digital media to our advantage. In the community of floral artists, there is some resistance to using photography, which arises because its use to botanical artists is limited, and is not acceptable in botanical illustration because it simply does not provide the right type of information.

Photography is never a substitute for drawing, but it is a worthy tool in its own right. It can be very useful for capturing information quickly, such as fleeting rays of light through leaves, or the position of tulips in a vase before they swing around to the light, entering the window. Photographs themselves can be invaluable inspiration, particularly for abstract paintings.

PLAY TIME

There is substance in the axiom that says there is something beyond the ability to handle materials that leads to success; interest, creativity and talent come readily to mind. But it is also true that no matter how inspired, talented or creative an artist is, unless they can handle the materials success will never come. It could be argued that someone with the desire to paint will automatically take the trouble to learn how to handle the materials, but this does not necessarily follow. Often the end product, the painting, takes precedence over the process of painting it, the latter being seen as simply a means to an end. For example, a student will ask, 'How do I paint this rose?' The focus is the rose, and the expectation is that they will be shown *one* way of painting it.

When the act of painting is undervalued in this way, there is a tendency to neglect developing an understanding of and a familiarity with the materials. The question should be, 'Which techniques shall I use to paint this rose?' with an understanding that the painting of it is as enjoyable as the finished piece, and a choice in how to go about it. The process of painting should not be simply a means to an end. Learn to enjoy the medium for its own sake ... *play with it*! Play is a worthwhile occupation in its own right; when you play effectively you learn from it, and discover new and exciting ideas. Chapter 4 sets out guidelines for effective play, one of the most important elements in this creative approach to painting.

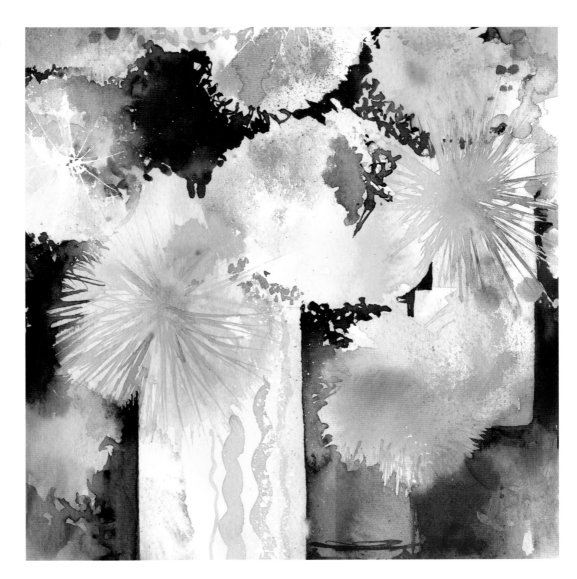

Doodle Flowers. This painting was the result of playing with some new paint colours. I began simply by dropping colour onto wet paper, and watching how the colours interacted and moved. Doodling with brushes, I added more layers of paint, and began experimenting with brush marks. I didn't rush; waiting for effects to develop takes time. Playing with tones and shapes can be a good opportunity to practise balancing a composition. I introduced some lines, which to the imaginative viewer might suggest vases, but was not really important at the time. The purpose was experimentation for the fun of it.

THINK LIKE AN ARTIST

This book describes an approach to painting flowers that is genuinely creative. The approach encourages understanding the fundamental aspects of painting and their importance in designing an image. Along the way it encourages you to have the confidence to make conscious aesthetic decisions, which will lead to a flowering of your own creative style. What this book shares is that the creative process is a considered one, not a magical experience that leaves you hoping for good luck each time you pick up a brush.

There will be demonstrations, exercises, studio tips, and projects for you to undertake, but rather than simply working through them as prescribed activities, you will be encouraged to think like an artist. From inspiration to finished painting, you will be shown how to develop your ideas, working as a creative person works. Yes, it requires discipline, but it also requires a sparkly sense of fun and artistic abandon.

Take another moment to imagine the excitement of finding an inspiring subject that you are passionate about, and that surge of enthusiasm to begin painting immediately.

Take a moment to imagine being able to enjoy the process of painting in that way. It sounds wonderful, so keep it in mind. Let it be your aim, and believe it to be achievable.

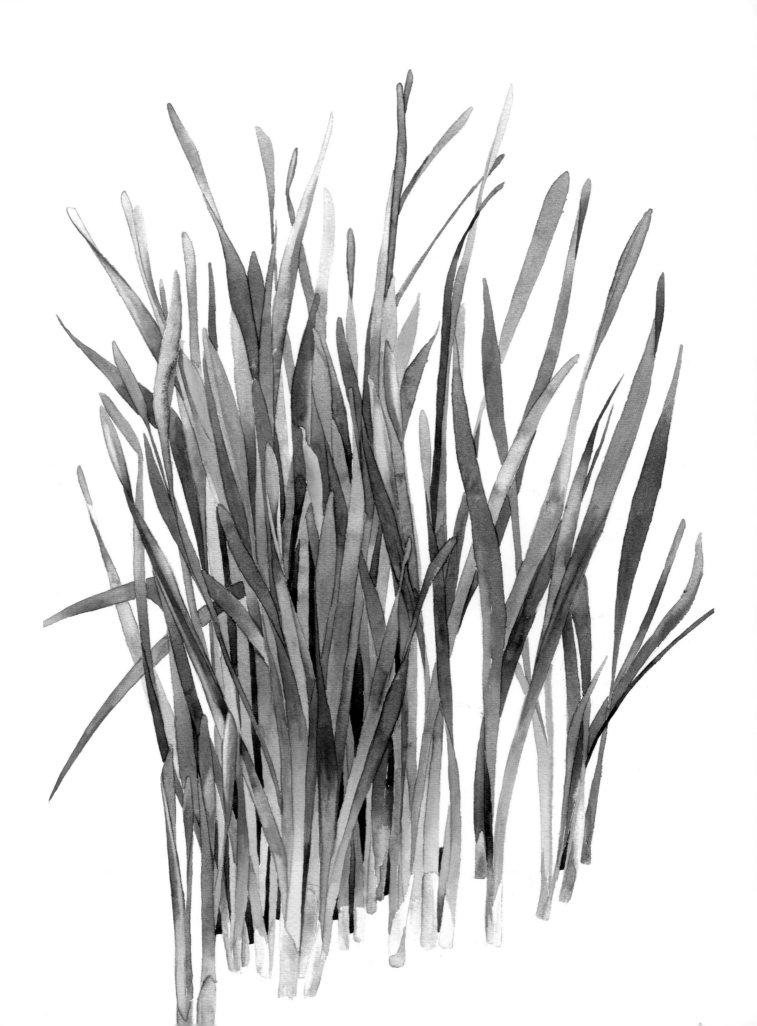

Chapter 2

From illustration to invention

I t may be surprising, but the best place to start your journey towards greater creativity in painting is at the end.

Imagine for a moment a watercolour painting of a vase of flowers, framed and hung on the wall in a gallery. Visitors to the gallery see the painting, and respond to it. They reinterpret the image, their own memories and emotions adding to what is in front of them. They form an opinion; do they like it enough to want to look at it longer? Whatever they are thinking, the point of note here is that they are not responding to the flowers themselves, but to a delightful arrangement of colour, tones and painterly brush marks representing a vase of flowers. This is something different to the vase of flowers itself; it is something new, a 'thing' in its own right.

As mentioned in Chapter 1, the first stages of an artist's creative journey usually involve attempts to depict their subject matter in two dimensions, whether in a drawing or in paint. The paintings made at this stage are, almost necessarily, quite illustrative. The artist's focus is on the subject matter. It is an important stage; a lot is learned about the techniques of handling the medium, and the observational skills acquired are invaluable.

When the artist comes to a realization that the image they are making is a thing in its own right, worthy of time and consideration for what it is, it causes a change in

A painting is a new creation in its own right, separate from the subject that inspired it. Create images you want to enjoy looking at.

Promise of Spring. I adore everything about daffodils; they are truly joyful in the way they announce the arrival of spring. In the painting, *Promise of Spring*, I wanted to capture the feelings of anticipation and hope I feel as the day the first buds open approaches. You have to look closely to spot the buds but once seen, it is difficult not to imagine them fully opened on what is a bright, clear, crisp spring day.

attitude that moves the focus from the subject matter to the painting itself. This is very liberating!

Free to express their ideas through their paintings, artists can move beyond simple depiction to designing images to express an idea or emotion, whether entirely for their own benefit or to elicit a response in another person. They can experiment with colour, shapes, concepts, narrative… they are producing a piece of art.

When you reach this point you are at the start of a journey of discovering what you want to paint, and how you want to paint it; you are on the cusp of developing your own style, of being inventive and original. Ultimately there are no rules; I can still sometimes be heard gleefully muttering to myself, 'It is my painting, I can do what I like!' But since too much freedom can be bewildering, if not a little frightening, some guiding principles will be very useful.

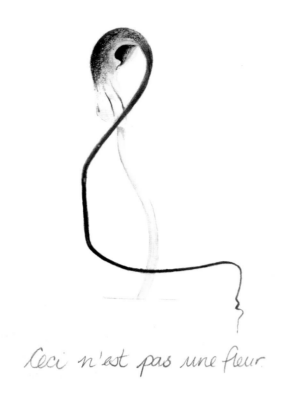

Ceci n'est pas une fleur.

This journey is a very personal one. I do not think it is appropriate to give a definitive set of guidelines as such, but I prefer to share with you the method I use when deciding what to paint, and how I want to paint it. It is based on knowing which questions to ask to clarify your thoughts. Treat them as a starting point to develop your own working method, and ultimately your own painting style.

WHO ARE YOU PAINTING FOR?

Asking yourself the question 'Who am I painting for?' reveals a subtle, often surprising degree of tension. It is a far more complicated question than it first appears to be.

When we paint, we are part of the painting. It is the artist who decides what the painting is about, what to leave out, what to include, and how to execute the painting. It is the artist who responds to the initial inspiration and works through the development of the idea. There is a tension here; you, the artist, are part of the painting, and the painting is part of you.

The reticence many artists feel when showing their work is borne of an understanding that as they present their work to the viewer, they are also presenting something of themselves; are they ready for such a revelation? It is not that this is always because each brushstroke has been torn from the depth of their soul; the concern could be on a much simpler level, relating to their ability to impress the viewer with their artistic ability, and this is particularly so for beginners. However, it is a rare artist who hides away each piece of work, never to be viewed by another human being. After all, most of the time artists have something to say. They are using the medium of paint to say it, rather than words, but to have their voice heard they need to show their work.

Once shown, the viewer too becomes part of the painting. They consider the image, and impose their own interpretation on it, using their imagination to re-create the subject matter in their minds. Without the viewer's ability to do this, paintings would have little meaning. Remember that the painting is a thing in its own right. If your painting is of a garden, you are presenting your viewer with a painting of a garden of flowers, not inviting them into the garden itself. They take themselves there, in their imaginations, as they view your painting.

Always paint first and foremost for yourself

That is the only way your work will have any integrity and honesty. Just as boredom will show through the painting, so will a lack of sincerity. Do not paint worrying about what others will think. You cannot second guess another's response anyway. Know what you are aiming at, and do your best to achieve it. Paint your picture the way you want to paint it. Grasping this concept can be immensely freeing, and will result in a real breakthrough in your creativity.

INSPIRATION

A painting starts before the first brush load of paint touches the paper, before the first sketch is made, or the first photograph taken. Paintings do not begin in the physical world, but in a moment of inspiration. It is not the subject matter that matters, but the emotional response of an artist to something they have experienced.

A moment of inspiration is delicious, exciting, exhilarating. It can cause a sharp intake of breath, or an exclamation of delight. For an artist there is a feeling of wanting to capture the subject in a painting or drawing

that is difficult, at times impossible, to ignore. That is the moment the painting begins. The very best paintings all begin with such a moment. There is an indescribable 'something' in the resulting painting that is instantly recognizable. This is where words fail, and the artist knows that the only viable way to react to the experience is through making a painting.

Where does inspiration come from?

If inspiration is an emotional response to a stimulus then the answer to this question has to be 'within the artist'. But when asked if an artist answers truthfully, 'I don't really know, it is something inside of me', or even 'I don't know, ideas just seem to pop into my head', it can sound evasive, as though they are trying to perpetuate the mystery that is art.

There is only one valuable thing in art: the thing you cannot explain.

GEORGES BRAQUE

Why is inspiration so important? If you have ever attempted to draw or paint a subject you were not especially interested in because someone else has told you to, for example in an art class, you have probably experienced what happens when the subject matter bores you. The painting is boring. The lack of enthusiasm is evident in every brushstroke, the resulting painting lacks energy and life. You were bored, and it shows in your work. But when you are enthused by your subject, when you feel you are passionate about making a painting of it, when you are *inspired*, the difference can be phenomenal. The paint flows, and the painting sings. These are the paintings where the viewer can imagine picking up the flowers and breathing in the delicious scent.

As humans, we have been reading images for millennia, and the degree of subtlety we are capable of perceiving without even realizing it is quite astonishing. When you are not interested in your subject matter, it shows, even to people who claim they are not in the least bit artistic. Discovering what inspires you is important.

What inspires you?

The trick is not to start by looking at what has inspired other people (this might help later) but to learn to recognize that feeling within yourself. Inspiration comes at

unexpected times, in unexpected places, but take the time to record the exciting moments; make a note of it, take a photo, even make a quick sketch. You do not have to turn every one of these occasions into a painting (although you may want to!).

Flower painters are in the enviable position of having their preferred subject matter presented to them on an almost daily basis, whether in the form of a beautiful bouquet, a bunch of flowers from the supermarket, a pretty garden or a tiny weed in just the *right* place. But what makes you stop, and look for longer? The colour? The shapes? The way the light comes through petals, or the way the flowers dance in the wind? An atmosphere or mood? Is there something that repeatedly causes you to catch your breath in anticipation of picking up your paint brushes to capture the flowers in a painting? Once you are aware of the type of thing that excites you, you can begin to go looking for that type of stimulus.

Dismiss nothing that excites you. You may not feel you have the technical skill to do justice to a particular subject yet, but make a note of it anyway. Inspiration can be quite persistent; while some ideas are fleeting, others can remain an inspiration for years – your technical skills may catch up. Keeping a record of what you find inspiring may give you an indication of the particular skills you need to learn first.

Do not dismiss an idea because you think other people would think it uninteresting. This is similar to painting something you find uninspiring because someone has told you to. There is a painting by Lucy Willis, *Marrow Seedlings*, that is of a tray of recently emerged marrow seedlings in black plastic pots on an ordinary windowsill. A seemingly uninspiring subject, but the painting was so full of light and a promise of delicious future meals that has made a lasting impression on me. Remember other people will be responding to your painting, not to the original subject, and the painting is going to be captivating.

Over time you will understand more about what you want to paint. Make a decision to trust your instincts. Inspiration is *very* personal. If you find a subject inspiring, be confident that it is worthy of your time and attention.

Starting points

Inspiration can be found anywhere. Flower lovers will always enjoy a visit to a garden, large or small, formal, cottage or potager. Florist shops and markets are another wonderful source of inspiration, with buckets stuffed full of glorious colours and shapes, bouquets being made up

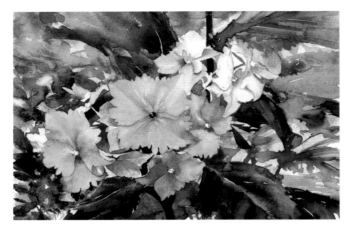

I spotted this hydrangea (a slightly odd shape, acquiring its autumn colour) hidden and under some leaves. I instantly found the play of light and the colours very inspiring. Many would find this an odd choice in a garden of perfectly formed hydrangeas still in full bloom, but instinct told me that this was the one I wanted to paint.

and delicious scents. My personal favourite, a walk down a country lane, never disappoints, whatever the season. As inspiration for painting flowers, look also at other forms of art; consider collages, paintings in other media, drawings, photographs, sculptures, music, song lyrics, poetry … in short, anything which puts an image into your head can be useful.

An inspiring subject rarely appears at opportune moments, so it makes sense to be prepared to record those moments whenever possible. Keeping sketchbooks and pencils in the car, in handbags, rucksacks or your briefcase will ensure you always have something to hand. A camera, including those on phones or tablets, can be very useful for quickly capturing an *aide memoire*, and is especially useful for recording light effects, such as a sunbeam shining through petals, or an interesting shadow. At home or in the studio, collect images from magazines, tearing them out and dropping them into a box file. Keep a photo album on your computer, so that when you come across an interesting image while browsing the internet, you can save it and paste it in.

Never underestimate a good, hard, concentrated stare! A memory made by taking a few minutes to drink in the sight before you often makes an excellent starting point. These days we have a tendency to rush around so much that we miss more than we see. I keep a copy of William Henry Davies's poem *Leisure* pinned to a notice board in my studio as a gentle reminder that standing and staring is most definitely *not* a waste of my time. It is especially useful to re-read it during very busy times, but also a reminder of how inspiring it can be to spend still, quiet

Inspiration can strike at odd moments when you do not have the opportunity to act upon it. Collect inspiring images and pop them into a file for later use.

time simply drinking in the world around me. Of course, the more details you are able to capture, the more you will have to work with when you begin to turn inspiration into an idea for a painting; how to collect information in detail as considered in Chapter 5.

TURNING INSPIRATION INTO IDEAS

Pablo Picasso is reputed to have said that inspiration does exist, but when it appears it must find us working. A flash of inspiration can be very exciting, but in itself it does not give you the information you need to make a painting. It makes you *want* to paint the painting.

Inspiration sparks an idea; the idea interprets the inspiration, translating the feeling into something more tangible. An idea for a painting begins to form; in truth at its inception it rarely equates to a fully resolved design for a painting. Ideas need to be worked on, developed, and frequently undergo a lot of revision before they reach a stage when painting can begin. Surely this is what Picasso was referring to; without taking the idea and working on it, the inspiration will amount to nothing.

Finding an inspiring subject that genuinely excites you can give you a real sense of urgency to grab your brushes, your paints and *just get on with it.* There are very few artists who would not recognize this feeling. Sadly, launching into an unresolved idea will almost certainly result in failure and disappointment.

Inspiration happens. Ideas are looked for
Developing an idea can be an interesting and enjoyable process. In many ways it is far more creative than the actual application of paint. It is a time of experimentation and discovery, a time to play, to invent, to revel in the concept or to have fun with the materials. You are safe to approach this in a relaxed state of mind because at this stage you cannot get it wrong, you can only decide to accept or reject the various options you discover. This is a time for deciding how you want the finished painting to look, and how you are going to achieve that. Effort is involved; 'work' is not a misnomer, but the pleasure involved and the sense of achievement gained far exceeds the usual connotations of the word. The benefit of

anticipating a successful painting is worth every minute spent in the planning.

For watercolourists in particular, it is important to resolve as much of the painting as possible before beginning, as the opportunities to change things on the hoof are more limited than in other media. (That is not to say impossible, though; changes can be made as the painting progresses, and mistakes can be rectified.) The more you think through your idea, and the various elements of physically producing the painting, the more likely you are to be happy with the results. Far from inhibiting creativity, a disciplined, considered approach which allows for responsive exploration can be very liberating.

Developing your ideas
Why are you painting what you are painting?
To begin developing your idea rather than ask 'What is the painting of?', ask 'What is the painting about?'

The answer to this question allows you to explore your reasons for wanting to make the painting. It relates back to the moment of inspiration, and needs you to begin to analyze what really excited you. Sometimes the answer to this is obvious, and you know instantly that you simply want to record the subject as you saw it in that moment, to share it or remember it. Sometimes it is less discernible, and you need to spend some time thinking through what you want to communicate through the painting.

Figuring out what you want to say through your paintings can help you to develop your own style. By deciding what is important to you early in the process, you can make decisions about the style of painting (for example, botanical art or floral abstract), the colours to use, the composition, and the mark-making. These aspects of painting are covered in later chapters; for now, consider *why* you are painting what you are painting, and begin to assess how this might affect the design for the image you want to produce. This in turn gives you more ideas for how to make a start with the practical elements such as collecting your reference materials and preparatory sketches.

Remember that no genre of flower painting is more or less creative than another, they merely address the different purpose of the artist painting them. Unless you feel very comfortable placing yourself in a particular category of flower painter, it is probably a good idea to keep an open mind when considering the various possibilities for what the painting might be about. You may find yourself surprised by your answers, or discover a new confidence in what you are currently doing. As you apply this to

each new painting you do, you may find that you have a definite preference for one particular style of painting, and begin to develop a recognizable style very quickly. You may, like me, realize that you respond differently to each situation; the type of flower or the environment you find it in inspiring a different type of idea, resulting in a new style of painting.

The following questions are good starting points. Remember these are questions, not categories. It is not an exhaustive list; it is perfectly acceptable to come up with your own.

Do you want the painting to be descriptive?

It may be that subject matter you are considering is just so beautiful you want to remember it exactly as it is, or you may want to share it with someone who has not seen the actual object(s). You want to describe it as you see it in front of you, making a 2D representation in watercolour. This is an excellent and traditional motive for painting all subjects, not just flowers, and is hugely appreciated by the general public. This still allows for plenty of stylistic choices when it comes to applying the paint, as this can be achieved in precise detail, or in a more abstracted form.

A single flower can be quite stunningly beautiful. It doesn't need anything added, nor does it need to be simplified. Placing the painting of the single flower on a plain white background is often enough. Do you want your viewer to focus fully on the rich and delicate details without any distractions? Would a very figurative painting best suit your purposes?

Flower painters often become very good at floral arrangements, and setting up still lives. Jugs, vases, curtains, table cloths, all manner of items in fact, can be arranged in an attractive way as the basis for a painting. The inspiration may have come from just one item – it need not even be the flowers. The star of the show is complemented by the supporting cast to make an interesting painting that will hold the viewer's gaze for hours. Setting up a still life in this way can ease decisions later about composition, as you are composing the scene to be visually interesting in 3D at this stage. Would setting up a still life help you develop your idea? Or would you prefer to work from a series of detailed sketches and close-up photographs, so that you can focus attention on the details that inspired you?

Flowers *in situ* are an endless source of inspiration, whether in formal gardens or growing in the wild. If you are inspired by the sight of a long, formal border, how

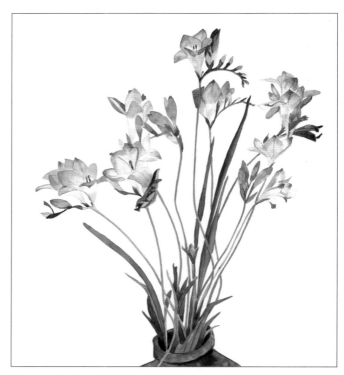

Lilac Freesias. My motives for making this painting were very traditional. I simply wanted to depict the flowers as I saw them in a figurative style, capturing the delicate colours and interesting shapes.

much detail do you need to apply to each flower? As your idea develops, do you want to highlight one species, and use the rest as a backdrop, do you want to capture the blaze of colour, or the architectural qualities of the plant groups? Similar questions can be asked of a hedgerow or wild flower meadow.

How figurative do you want to be? Is it detail that inspired you? Or are you happy to describe the flowers loosely to give an impression of them, capturing their character rather than interpreting them more literally? Your answers to these questions will have implications for how you design your composition, and the painterly techniques you use to describe the different textures.

Do you want your painting to have a narrative, or convey a message?

As in all art, flowers and plants can be used in paintings to convey a story. You may still be painting flowers, but they have a purpose within the image. The painting is of the flowers, but not about them. You are inviting your viewer to question and think about something other than the painting, rather than purely admire it for its visual qualities. As you work through your idea, you will need to consider how you place the flowers on the page and the

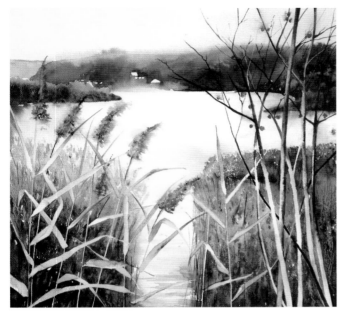

Reeds at Slapton Ley. This painting was inspired by a reed bed in autumn. Sitting on a viewing platform, usually used for observing wildlife, I became fascinated by the architectural qualities of the stalks and leaves, and the fluffiness of the seed heads, all of which are exaggerated in the image. I also wanted to include bright, autumnal colours, and to enjoy the qualities of the pigments I used to provide texture.

Place Your Bets! This was one of a series of paintings inspired by a newspaper report of the traditional game of 'Conkers' being banned in schools in case the children hurt themselves. This game was enjoyed in school playgrounds for many generations; there may have been a few bruised knuckles, but compared with lots of other childhood games it didn't enter the public consciousness as a major problem. If we overprotect our children, how will they learn to take care? I worked out my concerns via the paintings!

importance they have in the overall composition. Titles can be very important too.

Do you want your painting to describe an emotion?

Anyone who loves flowers will be well acquainted with the emotions they can elicit. It is generally accepted that flowers can cheer people up; to capture this cheerful feeling and evoke it in your viewer, you might want to develop your idea by choosing bright, happy colours, placing the flowers in an energetic arrangement, and choosing brush marks that have some energy about them. You might decide you want to paint roses to portray a serene summer afternoon; to capture a sense of calm you would choose a much softer palette, and possibly keep the tonal key lower.

Take a moment to imagine painting a field of flowering grasses on a warm, bright summer's day. Imagine standing there, the pleasurable feeling of the sun on your back, the sound of birds, the softness of the grasses; consider the palette and brush strokes you might use. Can you imagine how you might alter your design to express the fear felt by a hay fever sufferer standing in that same field?

Do you want to celebrate the medium?

Sheer enjoyment of the medium can be inspiration enough to begin a painting. Watching paint mix on your palette,

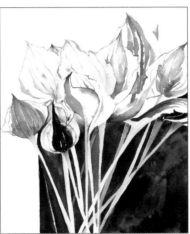

Before the Slugs. A carefully chosen title can make a surprising difference to a viewer's response to a painting. The title of this piece evokes a whole range of emotions, and animated conversations, in viewers who love hostas.

the enjoyment of experimenting with a new technique or the discovery of a new pigment is all that is needed to make you want to paint. It is as valid a reason as any other to set about making a painting.

Letting the medium lead the development of a painting can be great fun. Developing a successful painting this way means finding a suitable subject matter for the appropriate application of the particular technique that is inspiring you. More guidance is given on this in Chapter 4.

It does not necessarily follow that the paintings have to be loose and 'free' to work this way. It might be that the

For as long as there have been people on earth, people have found meanings in flowers. The symbolism of flowers pervades art and literature.

In Shakespeare's *Hamlet*, Ophelia hands out flowers, giving their meanings as she does so: "There's rosemary, that's for remembrance. Pray you, love, remember. And there is pansies, that's for thoughts…"

In classical and religious art, flowers were rarely used as a decorative device, but for their symbolic meaning. There is a very strong tradition of using lilies to symbolize purity and virginity. Roses are also used to symbolize the purity of the Virgin Mary, but are also known for their association with Venus, the goddess of love. In Anthony van Dyck's portrait of Isabella Brant, her flower symbolizes her love for Rubens. Today, anyone who receives a single red rose understands it to be a declaration of love.

There is evidence that language of flowers, or florigraphy, has been practised in cultures across the world for thousands of years. In Victorian England, coinciding with a growing interest in botany, florigraphy became an extremely popular method of secret communication. Hampered by the strict rules of Victorian etiquette which prevented people speaking freely to one another, lovers were able to send each other secret messages through carefully selected bouquets. Dictionaries of the meanings of flowers were written, and were very popular. It was a risky business though, as meanings varied between dictionaries. Beyond the meaning of individual flowers, the way bouquets were arranged, delivered and received also mattered. If a bouquet was received and held at heart level it indicated acceptance, but if held pointing downwards it indicated rejection.

Rosemary for remembrance, pansies for thoughts.

If the meanings of flowers were applied to watercolour paintings of flowers, perhaps in *Promise of Spring* I should have included some gooseberry flowers, indicating anticipation, snowdrops and hawthorn for hope, and the lesser celandine to symbolize the joys to come.

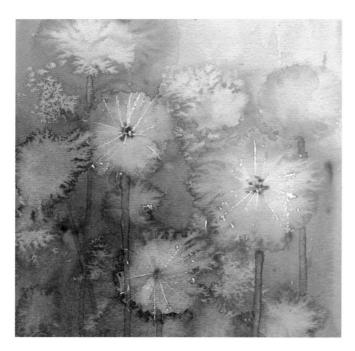

Cauliflower Dandelions. This painting of dandelion clocks was a response to the pure enjoyment of watching 'cauliflowers' develop in drying paint.

technique that fascinates you is one that calls for great control, and the pleasure comes for learning to manipulate the paint to do as you wish it to. But watercolour has a life of its own, and it could be the opposite, that you are taking great enjoyment in watching the paint create shapes and textures with very little guidance from you.

Developing a habit of answering the questions in a deliberate and methodical manner before embarking on a painting will significantly improve your chances of success. I am convinced that successful, mature artists do this so instinctively they may not even be aware they are doing it at all – they may even deny it. Over time a habit becomes instinctual, and you will reach a point where you, like the mature artist, will not notice you are doing it. If the subject you are considering has really inspired you, you will instinctively know the answers to most of the questions without thinking about them too hard. Asking questions will help you to turn inspiration into an idea, and to develop the idea into a plan for an inventive, impressive painting.

What inspires you?

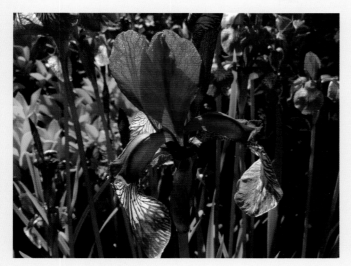

Exercise: What inspires you?

This exercise is an example of the way you might begin to question why you want to paint a subject. For different subjects, other questions might be more appropriate; once you begin to ask why you want to paint something, you will find the questions often present themselves. Treat this exercise as a starting point; hopefully you will discover some useful questions of your own.

Consider the photograph of irises and, as an exercise, work through the following list of questions below. If you find it inspiring, you might want to go and paint a picture based on

it. If not, the exercise may help you to discover why you do not like it, and this in itself may be informative.

Do you like irises?

Consider the shapes of the flowers. Do you find them attractive? Do the shapes of the petals define the nature of irises for you, or are they defined by the colours, or markings? How important would it be for you to record these details in a painting of them? Your answer to this last question may help you decide on the style of the painting.

Do you like light through leaves and petals? Do you find the brightness of the leaves where the sun comes through them attractive? This might require a dark background to push the highlights forward. Does this appeal, or would you prefer to place the plants against a white background, focus on the shapes and the shadows within them? Would you like to capture the brightness and warmth of a sunlit scene, and mentally transport your viewer to the garden?

Do you look at the photograph and begin to imagine yourself painting? Have you already looked past the iris in the foreground to what is behind it in the photograph, and begun to think about which textures and brush marks you might use to suggest the other flowers? Would this photograph inspire you to enjoy the paint as much as the subject matter? The answer to these questions might help you decide whether you want to paint in a very controlled manner, or whether you want to use looser techniques for this image.

LEARNING FROM OTHER ARTISTS

In all aspects of life we build on what we already know, and art is no exception. A good artist will acknowledge that readily and with enthusiasm for the work of the artists who have moved them. The more art you look at, the more information you have to work with. Make notes, save web searches, buy books, visit galleries. Over time you will build up your own collection of ideas that you like. Our ideas are a mix of all sorts of things that we have already seen. It is in putting disparate ideas together in new and exciting ways that we invent new images; we produce original art.

Do you find the work of another artist inspiring? Take time to identify what it is that attracted you to their work. This is important, because when you really start looking at the work, you can analyze which elements of it will be useful to you. To make the most of the opportunity to learn

from your artistic heroes, ask yourself practical questions. When standing in front of an awe-inspiring painting that has taken your breath away, it can take a few moments to remember to do this. But it is worth doing, because it gives you the opportunity to pick up self-knowledge and skills that will be useful to you when you are painting. In all likelihood you will also find elements of it that you do not like. For the purpose of your own development, you can safely reject these elements. You don't need them. The following questions can lead to informative answers.

Are you especially attracted to the subject matter?
It is possible that you are regularly drawn to paintings of your favourite flowers, the flowers that inspire you to paint yourself. How has another artist dealt with the same subject matter? Are they painting the flowers with

a completely different approach, being more abstract or more botanically orientated than yourself, but inspiring you to try a different way of painting? And do you find this prospect exciting, or has it confirmed your confidence and comfort with your current approach?

Are you drawn to interesting compositions?

Do other artists come up with particularly delightful compositions, arranging the flowers on the page in a way you would not have thought of, but that give you ideas for more interesting compositions of your own? Are you drawn to simple designs, maybe those that have clarity and are calm? This might indicate that you need to learn how to balance an image carefully to maintain the tranquility.

Or do you prefer more complex compositions that are busier, maybe exuding energy and have the eye dancing all over the painting? Does this tell you that you need to learn how to lead the eye around the painting, to points where it can rest before being drawn to another element of the design?

Do interesting marks and textures catch your eye?

If you find yourself inspired by the application of paint, looking closely at how other artists have applied the paint can teach you a great deal, introducing you to new techniques. It is said that you can always spot which visitors to a gallery are artists themselves. They are the ones with their noses close to the paintings, trying to see how the paint was laid down.

Do the colours used attract you above everything else?

When entering a gallery do you scan the room, being first drawn to paintings in particular colours? Does the same happen when you are browsing the internet? If you find this happens regularly, you are showing a preference for a certain range of colours. Knowing this can be very important as you are discovering your own style. If you do not like the colours you are working with, you are extremely unlikely to like the finished painting.

Studying how other artists have used colour can be incredibly informative, since colour can be used so readily to evoke emotion. It can be used to give a painting energy by using complementary colours, while harmonizing colours will produce a calmer painting.

Look closely at how the artist has arranged the colours within the composition, which can help to lead the eye around the image, and give a sense of balance. How

Detail from *Thank You, CRM!*, a step-by-step project in Chapter 7.

limited is their palette? Can you work out how many different pigments the artist has used?

Are you drawn to paintings that evoke a particular mood?

If the reasons you admire the work are based on narrative or the emotions it evoked, note those too; conveying an emotion or message will be important on designing your own work. When thinking in cold terms about flower painting, the idea of conveying a message or emotion may seem distant, but is more easily understood if you compare Redouté's roses, van Gogh's sunflowers, and Monet's waterlilies.

Thank you, CRM!, a step-by-step project found in Chapter 7, takes inspiration from a painting by Charles Rennie Mackintosh, and demonstrates how studying the work of another artist can inform decisions about style and techniques.

LEARNING BY COPYING

Copying the art of others is a very well known and thoroughly acceptable way of improving your techniques. But it is *essential* to understand why you are copying, and how to copy effectively to improve your own skills and enhance your originality.

Choosing paintings to copy is easy. Simply find one you like. Look at the work of your artistic heroes, and choose examples of their work. Don't just copy the work of one of them, copy work from many of them. This way you will pick up something from each of them, and mix it all up to develop your own style.

Your inspiration here is the work of another artist. The original artist had the inspiration, then worked through the ideas; you enjoyed the resulting painting enough to

copy it. The point of copying is not to express yourself, but to enhance your artistic skills, in particular the practical aspects of making a painting.

Try to work out why the original artist made the decisions they did. One of the most useful reasons for copying is not to reproduce the techniques used, but to consider the thinking behind the techniques. Why did they choose that subject, why did they paint it that way and what were they trying to say? As Austin Kleon says, "You don't want to look like your heroes, you want to see like your heroes." [Austin Kleon, *Steal Like An Artist* (Workman: 2012)]

Copy the work as accurately as you can, noticing fine details, working out the order in which the layers of paint were applied, the colours used, the layout of the composition and so on. You will not be able to copy it exactly any more than you could forge someone else's signature, but do not be disappointed or feel like a failure because you will learn along the way. You will adjust the techniques you notice to suit your own hand; you will choose the ones you enjoy practising; you will reject the ones you cannot achieve or simply do not like. Over time you will accumulate a set of skills unique to yourself to apply to your own inspired ideas.

WHY YOU SHOULD VISIT GALLERIES

These days it is easy to find images of art work by other artists, whether we want to see work by the masters like Monet, Georgia O'Keefe and Redouté, or contemporary artists like Rosie Sanders or Marney Ward. Many less well-known artists have websites, even if their work has not been published in books. This of course is a great joy, as it enables us to expand our knowledge easily. Any form of reproduction, however expertly it has been executed, loses something of the original. The most obvious one is the impact of size. Rosie Sanders's paintings look amazing in whatever format they are viewed, but books and the internet do not prepare you for the impact of their sheer size. Colours too are always distorted, whether by the printing process or the computer screen. Van Gogh's *Sunflowers* is extremely well-known, and rarely reproduced in colours anywhere near the original. An image in a book or on screen is flattened; even watercolours, which have less physical depth than oils or acrylics, lose the texture of the paper when photographed.

There is nothing that comes close to seeing the actual paintings. Take every opportunity you have to view art first hand. From small local galleries to the major galleries such as the National Gallery or the Tate, your experience of the art will be greatly enhanced by standing in front of it.

COPY WITH CAUTION

You need to differentiate between using art already in existence as a spring board for your own ideas and learning techniques, and plagiarism. Plagiarism, attempting to pass off someone else's work as your own, is copyright infringement, and is against the law. Make a point of understanding the copyright law of the region you live in, and anywhere where you expect to exhibit or sell your work, since the penalties can be severe.

'MULLING TIME'

Creative people *need* time to daydream. Daydreaming is extremely relaxing — can it really be considered the 'work' of an artist?

The answer is yes, it can. Daydreaming has been shown by neuroscientists to be a special brain state that allows connections to be made between disparate thoughts and ideas, which can lead to great creativity. But artists didn't need neuroscientists to tell them that. Creative people are usually well aware that ideas flow most readily when they are relaxed and daydreaming. That's when ideas 'pop into our heads'. I call this 'mulling time'.

Mulling time is more than just daydreaming. Sometimes it is pure daydreaming, sometimes it is more directed thoughts. It is time when you sit and ponder over all the ideas you have had, the plans for your paintings, the artwork you have looked at, and the answers to the questions you are asking. It is a time for consideration and development of your ideas. It is a time to consider your approach to painting.

Consider mulling time to be part of the rhythm of painting. This is not a matter of composition where you are considering the rhythm of shapes and passages within the painting, but rather the rhythm of the execution of the painting. Do not put yourself under constant pressure to produce. The gaps, rests, times away from the work will be incredibly informative. It is more of matter of think—paint—think—paint. Do not be afraid to put your brushes down and walk away, maybe momentarily, maybe for weeks. The rests are important.

It can be difficult persuading others you are actually working when you are apparently just sitting on a bench in the sun staring at the garden. What you are actually doing is putting yourself in a position to allow constructive, creative thoughts to happen, allowing your mind the freedom to invent beautiful new images.

Chapter 3

The studio and equipment

Every artist needs a space where they can feel free to experiment and play. This is a space that gives you the peace to concentrate on the process of painting, without interruptions or interference. This is where you can be yourself, try things out, and allow yourself the luxury of having the freedom to fail, because no-one else needs to see it. The better you are able to organize such a space, the easier it will be for you to focus on the task in hand. It is about being comfortable and at ease, and ensuring the only challenges you face are the enjoyable challenges of creating a painting. Of course, the ideal space is a dedicated studio, but for many artists this is a luxury the size of their home will not allow. Sometimes the only suitable surface is the kitchen or dining room table, with plenty of other calls on its use. If you do not have an ideal space, do not let this impede your creativity, but set about finding solutions.

How much space do you need?

Firstly, give thought to the amount of space you will need. Watercolourists do not usually work on very large paintings, partly due to the nature of the medium and partly due to the size of papers available, so the space needed for the actual paintings you want to do might not be very large. A table or drawing board that can accommodate a stretched piece of paper up to A1 in size is usually more than adequate. You also need to allow space either side

In addition to artists' materials, a flower painter's studio includes a collection of vases and floristry equipment, such as secateurs, oasis and floristry wire.

My studio is a large shed, which gives me the feeling of being in touch with nature and the opportunity to move my workspace outside when the weather permits. An A0 drawing board and a side table provide ample space for my materials, reference materials and the painting.

of the painting for your paints and palettes, water jars, brushes, and kitchen roll. Remember to allow enough space to give yourself a good, clear view of your reference material. This might be a vase of flowers, your sketchbook, printed photographs, your tablet or computer, or even a reference book such as this one.

An important point, often overlooked in setting up a plan to paint, is room for yourself. As well as being comfortable and having everything accessible, you need room to move. It is important not to restrict yourself to tiny hand movements, when what you need to do to achieve the gestural marks you might wish to make is to swing your whole arm, or even throw something at the paper.

If you do not have a studio, and can only donate a small corner of your home to your art, it is important that you

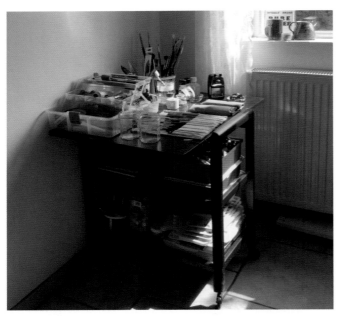

If a dedicated studio is not an option, be creative in setting up storage and a workstation at home. This trolley with an extendable table-top is both convenient and mobile.

Handiness

Having your materials handy is particularly significant for anyone who enjoys painting flowers. Flowers are at their best for such a short space of time that it is good to be able to capture them at just the right moment. Having your materials to hand means that even if you cannot create the whole painting just then, you can at least make some colour swatches, sketches, or spend a few minutes finding appropriate brush marks while you still have the subject in front of you. Information gathered from direct observation will be a useful addition to your references when you do get the chance to make the painting.

Just a few minutes painting can also be useful for practising techniques such as experimenting with a new brush, or playing with colour mixes. This might be a lost opportunity if you had to spend that time just getting your materials out. Rather than just placing all your art materials in a cupboard, try to find a method of storing them that means they are easily available to use such as a trolley, or an art organizer.

TIME

Finding time to paint can be difficult, even for a professional artist, because we all have so many other calls on our time. If time is short, invent ways to use it effectively. Try not to let yourself think 'I haven't time to paint today.' Instead, think creatively, and choose to paint something that can be achieved in the time available.

Keep it simple. Instead of a vase of flowers, maybe just paint one flower and one leaf … or just the flower. Decide at the outset that you will use the time for quick sketches, rather than a highly finished piece of artwork. You might decide to have some fun investigating new techniques.

Alternatively, if you already have a bigger project on the go, you could use the short spell of time choosing your palette, practising the brush strokes you think you might use, or investigating suitable textural marks. If you are already in the process of painting it, don't just carry on to see how far you can get as you will likely end up rushing and spoiling it. Instead, decide how much you feel you can achieve in the time you have available before you resume working on it; for example, you may focus on a petal, or add a unifying wash across a section of the image.

Setting achievable goals take the pressure out of the situation, leaving you feeling more relaxed to enjoy the time you have and, in all likelihood, feeling more successful too.

find an area where you can prop up the painting to view it from a distance. Concentrating intensely on a particular part of the painting can throw your perception out, so that that part seems dominant. Standing back will enforce at least a short visual break as you walk away; when you look back you see the progressing image in its entirety and the part you have been focussing on intently in the context of the whole, which can be invaluable. Aim to make this the distance at which you anticipate the finished painting being viewed at. A large painting needs more distance, whereas a tiny, detailed floral study that may be placed next to a desk or bedside table needs a much shorter distance.

What type of space do you need?

The type of space is important too. Delicate botanical studies are painted calmly and sedately, and in general do not cause much mess. However, a big energetic flower painting can involve dripping paint and fast movements which are inhibited if you have to make sure the curtains don't get splashed. If you feel you need a space where you can paint with abandon but do not have anywhere suitable you could set up near an external door, and go outside for the more animated sections. Or invest in decorator's plastic sheeting, and cover everything in the firing line. However you resolve this, do not inhibit yourself for the sake of carefully planning where you paint.

A problem with using family space to paint in is that you don't have a place where you can settle down without interruption, and paint unhindered by conversation that is irrelevant to what you are doing. People who do not paint do not understand your need to concentrate, so you need to find a way to let them know. When our children were young, my husband solved this with a stroke of ingenuity. He adopted a 'Painting Hat'. It was a sunhat, incongruous enough to be noticed, especially when worn inside in mid winter. When Daddy was wearing his Painting Hat, the children were trained to pretend that he was not there. (We tried to convince them he was invisible, but that was a step too far.) They knew that when Daddy was wearing the Painting Hat they were not allowed to talk to him, or use the table.

The Painting Hat. When worn, it is a clear indication to the rest of the family that you are gainfully employed in creative endeavours.

MATERIALS AND EQUIPMENT

Watercolour, a sensitive medium

Watercolour is a popular choice for painting flowers and plants, perhaps because the medium has inherent qualities in common with flowers. Both flowers and watercolour are light, delicate, translucent, sensitive, and almost ethereal in nature. Just as flowers can glow in the sun, watercolour paintings have a radiance that is unique to this medium. As a florist understands the delicacy of plants, so the flower painter must fully understand the sensitivity of watercolour.

Watercolour is an extremely sensitive medium. It is also very responsive. The way it behaves as you work with it is affected by the quality of the paints you are using, the type of paper you are painting on, the brushes you use, the water, the weather... All of which is to be celebrated, because this is what makes it so exciting and expressive.

'A bad workman blames his tools', and in such a sensitive medium it may be that the materials are the reason

Fourteen Minutes. Filling in a tiny slither of time, this quick sketch was made in just fourteen minutes of fun (using a hairdryer between layers of paint). Although not enough time to do anything too serious, it was still time well spent.

Watercolour is the ideal medium for capturing the radiance of the sun through translucent flowers.

One brush which had been dipped in purple paint was rinsed in a jar of water on the right. Look at the difference it made to the vibrancy and clarity of the stripe of yellow paint below that jar when compared to the stripe made using the crystal clear water.

you cannot achieve the effect you are looking for, if you have not chosen the right tools for the job. But it is a truism that a master craftsman would not think of working with tools of an inferior quality. The quality of watercolour materials is very important. Artists Quality materials are the result of years of experience and research, and in watercolour, the difference between the top of the range materials and the cheaper versions is very evident. Always buy the best watercolour materials you can afford. It is better to have fewer materials of a high quality than lots of poor quality. Even a small change can make a big difference to the way the watercolour behaves.

Clean water

It is simply not possible to paint a watercolour without it, yet water is the one 'material' in an artist's studio that is constantly overlooked. One of the most common complaints made by watercolourists is that their watercolours end up muddy. This may be due to overworking the painting, but it is far more likely to be down to the use of dirty water. While landscape painters working with an earthy palette may occasionally get away with it, artists who paint flowers never will. To capture the essence of fresh flowers, the paint needs to remain fresh and clean. The importance of clean water cannot be overstated.

For a bright, transparent, glowing painting, the water needs to be *absolutely clean*. Even the slightest amount of pigment in your water can affect the vibrancy of the paint you are applying. Use a minimum of two water jars,

one for rinsing your brush, the other for picking up clean water to paint with. Jam jars are a good size, and being glass means that you are able to keep an eye on how clean the water is. Larger water containers take a little longer to get dirty enough to muddy paint, but since very little pigment is needed to do this you gain very little from their greater capacity.

Watercolour paints
Colour

Anyone who loves flowers is likely to be enthusiastic about the colours. Florists, gardeners and artists all talk excitedly about the palette they use, whether they are referring to a bouquet, a border or a painting. For artists, the colours of flowers and plants are a, if not *the*, major source of inspiration. Colour excites, enthuses, invigorates and inspires. Colour is very emotive, and we are all susceptible to its influence. Understanding that colour does this is an important part of painting expressively, as changing the palette for a painting can seriously alter the moods it elicits in its viewers. Intense bright colours can be energizing, cool blues can be soothing; in a simple painting of flowers, colour can impart narrative. When I tutor, I talk about guidelines, not rules, because what suits one person may not work for another. My only *rule* applies to colour: only use colours you like.

This rule is based on many years of tutoring and my own experience as an artist. I have yet to witness someone liking a painting in colours they did not like. It follows that if you do not like the colour of the paint, do not use it. You wouldn't cook with ingredients you don't like, so why paint with colours you don't like?

There is a possibility that artists painting flowers will be more susceptible to using colours they dislike than people who paint other subjects. There are times when it might seem like you need a colour you find unpleasant to match the colour of the flower, especially if verisimilitude

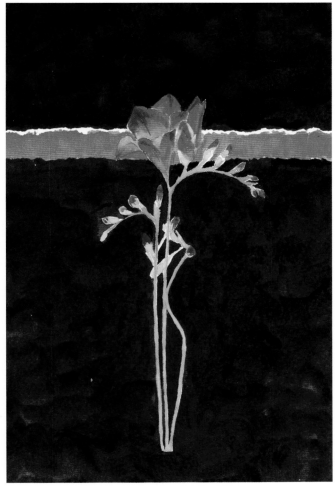

Flamboyant Freesias. The rich, vibrant colours used in this painting of freesias elicits a very different response to the delicate, pastel colours used in *Lilac Freesias* in Chapter 2.

It is commonplace for books such as this to list a basic palette for the reader to work with. This can be helpful for beginners, and you will find such a list in the Appendices, with the firm proviso that if you do not like any of them, make substitutions for colours you do like. The same applies to the demonstrations in this book; if you do not like the colours I have used, please make substitutions, or you will not like your version of the painting.

Whichever pigments you choose, it is important that you get to know them really well, their particular characteristics and how they mix with other colours. A few paints you know intimately will be more rewarding than a lot of colours you are unfamiliar with. A useful approach to getting to know the pigments you have is described in Chapter 4.

Portraying the colour of flowers accurately gives flower painters an excuse to buy lots of different paints, especially the primary colours, but most find that they have about twenty favourites from which they can mix almost everything they need. For each painting, a restricted palette of as few colours as possible, the per-painting palette, is selected from the 'studio palette' (all your paints).

Quality

Given the sensitivity of watercolour, it is important to buy the best quality paints you can. Artists Quality paints are noticeably superior to student quality paints. The quality of the pigments is better, the medium in which it is suspended is clearer and flows better, and the result is brighter, more vibrant colours. Student paints have more 'filler' in the suspension which means they are less transparent, are more difficult to mix and have a greater tendency to muddy. It is difficult to mix really rich darks with them. Artists Quality seem to be a lot more expensive, but this is offset by their higher strength, so you do not use as much.

The choice of tubes or pans

Many botanical artists, following the tradition of botanical illustrators, prefer to use pans. This is fine when you only paint small areas at a time, because you only need small quantities of paint at a time. It is also not a problem if you use glazing to build up depth of colour or tone, a technique commonly used by botanical artists and illustrators.

However, if you need a good puddle of paint to cover a larger area, it can be quite difficult to get enough paint to mix a rich tone, especially if you need a rich dark. It is unusual for a painter to build up depth of colour or tone

is important to you. Before committing to its use, check whether there is an alternative available that will do just as good a job. The difference might be subtle, but it can alter how you feel about the piece, which will come through in the finished work. Also consider why you are painting the flower if you do not like the colour – do you have a good reason?

Whether flower colours are bright and vivid, or soft, subtle pastels, they always have a luminosity; they radiate life. To capture this on paper, choose colours that do the same. Look for colours that have a brilliance and an intensity of hue. Transparent colours are excellent, as they allow light through, which then bounces back off the white paper so that they appear to glow. This immediately brings to mind sunlight though petals, the medium itself capturing the essence of the plant. The newer synthetic pigments are crisp and clear, and are a joy to use. Earth pigments are best avoided, as they often dry to a much flatter finish.

Tube and pan paints are of equal quality. The choice of which to use will depend on your preferred working methods.

over a large area using glazing techniques starting with a light tone; it is more effective to start with a mid tone, or simply go straight to a dark tone. It can be very difficult to mix puddles of mid and dark tones from pans; sometimes the pans require soaking with a few drops of water first, and the time it all takes can interrupt the flow of the painting. Also, colours can be difficult to identify when they are dry, and the labels are hidden under the pan.

Using tubes of paint solves these problems. Wet colour is more easily recognizable than dry colour, and the labels are easily viewed. Squeezed onto the palette, the paint is ready to use immediately. It is already at its darkest tone, just add water to make it lighter or flow more easily. Large quantities of paint can be mixed very quickly, which is important for big washes. It is easier to mix colours in the palette because you have plenty of paint to play with, and can see the range of hues developing in the mix from dark to light tones. Tubes are the better option for anyone who wants to paint loosely, because of the ease with which you can get a quantity of colour for splashing and flicking.

Papers for sketching

There is such an enormous range of sketch books on the market that it is difficult to know where to start. Think about the genre of flower painting that you like to do. If you like very precise work, you will need a sketchbook with very smooth paper in order to draw the fine details. If your nature is to make looser paintings, you might be happier with a surface with a slight tooth to it, which will give a bit more texture to your drawings.

Do not be afraid to feel the paper before you buy. Running your fingers across its surface will give you an indication of how it will work with pencils and other drawing media.

Consider also the size of the book. Sketchbooks are very personal, and trusting your instincts on size is a good idea. Buy one that *feels* a nice size to work with, because you need to be comfortable. If you struggle to make tiny sketches, do not buy one too small just because it fits in your pocket.

Papers for painting

Choosing paper

It really is quite amazing how the type of watercolour paper you use can affect your work. Watercolour papers have been very carefully designed for the purpose, each having its own peculiarities that responds differently to the brushes and paint. The type of painting you do will affect your choice of paper. The decision about which one to use should be made for each painting as part of the design process, choosing a paper that is suitable for your current project.

The best papers for you are not always the most expensive, they are the papers that give you the marks and textures you enjoy using to make a painting. You can only find this out by trial and error. When trying a new type of paper, always buy several sheets because a single sheet will be too precious and will prevent you experimenting freely. Practise mark-making on a few of them before attempting a painting. That way you will get to know how it behaves, and can make your own decision about whether you like it or not. Practise with the papers you are drawn to and learn how to exploit their characteristics.

Be prepared to pay for good quality paper. Cheap papers should be avoided as they are poorly designed, inconsistent and many are not actually fit for purpose. 'Practise papers' are a waste of time as the effects and colours you get will be different from the artists papers you will be painting on.

Surface texture

The attribute you are most likely to be aware of is surface texture. Papers come in three types of surface. Your choice should be based on your subject matter and the way in which you want to paint.

Hot pressed, HP, is very smooth with a delicate tooth, and therefore very good for fine, detailed work. Botanical illustrators and many botanical artists use HP paper because it suits fine, continuous lines, and smooth areas of paint. Flower painters working in other genres will find HP paper suitable for evoking calm, quiet moods.

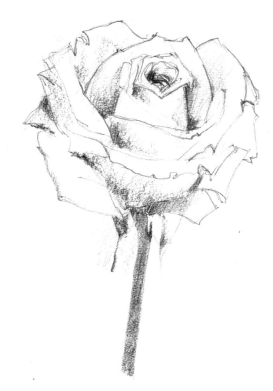

This rose was sketched on fairly rough sketching paper. The grainy surface gave a texture which seemed to spoil the essence of the texture of rose petals; the sketch remains unfinished.

This rose was sketched on a paper with a very slight texture, which seemed to impart a rose-like velvety-ness to the petals.

This single brush stroke crosses three paper surfaces, from left to right: Hot Pressed (HP), NOT and Rough. The effect of the different paper surfaces can be clearly seen. The very smooth texture achieved on the HP paper would not be achievable on the NOT or rough surfaces, while the broken texture achieved on the rough surface would not be possible on the HP paper. The NOT paper provides a middle ground, making it a suitable choice for a variety of styles.

Rough, as the word suggests, has a much more heavily textured surface. Paint can pool in the dips, or skim the surface of the bumps, producing lovely effects when using dry brush strokes or granulation. It is a good choice if you are planning rich textures and a sense of movement.

NOT paper (literally NOT hot pressed) has a textured surface between the two. It is a versatile surface because it is not too bumpy to incorporate some degree of detail, but rough enough to allow for making interesting textural marks.

There is no industry standard for what counts as HP, NOT or rough, the surfaces varying between the different manufacturers; it really is a matter of trial and error to see which suits you best.

Surface 'hardness'

All paper surfaces are delicate, so this loose description of the surface of watercolour paper refers to how much you can work on it before it starts to disintegrate. Some papers will take more brushwork, erasing, and scrubbing off of

A selection of 'white' watercolour papers. Notice the variation in colour, from white, through cream, to a grey tinge. Because watercolour paints are transparent, the colour of the paper will affect the colour of the finished painting.

paint then others. Masking fluid can be used with some papers, but not those with softer surfaces because it soaks into the paper and cannot be removed. Again, you should consider the techniques you are likely to use for a painting before choosing which paper to use for it.

Paper colours

The colour of the watercolour paper also varies. In spite of the fact that most of them are called 'white', most are a creamy colour. Watercolour is transparent, and the luminescence of the flowers is captured by allowing the white of the paper to shine through, so for paintings of flowers, the whiter the paper the better. Sometimes using a creamy paper can be an advantage, for example, if the flowers you are painting are cream themselves, the cream paper makes it easier to mix a good colour.

Weight of paper

Watercolour paper comes in a range of weights, for example, 300 g/m2 (140lbs/m2), 425 g/m2 (200 lbs/m2) and 640 g/m2 (300lbs/m2). The heavier the paper, the less likely it is to cockle when wet. Cockling happens during painting because the wet surface expands slightly, but the underside remains dry due to the sizing within the paper. As washes are applied, the two sides of the paper become different sizes, causing the paper to bend, or cockle. With hills and valleys in the sheet, it is very difficult to control

the paint. Water runs down the hills and takes the paint with it, where it settles in the valleys.

This watercolour challenge is an unnecessary one. There are two simple answers; buy heavy paper, or buy lighter paper and stretch it. There are two things to consider when making this decision.

The first is the way you apply the paint. If you usually work on small areas of a painting, and work wet-on-dry, or just lightly dampen the paper (damp washes), the paper is not likely to cockle, so light weight paper can be used successfully without stretching it. If, however, you apply wet washes, enjoy the flow of paint across the page and use wet-in-wet techniques; you will need to buy heavier paper, or stretch it. As a guide, a wet patch roughly the size of an apple will cause 300 g/m2 unstretched paper to cockle. The choice of paper does not really relate to the genre of flower painting you are doing, more to the way the paint is applied. Having said that, botanical artists, due to the way they work, are more likely to have success on unstretched paper than artists who prefer floral art or abstract florals.

The second consideration is budget. Watercolour paper becomes increasingly more expensive the heavier it gets. If a heavy weight paper (425 g/m2 and above) is going to stretch your budget to the point where you feel tense working on it, or do not want to experiment and practise on it, you are better off buying a lighter, cheaper paper and stretching it. That tension will show in your work, and may even cause you to spoil it. Buy heavier papers once your confidence has grown.

Gummed pads are seen by some as an alternative to stretching. They are not; the sides are stuck down, but the paper has not been wetted and stretched. The paper will still cockle if you apply a lot of water, making the paint difficult to control. If you work damp, it may dry flatter than a loose sheet would. They are not a very cost effective way of buying paper, as they can be expensive.

Gummed pads are useful for other reasons. They are easier to carry than stretched paper, and the pages cannot blow in the wind, which means they are a good choice for painting *en plein air*. They cockle less than loose paper, so they are good for watercolour sketches and information gathering. They are convenient to store, which is an advantage if space is an issue.

Suggested papers

I use a variety of papers when I paint, and I am always experimenting with new ones. My choice of paper for each painting depends on the subject matter and the techniques

I want to use. I tend to use 300 g/m2, which I always stretch for a painting, but I might work on it loose for mark-making experiments and colour swatches.

Fabriano Artistico HP 300 g/m2
This has a beautiful smooth surface to work on for fine detail. I use it for botanical studies, and images made with drawing media, where I want to control the texture of the pencil lines. It has a slightly creamy colour, although it is called white. I'm afraid I usually lose the four deckle edges because I stretch it.

Fabriano 5 300 g/m2
This is similar to Fabriano Artistico. I use it when I want a whiter paper.

Bockingford 300 g/m2 NOT
This is my default paper. I find it an excellent choice for experimenting, as it takes a lot of brush work and rubbing on the surface. It takes masking fluid well, which is important for many of the techniques I use regularly. The surface is bumpy enough for some interesting effects, but smooth enough for a reasonable degree of detail.

Brushes

By far the most important feature of a brush is what *you* can do with it!.

The only useful way to find brushes that suit you is to try them. Shapes, sizes and the quality of the fibers are all relevant, but until you have used them you will not know how useful they will be for you. An artist's choice of brush is *very* personal.

I have always experimented with brushes and always will. I have a fairly small collection of brushes that I always have with me. The collection developed over time, each one being selected because of what I found I could do with it. Together they give me a range of marks that satisfies me for most of what I do. Some people express surprise when they realize that not all my brushes are Kolinsky sable, but what I can use a brush for is more important that what it is made of.

In addition to these, I have a selection of other brushes I use sometimes, if the painting requires a mark that I will find easier with another brush. I know exactly what each of my brushes will do when I use it, whether it is from my day to day set, or from the shelf in my studio.

In Chapter 4, I have described how to make a Dictionary of Marks, which is a method of discovering

The contents of the brush roll I always have with me:
- Two flats (¾ inch and ⅝ inch)
- Three swordliners (large, medium and small)
- Two daggers
- Two sables, Da Vinci Series 35, sizes 4 and 2.
- An old brush that I use for mixing paint in my palette
- Toothbrush
- Mapping pen
- Colour shaper
- Also shown here are Da Vinci Series 10, sizes 4, 2 and 1.

which marks you can make with each brush, and which then acts as a reference source until the time when you are so familiar with your brushes that you know which one to use, and confident that you can make the mark you are looking for. Some brush shapes you could try are round, flat (also called one stroke), rigger, mop, fan, filbert, and of course the sword liners and daggers.

Filaments

Sable brushes are considered to be better than synthetic bushes; they have a lovely 'spring', popping back into shape as they are lifted off the paper, which means you are able to make consistent marks. This makes them an excellent choice for anything requiring precise detail. They hold a decent amount of paint for their size, enabling a longer flow of paint, which in turn enables fluent movements with your hand. All of the brushes I use under size 5 are sable.

Having said that, sable brushes are expensive. For smaller sizes this is not really an issue, as they do not cost too much and, if well cared for, last a long time. However, larger sizes can be incredibly expensive. If the benefits of sable are not essential to your methods of painting, you may prefer to choose a cheaper alternative such as synthetic/sable mix, or synthetic brush from a good manufacture such as Pro Arte or Rosemary's Brushes.

How to stretch watercolour paper

You will need

- Watercolour paper
- A board to stretch it on
- Boards can be made from exterior grade ply. Approximately 45cm × 60cm is a good size for half sheets of paper.
- Gum strip
- Bowl of water
- Kitchen roll

Step 1: Calculate the size of paper surface you want to work on, and add 2.5cm all around to allow for the width of the gum strip.

Step 2: Cut four lengths of gum strip, long enough to allow for an overlap at the corners.

Step 3: Lay your equipment out as shown, as once the paper is wet, speed is of the essence.

Step 4: Thoroughly wet the paper on both sides. This can be done by running it under a tap, or immersing it in a bath of water. Be careful not to touch the surface you intend to paint on as the surface is delicate when wet, and finger marks may show up later.

Step 5: Lay the paper flat on the board. Working one strip at a time, dampen (not wet) the gum strip with the wet kitchen roll, taking care not to wash off all the glue. Starting with the long edges first, stick it down, half on the paper and half on the board.

Step 6: Very gently mop any page puddles of water up with kitchen roll. Too much pressure will leave an imprint of the kitchen roll pattern on the surface of the watercolour paper, which will show in the painting. Leave FLAT to dry. Do not panic as cockles appear. They will flatten again as the paper dries.

Step 7: Drying times vary according to the weather. It might be a few hours on a hot day, or overnight in damp weather. Do not be tempted to hurry it up using heat, as the upper surface will dry before the lower one, causing tears. The paper will flatten again as it dries. Once the paper is dry it is ready to work on.

An incredibly useful brush that can produce a wonderful range of useful marks is a cheap toothbrush. They can be used for applying paint, water and masking fluid. Cheap toothbrushes have evenly sized bristles, all of the same material, and cost next to nothing. More expensive toothbrushes, better for their intended purpose, are not so good for painting with.

Caring for your brushes

Watercolour brushes are cleaned by rinsing them thoroughly in clean water, throughout the painting process and when you finish using them.

Do not leave them standing in water, as they will bend, and they are very difficult to reshape. They will also bend if left pressing against something when they are wet, for example, the side of a bag. Use a brush roll or carrying case to transport them, making sure that the filaments do not bend as you close it.

In the studio, do not leave wet brushes tip upwards. The water will fall into the ferrule, and may cause rust, or decay the wooden handle, causing the ferrule to wobble. Instead, place clean wet brushes on a piece of kitchen roll to dry, preferably with the tip at a slight downward angle.

Dry watercolour brushes can be stored, tips up, in the studio in a pot or in a brush holder.

USEFUL STUDIO EQUIPMENT

The equipment available to artists is vast. Remember that taking an experimental approach means that it is always worth trying something new; new colours and new brushes are extremely tempting for a creative artist. Remember that it is how you use the materials that matters, and time spent investigating each new paint or tool independently of using it in a painting will be time well spent. Take time to play! Reject materials you are not comfortable using, or do not like, even if they are popular with other artists.

Here is a list of materials and equipment that are very useful for flower painters; use it as a starting point for your own investigations into building your own set of equipment.

Cameras, tablets and computers
Digital tools and equipment are as much a part of an artist's studio as more traditional materials and tools. Learning to use them in ways that will enhance your progress as an artist is discussed in Chapter 4.

The large flat wells in this plastic palette are ideal for the method of mixing paint demonstrated in this book. Lightly scratch the surface with a kitchen scourer, so that the paint will remain spread out and the colours visible.

Palettes
Palettes with large flat wells are best for the method of mixing paint demonstrated in this book. Most palettes with large, flat mixing wells are made of plastic. To avoid the paint receding into mercurial blobs of homogenous mixes, I scratch the bottom of the palette lightly with a kitchen scourer. The paint will then spread out nicely. It is possible to pull the paint around in the well to see exactly which colour I am picking up. I very rarely mix deep wells of homogenous colour, but these larger wells have the capacity if needed.

The small wells around the edge of my palette are used for masking fluid, granulation medium and so on. I prefer to use paint when it is freshly squeezed from the tube, which is better for mixing creamy darks. Squeezed into the small wells, it will dry and harden, and behave as a pan paint, so my preference is not to use them this way.

Palette tip

Do not rush to clean your palette at the end of a painting session. Being watercolour, the paint can be left to dry and re-wetted when you continue working. If the painting is finished, use the leftover paint to practise mark-making, or getting to know a new brush.

Kitchen roll
Kitchen roll is an essential piece of studio equipment. Its most important use is to ensure the correct degree of wetness of the brush by lightly touching the brush onto the kitchen roll to remove excess water (or paint). This sounds like a skill that takes time to learn, but it is actually one that is picked up very easily.

It can also be used to lift wet paint off the surface to make interesting textures.

Masking fluid

Masking fluid is amazingly useful for preserving white paper, or the first layer of paint. Sadly it often gets a bad press, but when time and trouble have been taken in getting to understand how to use it properly, it is one of the most useful accessories a watercolour painter could have. Take on board the following guidelines for using it and you will find it an invaluable addition to your studio.

1. Masking fluid cannot be rushed. At every stage take your time.
2. Masking fluid dries quickly. To avoid it setting in the bottle, open the bottle, decant into a suitable receptacle like a saucer, replace the bottle cap before using the masking fluid.
3. When applying the masking fluid, imagine you are applying paint, and make your marks just as carefully.
4. Always apply to completely dry paper. If working on stretched paper, ensure it is completely dry before applying the masking fluid.
5. Allow it to dry completely before painting over it. If only the surface of a blob of masking fluid has dried you may knock it off, and the wet fluid from inside the blob will ruin your brush.
6. After painting, always wait for the paper to be completely dry before removing masking fluid.
7. Masking fluid is not compatible with all papers due to the way the paper surface is finished (for instance, the coating. This is not about the surface texture.). If in doubt, do a test before using it. If masking fluid is integral to your design, you may choose to use a different paper.
8. Remove by lightly rubbing your fingers across the masked area. Some people prefer to use an eraser, but using your fingers means you can feel if it starts to pull the paper. You can then change direction, or even carefully snip off the fluid that has already been separated from the paper.
9. Don't believe anyone who says masking fluid is safe to use with your good brushes. It is not. Always use a rubber tipped colour shaper, a ruling pen, or an old brush you have specified for the purpose.

Ruling pen

Also known as a making pen, or a lining pen, this is an adjustable dip pen. Using the screw on the side, the width of the line can be altered. It can be used for drawing fine lines in paint. It is extremely useful for applying fine lines

with masking fluid; cleaning it is easy as dried masking fluid simply peels off.

Colour shapers

Colour shapers have a brush shaped handle with a rubber tip. The tips come in different shapes; the chisel shape is particularly useful. They are very useful for applying masking fluid, when they can be used to spread an area of masking fluid with a good degree of accuracy. With practice they can be used for applying fine lines of masking fluid.

Embossing/burnishing tools

These have rounded metal ends, available in a variety of sizes. They can be used for indenting the paper; paint will flow into the dent, and dry as a hard line, which can be useful for fine detail. When working with graphite pencils, the embossing tool can be used to reserve fine white lines, by indenting the paper and skimming the pencil across the surface; alternatively, they can be used to create and burnish an area of graphite.

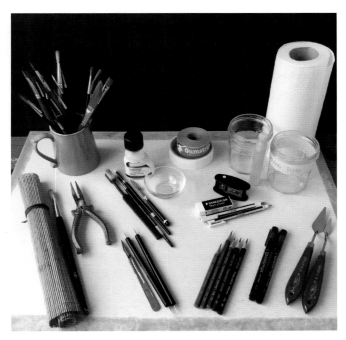

This photograph shows the most basic piece of studio equipment without which I would be truly lost. This small selection is used during the creation of almost every painting. My vast array of additional studio equipment is used far less frequently, but is nonetheless important when it is needed.

Embossing tools are also useful when tracing; instead of using a pencil or pen to transfer the image, use an embossing tool lightly to preserve the tracing for further use.

Scalpel

A scalpel (or craft knife) can be used to cut paper much more accurately and finely than a pair of scissors.

Scalpels are also excellent at scraping wet paint, producing beautiful textural marks, but take care not to damage the paper surface. Alternatively, deliberately scratching into the paper surface at the end of the painting can reveal some crisp whites.

Scissors

An invaluable piece of studio equipment. A pair with long blades are useful for cutting paper to size, a pair with a pointed end are useful for accurately cutting shapes.

Pencil sharpeners

It is surprising how the design of a pencil sharpener can affect the marks that can be made when drawing. Look for sharpeners that give a long point, so that the side of the pencil tip can be used more effectively in creating interesting textures.

Also consider a winding sharpener, or even an electric one. When drawing over a long period, they can save a great deal of time, and reduce stress on your hands.

Spray bottles/spritzers

Used either before or after applying paint, these can help produce some beautiful textural marks.

They are also useful for occasionally spraying the paint in your palette to keep it moist without affecting the tone too much; the small amount of water added does not significantly alter the consistency of the paint.

Syringe

Used for transferring water to the palette quickly when making up a large quantity of paint, or squirting a puddle of paint at the paper.

Watercolour media

There is a good selection of watercolour media available. Granulation medium increases the granulating effects of some paints, gum arabic slows down the flow of paint, iridescent medium adds a little sparkle to the paint. Available from good suppliers, they are worth experimenting with.

Paper doilies

Paper doilies make an excellent mask for creating lace-like effects, and are available from any good kitchen store. They can be very useful for floral still lives, which include curtains or table cloths.

Always be on the lookout for fabrics and papers which would make good masking tools; actual lace, or builders scrim also work well.

Miscellanea

Collect anything that you think might make an interesting mark or texture, such as feathers, brush protectors, string and so on.

Florist's equipment

A non-flower painter's studio would be complete without a selection of florist's tools. A selection of florist's wire, floral foam blocks, florist's tapes, a sharp knife and of course a good pair of sharp secateurs are very useful. Flower painters often find themselves collecting vases and pots, not simply as props for the flowers, but because they make good subject matter in their own right.

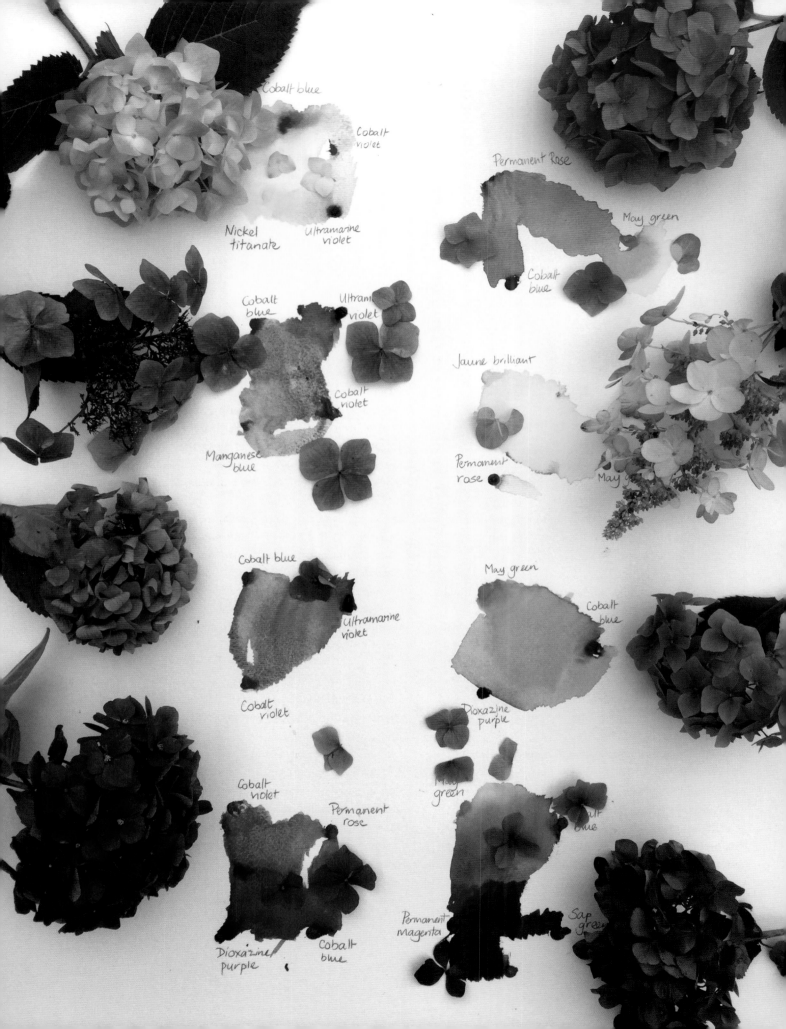

Cobalt blue

Cobalt violet

Nickel titanate

Ultramarine violet

Permanent Rose

May green

Cobalt blue

Cobalt blue

Ultramarine violet

Jaune brilliant

Cobalt violet

Manganese blue

Permanent rose

May g

Cobalt blue

May green

Cobalt blue

Ultramarine violet

Cobalt violet

Dioxazine purple

Cobalt violet

Permanent rose

May green

alt blue

Dioxazine purple

Cobalt blue

Permanent magenta

Sap green

Positive steps towards artistic freedom

Successful paintings radiate a clarity and confidence that give the impression they were painted with ease. How does one emulate artists capable of displaying their creativity in this seemingly effortless way?

The secret is a simple one, and lies not in the particular materials used, nor in the special qualities of each material and how it behaves. The secret does not lie in buying the latest paint colour, a new paper, or a new brush. It does not lie in copying a successful painting, even though much can be learned from doing so.

The secret lies in discovering what you can do with your materials

Take note that the secret does *not* lie in discovering what *can* be done with them, but in *what you can do with them*. It is very sad that this vital piece of information is overlooked by so many fledgling artists. It is hard to watch enthusiasm quashed because, eager to start painting, they will launch straight into painting with very little idea of *how* they are going to achieve it.

What follows is an approach to exploring art materials that is fun and informative. A properly creative approach involves experimenting, practising and acquiring skills with materials before attempting to use them in a painting. It means internalizing them, so that their use becomes intuitive, natural and easy. It enables a design approach that allows for the deliberate choice of particular

Colour matching hydrangea flowers. Note too the reflected colour from the flowers on the page.

techniques and materials as elements of your painting. It means that you can concentrate on why you are painting, or what you want the painting to convey to your viewer, confident in the knowledge that you can achieve it. Your chances of success improve dramatically.

There is research that indicates that an active learning experience (doing a task), is much more effective than a passive learning experience (such as reading about a task). Not only does the person learn more about the task in hand, but it is much more likely that they will remember what they have learned. For example, it is simply not possible to tell you exactly how wet your brush needs to be, nor exactly how much more of the second pigment you need to add to a mix. This type of knowledge only comes through experience, and the only way to gain that experience is by trying things for yourself.

Using the same brush as an artist you admire will not mean that you are able to make similar marks. Knowing which brushes they use simply tells you a particular range of marks is possible with that particular brush, and gives you an example of one person who can make them. But whether you are able to achieve this yourself is not a given; you may find you can make a totally different set of equally useful marks from the same brush as your favourite artist, yet never achieve marks similar to those that inspired you to buy it.

The truth is, the deeper and more thorough your understanding of your materials, the greater your freedom to respond to an inspiring subject. While much can be learned by research, including reading books like this one and taking the advice of other more experienced painters, there is absolutely no substitute for trying things out for

yourself. It is only through practice that you will really understand how your materials work, individually and in combination with one another. The aim is to be so in tune with the medium that you are conscious of it, but not struggling with it. Familiarizing yourself with your equipment to the point where it becomes an extension of yourself will free you up enormously, allowing your creativity to flow.

At first you think it's a bit of a novelty, it took me a while to realize it's quite a serious tool you can use. And it took me a while to get skilful on it. **Skill is practice.** *It's not just a novelty. I realized this is a clever tool you can use.*

DAVID HOCKNEY,
THE HAND, THE EYE AND THE HEART

PLAY TIME

Strangely enough, time for 'playing' is something that many adults struggle with, so it is fair to say that this element of a creative approach requires a challenging degree of discipline. With adulthood comes a sense of responsibility, and a feeling that time is precious and not to be wasted. I am unable to disagree with that. However, when it comes to painting expressively and creatively, it seems I have a different viewpoint on what constitutes good use of my time than many of the people I have taught. You need time to familiarize yourself with your materials, but this should not be laborious or a chore. You *need* time to *play*. It is an important part of learning, not a sporadic treat.

As children, we learn through play. There is an enjoyment in it, and a lack of embarrassment at failure. It is almost pure experimentation, undertaken for the sake of it as we discover the world in which we live. If you watch a very young child you can almost see them thinking, Shall I, do l want to, what will happen? Pablo Picasso commented that as children we are all artists, suggesting that the problem is not how to become an artist, but how to remain one.

Do not underestimate the value of play, or see it as being childish. It can be relaxing, since there is no pressure to produce a beautiful work of art to impress other people. However, to 'play' effectively, to learn from playing how your materials work, takes observation and concentration. Relax when you are messing around, just to see what happens, but then concentrate when you try to work out exactly what did happen, and try to work out how you might reproduce the effect. As you work through the exercises and projects suggested below, take care to note how you *feel* about what you are doing. It is important to recognize which techniques and marks you enjoy making, and which you enjoy looking at, because this will inform you about the type of flower painting that suits you best. The method of familiarizing yourself with your materials described in this chapter is best approached as play; make it fun, enjoy it.

INVESTIGATING PAINTS

Pigments

The only truly effective way to learn about watercolour paints is by experimentation. The theory behind why they behave the way they do is an extremely useful guide, and understanding it will inform your choice of pigment while painting and when buying new colours. However, theory and practice are often at variance, and decisions based on theory alone can be very disappointing. When you are painting, you need to know how they will behave in practice. It is important to know these characteristics for each one of your paints, as they affect how the paint behaves, and consequently how you can use it. When deciding on your restricted palette for a painting, a colour might be included or rejected on the grounds of these characteristics.

Characteristics of pigments

There are four characteristics of watercolour that you need to be aware of, all due to the pigments, which are staining, granulation, opacity and light fastness. The manufacturers of Artists Quality paint will either put this information on the tube, or provide it elsewhere, for instance, in a chart. What the charts cannot tell you is the degree to which a characteristic affects the way you use the paint; this is best discovered through using them.

Some pigments stain the paper, some do not. If a pigment stains the paper the paint can still be lifted, and the

An example of a non-staining pigment (Ultramarine). It is possible to lift the dry pigment with a damp brush to return to clean paper.

An example of a staining pigment (Quinacridone red). When a damp brush is used to attempt to lift the pigment, a stain is left on the paper.

colour greatly reduced, but the paper will not return to its original colour. A non-staining pigment can be removed completely. The degree of staining is partly dependent on the paper being used. Staining can be an advantage in glazing techniques, but a disadvantage if you want to remove an error.

Some pigments granulate, others do not. Granulation occurs when particles of pigment separate out from the water and settle on the paper in tiny clumps, and is more obvious on NOT or rough paper. Granulation can give some amazing textures, for example, it can be used to 'paint' the leaves on a bush in a garden scene. It can be a disadvantage if you want a smooth surface, for example, a shiny holly leaf.

Tip: to encourage granulation, use plenty of water, and allow to dry naturally (do not use a hairdryer).

There is a spectrum of 'opacity'; some are completely transparent, some translucent, some opaque. When painting flowers, look for vibrant transparent paints that allow the white of the paper to shine through. I try to avoid opaque paints as I find they tend to muddy quickly and dry flat and dull, so I own very few. Opaque paints are very difficult to use in glazing techniques because the pigment lifts very easily, mixing with the layer being applied on top. Glazing techniques are used a lot in flower painting, especially towards the botanical illustration

Cobalt blue and Cobalt violet both granulate; Dioxazine purple and Viridian do not.

To test for opacity, rinse a blushful of pigment in clean water. An opaque pigment will quickly make clear water cloudy; a transparent pigment will not.

Mixing colour

Mixing colour is not a means to an end, it is an experience in its own right, and one of the most enjoyable parts of the whole process of painting. Whether it takes place on the palette, or wet-in-wet on the paper, watching colours blend is one of the most beautiful and rewarding experiences watercolour has to offer.

Set aside time to play. Choosing to find colour combinations through play and experimentation is much more productive than looking at colour charts for formulaic combinations, and a lot more fun. Through active observation, you will learn to see the colours through the eyes of an artist, watching and learning about the colours you are playing with.

To get the most out of the exercise, 'The method of mixing', mix colours out of context of a painting; this way you will concentrate on what is happening as you mix, and you won't be distracted from the task in hand by trying to find a particular colour. This method has the advantage of showing you all the colours that can be mixed from a particular combination of paints (rather than just a selection as in conventional colour charts) and in doing it, you will also learn how to add the right amount of each colour to get the mix you are after.

Do not allow colour theory to influence your observations; colour theory is useful, but is often at variance with actual practice. (In theory, yellow and purple should make grey. In practice they make brown, due to impurities in the pigments and medium.) Try the exercise in a palette, and also on the watercolour papers you use, as this will show you how the pigments are affected by the colour of the paper.

If you are amongst the many painters who are unable to resist buying new colours, you may already have a huge number of colours in your studio. As delicious as they are, they are of little use to you if you do not know how each of them behaves. You do need to get to know them intimately, but do not be daunted. Just start with one or two of your favourites; when you are confident you know exactly what to expect from them, you can introduce new ones. Build up your knowledge over a period of time, you will remember more.

end of the spectrum, for building up from within the flowers. Sometimes many layers are necessary, so knowing which paints to avoid can be as important as knowing which to use.

Since all watercolours are transparent when diluted, it is sometimes difficult to tell if a paint is opaque or not. Opaque paints have a slightly dull, chalky appearance. The easiest way to tell is to pick up a good brushful of paint and rinse it in a glass jar of clean water. If the paint is opaque, the water will turn cloudy. Opaque paints can be an advantage if you want a softness that cannot be achieved with crisp, clear transparent paints, for example, the whitish bloom on grapes.

The fourth characteristic you need to consider is light fastness, or permanence. Check the manufacturer's specifications. Do not paint with fugitive colours, which will fade quickly. Synthetic pigments have a very good light fastness rating.

EXERCISE
Investigating pigments

It is useful to make a habit of using an informative method to discover what each of your paints does. To get started take just six paints, two of each primary, chosen from amongst your favourite colours. After that, fill odd moments, such as when you are waiting for a wash to dry, by continuing with other colours.

It is better to build up your own colour charts slowly than to test all the paints in your studio at once. You will be more likely to remember information about the paint, rather than having to refer to the chart each time you paint. While useful initially, colour charts should quickly become unnecessary for your favourite paints, although they are likely to remain useful for those you do not use very often.

Step 1: Squeeze a small blob of colour onto watercolour paper.

Step 2: Using a *wet* brush, pull the paint out into a gradated strip. The aim is for the paint to flow rather than to acquire a perfect gradation.

Does the colour appear to change between the darkest tone and the palest tone?

Step 3: Watch it dry!

Does the strip appear chalky and opaque, or transparent?

Does this change between the darkest tones and the lightest tones?

Does the colour dull as it dries, or remain brilliant?

Does granulation occur as it dries?

Step 4: When the paint is completely dry, use a stiff brush to try to remove some of the paint.

Are you able to return the paper to white, or is there a hint of colour left?

Check your findings against the manufacturer's chart.

A selection of primary colours: Ultramarine, Cobalt blue, Lemon yellow, New gamboge (hue), Permanent rose, Alizarin crimson, Quinacridone red, tested for characteristics of staining, granulation and opacity.

May green (Schmincke: 524) changes colour a lot as it is diluted. A vivid, vibrant green as it comes out of the tube, it dilutes to a soft spring yellow-green, the exact hue of light through freshly opened beech leaves in May.

The method of mixing

This method of mixing colour requires white palettes with large, flat wells. When first discovering paint combinations, it is a good idea to squeeze the paint directly onto paper, which you can then keep for reference. (If using pans, make sure you are starting with a large enough patch of creamy paint to allow for successful mixing of the darker tones.)

Step 1: Squeeze out a pea-sized amount of each colour in the corners of each well.

Step 2: Using a clean, wet brush, drag one colour towards the centre.

Step 3: Rinse the brush, then repeat for the second colour.

Step 4: As the two meet, mix the colours together to make a gradated strip of colour that gradually blends from one to the other, showing the full range of colours that can be made from the two starting colours.

Step 5: Taking a damp brush, pull out a selection of the colours to create paler tones.

You can then choose the appropriate colour for your painting. Unless you need a large quantity, work from the gradated colour strip, constantly mixing the colour as you paint. Because of the way it is laid out in the palette, you can see exactly what is happening, so re-mixing a colour is easy.

Practising the mixing technique on paper will give you an indication of how the paper affects the colours, and a swatch to keep for future reference.

When painting, use a palette with large flat wells that allows you to pull the paints across to view the full range of the mix; you can then see the exact colour you need.

This method of mixing can be used for several different pigments at a time. It is a very useful technique for colour matching specimens. The colours of this hydrangea floret can be seen in the four way mix of Alizarin crimson, Sap green, May green, and a tiny touch of Cobalt blue.

EXERCISE
Re-mixing a colour

Step 1: Working on paper, repeat steps 1 to 4 of 'The method of mixing'. When dry, choose a patch of colour and circle it with a pencil.

Step 2: Starting with fresh blobs of paint, repeat steps 1 to 4 with the aim of matching the circled colour exactly.

Step 3: Repeat step 2. It is likely that this time you will remix the colour very quickly.

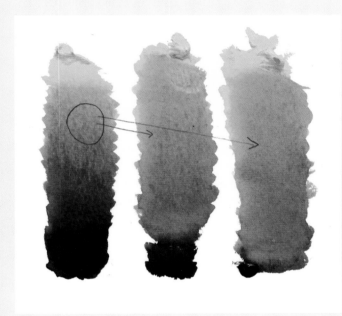

This method of mixing paint can be used to re-mix colours exactly.

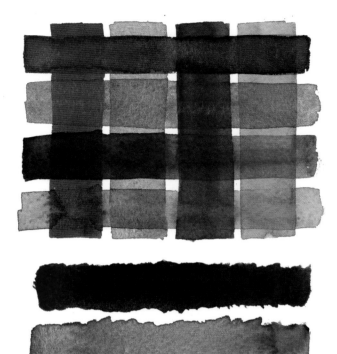

In the grid, Cobalt blue and Sap green are mixed by glazing; it is not difficult to see which colour was laid down first. The resultant mixes are more varied than the two strips of homogenous mixes of the same pigments.

Glazing colour
Glazing is a version of optical mixing. When a layer of colour is dry, another layer is washed over the top. This can be repeated with subsequent layers to build up colour. The perceived colour is a mix of the colours used. Because the human eye is capable of perceiving the separate layers, the result is richer and more varied than an homogenous mix of pigment laid down in one layer. It is a more difficult technique to master if the painting requires an exact match to the colour of a flower, but can also give a livelier feel to an image.

Colour and context, or optical mixing
As well as colours being mixed on the palette or on the paper, colour can also be mixed optically. This method of mixing was used by the Impressionists. Monet was particularly interested in this method of using colour. Many small broken areas of colour laid next to each other in the painting are perceived by the viewer as a single colour. Experiment yourself by painting lots of tiny yellow and blue dots in a small square. When viewed from a distance,

it will appear to be green; too small to be seen individually, the colour is mixed in the eye and brain, and is perceived as a blended colour.

To see how colour is affected by its context, try painting three squares of a single colour, then around each add a border (touching the central colour), one in yellow, one red, one blue. Note how the central colour appears to change.

This phenomenon is worth keeping in mind when choosing a restricted palette for a painting, and checking how the colours interact with each other when laid next to each other. When this information is used alongside the principles of the colour wheel (considering harmonizing and complementary colours), it is possible to manipulate how a colour is perceived by the viewer.

MARK-MAKING PRINCIPLES

When we learn to write, we begin by learning to form letters; letters join to form words, words to form sentences and finally the sentences become a story. We wouldn't expect a novice to begin writing by compiling a novel. Yet when we learn to paint, the preliminary steps are often missed, and the fledgling artist immediately attempts to paint an image.

In Chapter 2, I recommended 'starting at the end' by imagining the finished painting, to gain an understanding of a painting being a thing in its own right, a new object that the artist has created. This is what a viewer will respond to, the image in its entirety, just as a reader responds to the novel rather than individual words or sentences.

To evoke emotion and mood in a painting, we also need to recognize that, as humans, we are capable of reading very subtle nuances in the painting, which are there because of the way the marks were laid down. Just as individual phrases can be arresting in a book, individual marks within a painting can add excitement and interest.

To achieve all of this, the artist needs to learn how to lay down the paint. To achieve a coherent image, there has to be an understanding of the painterly equivalent of letters, words and sentences. That is what is meant by mark-making: learning to control washes, brushstrokes

and so on. In fact, in discovering the myriad ways of applying the paint to the paper, the artist develops their own vocabulary of marks, which they are able to combine and layer together to tell the entire story in the finished painting.

To start by attempting to paint an image without first learning to make marks is to miss out on the opportunity for the medium itself to be exploited. Learning to make marks and build them into an image is something that can be learned. Natural talent helps, but anyone with good observational skills, and an eye for shape and colour can develop their own Dictionary of Marks to use in their painting.

Just as handwriting is unique to an individual, so is the mark-making each artist is able to make. It is at the basis of developing an artist's individual and recognizable style. The marks you are able to make, and those you choose to use, identify your unique creativity.

With experience of mark-making, you will be able to incorporate this into the design of your painting. You will no longer ask questions like 'Which brush do I need?' or 'How do I achieve the texture of that seed head?'. You will not only know, you will have a choice, and can make a considered decision based on the style and mood of the painting. Painting will be easier and more intuitive, allowing you to concentrate on *why* you are painting what you are painting.

CREATIVITY IS NOT ABOUT NOVELTY

This book is not about finding new media, gimmicks and trendy ways of applying paint. The examples and demonstrations found here are a response to the world around me, things I have seen or experienced. The techniques described in this book are the ones that I have found useful, or have decided are appropriate for the subject of the painting and the way in which I wanted to paint it.

As you experiment with mark-making, constantly ask how useful each new mark will be. Practise and develop techniques that are most suited to your style of painting.

Building Dictionaries of Marks

Rather than build one large unwieldy dictionary of marks, it is a better idea to build separate dictionaries for different media and tools. There are a few simple guidelines which will help you to develop strong, useful dictionaries over a period of time.

1. Think of this as play!

2. The focus is on the materials you are using, not on finding marks for an image you are working on (that comes later).

3. Work on clean pieces of paper of the same type as you will be using for an image. For watercolour paint, use watercolour paper; for pencil, use drawing paper. Using a different paper will give you different results. Keep the pieces together in a folio for reference.

4. Use your time wisely. Mark-making can be done while waiting for a wash to dry.

5. Closely observe details of how the mark was made. Make written notes next to the mark to aide your memory later.

6. Make the same mark repeatedly. Practice makes perfect!

7. Always ask 'What could this mark be used for in a painting?' What might it represent? How might it be read in the context of a painting?

'A picture paints a thousand words...' and there are probably at least that many ways to make a mark on paper. Take the sample Dictionaries in this chapter as starting points. As this is a book on flower painting, I have included marks that will be useful for flower painters, but there are many more. Be inventive and resourceful. Remember that reading about them in this book is no substitute for making your own Dictionaries of Marks.

Dictionary of Brush Marks

Every brush makes a different mark, so it is worth practising mark-making with each of your brushes. The different marks that can be made with each shape of brush is well worth exploring. The size of the brush is relevant too; brushes of the shape will make similar marks, but you need to know exactly what size those marks are, and how much water and paint is held in the reservoir of the different sizes. This you will only learn by experience.

Holding the brush like a pen, near the ferrule, and resting your hand on the paper, will give you good control when small, precise marks are required.

Try lifting your hand from the surface of the paper, it will help you to make slightly freer marks. These marks can be longer, faster and more expressive, while retaining a good degree of precision. Try altering the angle of the brush too, to increase the range of marks possible.

Hold the brush at an acute angle, so that the side of the filaments are in contact with the paper. You will need to move your hand further up the brush handle to achieve this. Vary the angle to discover the range of marks you are able to make with each brush.

Try holding the brush loosely at the end. This allows for some rapid brush movements, and lovely, loose flick marks. Try holding the brush vertically, as shown here, or at different angles.

EXPLODING A MYTH

The size of brush you choose will depend on the type of painting you want to do. Botanical artists tend to use small brushes, down to tiny 00000, but if you prefer to paint large, loose paintings, you will need much bigger brushes.

There is a myth about brush size that is particularly pertinent to anyone who paints flowers. It is simply not true that 'It doesn't matter how big your brush is as long as it has a good point'. It does, as any botanical artist will tell you. When you are doing very precise work, with tiny details, you need to use a brush confidently. You need to know just how much paint is going to arrive on the paper when you apply the brush. A large brush has a large reservoir, and holds a lot of paint. Should you accidentally press fractionally too hard, you could easily flood the area with a puddle of paint, when all you wanted was a tiny dot. It is far better to use a brush that only delivers a tiny dot in the first place. Even large splashy paintings of flowers may need some finishing touches with a small brush; well-placed anthers and filaments can bring a painting together.

Changing your hand position as you move through the brushstroke can produce an even greater range of marks. Note that as the angle of the brush changes, so does the angle of my hand.

As you play, try holding the brush at different angles, and at different points along the handle. Some very exciting mark-making can be made holding it at the end of the handle where you have least control. Work on dry paper, and then repeat the same hand movement on damp paper. Try working sitting down, using wrist and lower arms movements, then stand, and move your hand and whole arm to make larger, sweeping strokes not possible in a sitting position.

Change the speed at which you work; some marks can only be made slowly and carefully, others need speedy, bold movements. Try changing hands, or flicking. Vary the pressure of the brush on the paper; gentle pressure to use the tip of

the brush, greater pressure to cause the filaments to spread out to produce wider marks. Do this in separate brush strokes, or as you move through a single brush stroke. Try rolling the brush across the paper, or a pushing action instead of pulling it along. Don't forget to make use of the water and the paper surface.

Overlay marks as you work, maybe changing brushes, perhaps using a different colour. Many useful combinations of marks are discovered this way. As you make each mark, try to envisage how you might use it in a painting, but be very wary of being drawn into painting a subject; just make marks at this stage.

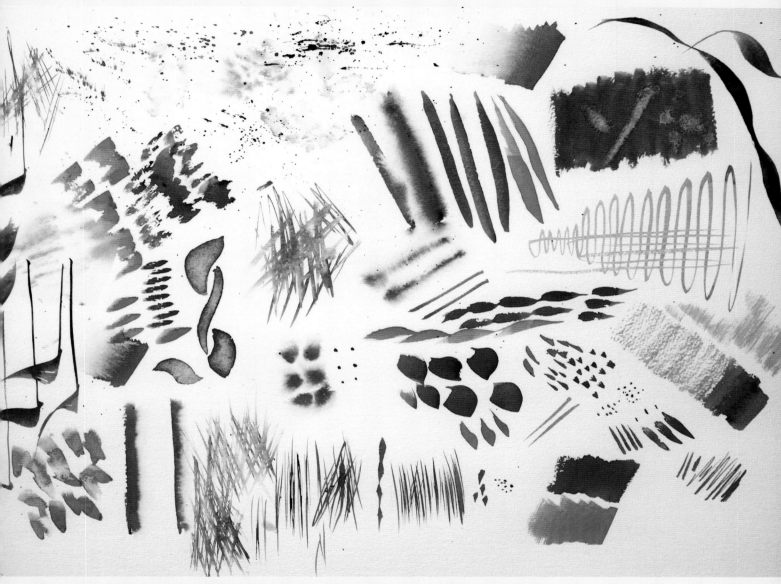

A Dictionary of Marks. Taking time to experiment to discover the range of marks you are capable of making with your brushes is vitally important.

These marks were made on a half sheet of paper (15 × 22 inches). A different colour was used for each of three different brushes. Can you identify which brushes were used by looking at the marks? Can you identify how they were each made, how the brush was held and the type of hand movement?

Challenge: There are more than twenty blue marks, all made with one brush. Can you make more than twenty different marks from just one brush?

This sort of experimenting with brushes is best done on a large sheet of paper to allow freedom of movement. Do not be tempted to organize the marks into neat squares because it is far too inhibiting to allow true experimentation. Make the marks repeatedly; do them enough times so that you remember how you achieved the mark, and can repeat it whenever you want to. In the initial stages, you may find it useful to annotate the pages in pencil as you go.

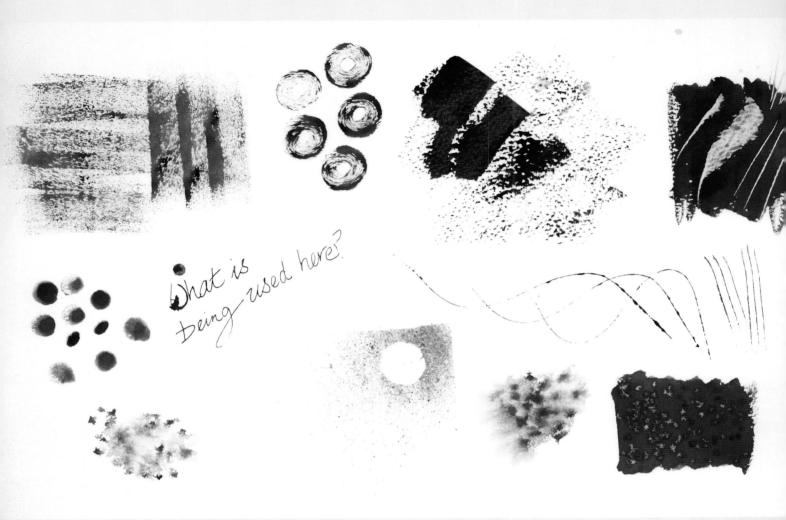

An 'Anything Goes' Dictionary. Anything that makes a mark on paper is valid. In making these marks, a palette knife, a sponge, a spritzer, the edge of a piece of paper, a mapping pen and fingers were used. Be inventive!

The 'Anything goes!' Dictionary of Marks

This is very experimental and great fun. There are no rules; anything that makes a mark on paper is valid. Just remember to note what you used, and how you used it so that you can make it again in the future.

Dictionary of Masking Techniques

Watercolour is applied from light to dark, so a great deal of thought needs to be given to the order in which paint is applied. Learning to use masks plays an important part in planning the execution of a painting.

Masking fluid can be applied accurately with a colour shaper to cover areas or small precise marks.

To apply masking fluid with a mapping pen, adjust the nib to the desired width, and dip into the masking fluid; hold the pen vertically.

To soften the edges around a masked shape, lift paint with a damp brush either before or after removing the masking fluid.

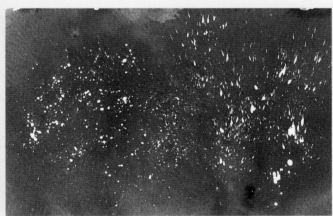

When you use masking fluid using a toothbrush, hold the brush at different angles to achieve different shaped marks.

Applying masking fluid with a colour shaper
Dip the colour shaper into the masking fluid, and apply to the area to be masked. The colour shaper can be used to apply a fine line, to draw, or to cover a larger area. Take care to push the fluid around lightly from the surface of the puddle; do not push the masking fluid into the paper. Take care not to leave any gaps as paint will find its way through the tiniest hole in the fluid. When you are finished, leave the fluid to dry on the colour shaper. It will pull off easily.

Application of masking fluid with a mapping (ruling/lining) pen
Adjust the nib to the desired width, and dip into the masking fluid. As you use the pen, keep it absolutely vertical to draw or write. The pen is very good for reserving small or accurate marks. Clean as for the colour shaper.

Application of masking fluid with a toothbrush
A cheap, flat topped toothbrush is best. Dip into the fluid and drag your finger towards you across the brush surface as shown.

These marks are very useful for adding texture and movement, implying floating pollen or seed heads, or texture on petals (for example, foxgloves, or orchids). The toothbrush can also be loaded with paint and used to produce similar marks.

Softening edges of paint before removal of masking fluid
To avoid hard edges around a masked area, take a damp brush and run it across the masking fluid to gently lift some paint before removing the masking fluid.

Dictionaries of Marks in other media
The principle of mark-making applies across all media; oils, pastels, crayons, pencils, acrylics all have unique attributes which must be understood and mastered.

It is not possible to create beautiful paintings without first understanding how the medium being used, and the tools being employed, work not only together, but most importantly, *in your hands*. Always allow yourself time to play and experiment.

The humble pencil can produce some very exciting marks. Starting a Dictionary of Pencil Marks is a good opportunity to practise making marks that convey an emotion.

Anemones in Blue Glass Jug 1. In this painting, I chose to keep the mark-making controlled and precise. The colours are bright and vivid.

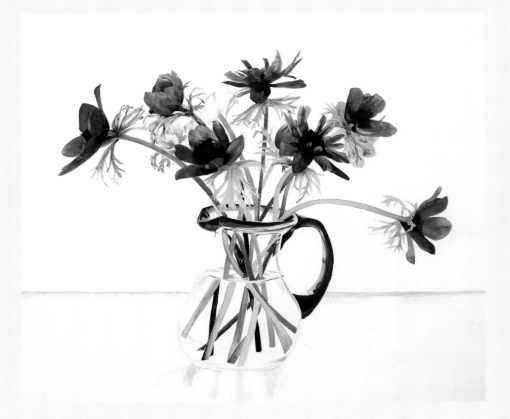

Anemones in Blue Glass Jug 2. In this painting, I worked much wetter, using loose, free marks. Although the colours are slightly diluted by the extra water, this painting is much more energetic.

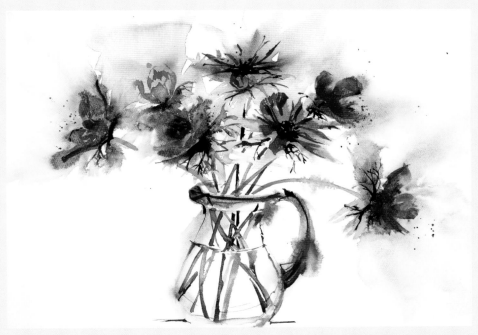

EXERCISE
A challenge

Can you identify the marks used in this simple painting? Look closely at the dictionaries, and try to identify which brushes were used to make this painting. As you become more experienced, you will be able to identify marks in more complex images. You will gain information by studying the work of others, and find new combinations of your own. Rather than asking 'How do I paint a rose?' you will begin to ask 'Which marks shall I use to paint the rose?' or even 'Which style shall I paint it in?'

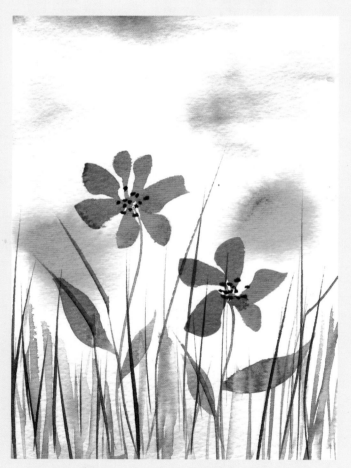

Are you able to identify how the marks were made in this very simple painting? Make your own copy of it. For the sake of learning to master your materials, try to make the copy as exact as possible.

A choice of style

As you gain experience in playing and experimenting with your materials, you will find that you have much more freedom when you paint. You will be more confident to make design decisions, and it will show in the finished work. Rather than asking 'How do I paint that vase of flowers?' you will begin to ask 'How shall I paint that vase of flowers? Which marks shall I I use?', or even 'Which style shall I paint it in?'

The two paintings *Anemones in Blue Glass Jug* were inspired by a set of photographs, in which the colour had been heightened, making the glass glow. The photographs had a lot of energy. As a demonstration of the choices which became available when you are conscious of your materials but not struggling with them, I experimented with different brush techniques. I used the same palette and drawing (which was traced) for both, so the differences are entirely due to the mark-making. The first version was painted with very controlled brushwork, the second with much wetter, loose, free marks. It is delightful to be able to choose the style of a painting.

Identifying marks

As you become more experienced, you will start to recognize how marks have been made in a painting. This is an incredibly useful thing to be able to do, as it means you are able to look at the work of other artists and understand how they executed the painting. Copying the work of other artists is a well recognized method of improving your own skillset. They may have used ideas and combinations that you wouldn't have thought of, but that you find exciting and would like to include in your own images. By dissecting the work of other artists in this way you can learn, and your own work will grow in depth and creativity.

WHEN THINGS GO WRONG

Sometimes a painting just goes wrong. There is no need to expand on this really, it is a fact of life. It can be sad, upsetting, annoying, disappointing but what you should not allow yourself to feel is that it was a waste of time. The process of painting is just as valuable as the painting produced, sometimes more so, and definitely when the image does not meet your hopes for it when you started it. Do not abandon these paintings unthinkingly. Painting is never a waste of time. We learn by our mistakes; begin by analyzing what went wrong, and why, so that you can try to avoid them in the future.

Failed paintings are opportunities for experimenting. Never forget to ask if there is some way you could use what you have.

First check whether you can use a part of the painting. Sometimes a judicious crop is all that is needed to create an enjoyable image. You may be able to use that part of the painting exactly as it is, or, after a quick rethink through the design principles, you may decide to keep working on just that section. Mark the area off with a pencil line, or masking tape, before continuing so that your eye is not constantly drawn back to the area you have decided to discard. You could even cover this area with paper to avoid it distracting you.

Sometimes there is nothing you can do to recover an image from your efforts, but you can still make use of what you already have. Use them to experiment. Some people find this very freeing, because at this stage you have nothing to lose. It is commonplace amongst inexperienced painters to underestimate the extent to which mature artists play and practise with materials and techniques, when in fact it is a natural part of their daily routine.

This type of painting provides an excellent opportunity for practising mark-making. There are already layers of paint on the paper, so you could experiment to find out what happens where one type of mark is a layer over another. You could practise altering the colour by glazing; as well as learning to alter colour this way, you would experience which paints work as an under layer, and which move too much. You could practise altering tone by glazing with the same colour, and making sure the edge of the new layer meets the old one exactly, which means you improve your ability to increase the number of layers you use without the painting becoming overworked. Do not throw away 'failed' paintings, use them to learn.

Experimenting on an overworked rose

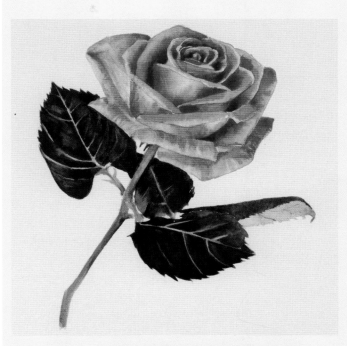

An overworked rose provides an opportunity to experiment.

This rose went wrong. I had intended a very figurative painting describing a fresh, pink rose. It became overworked, the colours flattened, the paint became thick and heavy and the rose reached the point of looking like it had reached the end of its vase life.

It happened because I had a number of interruptions while I was painting it, and rather than recognize my loss of concentration I continued painting when I should have stopped. Although I had time to paint it, I no longer had the mental space needed. The lesson to learn is to recognize when it is time to put the paints away. This is difficult when the desire to paint is still there. This is the time to discard the original plan, and to take the opportunity to experiment. Although not expecting to recover a successful image, this provides the opportunity to practise techniques within a context.

Step 1: Wetting the excess paint.

Step 2: Lifting off the excess paint with kitchen roll.

I began by washing off the excess paint. I knew I would not recover white paper as I had used staining paints.

I thoroughly wet the area. I wet beyond the edge far enough to allow an open edge so that more hard lines wouldn't appear. I left it to soak for a few minutes to soften the paint.

Next I lifted off the excess paint with a piece of kitchen roll. This is best done by dabbing, not rubbing, to protect the surface of the paper, which was already in danger of becoming damaged by previous overworking.

Using kitchen roll rather than a brush meant I could use the creases in the paper to introduce lines in the remaining paint, adding texture that seemed to represent the way the rose petals folded. As this was an experiment, I wasn't too bothered about making these lines match my drawing; I wanted to feel freer than that to counteract my overly tight first attempt. I allowed it to dry before continuing.

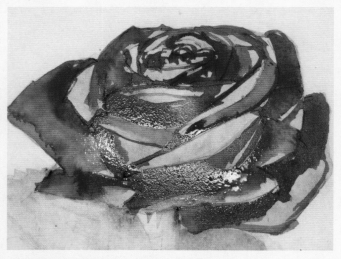

Step 3: Practising using a sword to 're-draw' the shape.

Reds can be a problem, looking delightfully bright when wet but when drying much duller and paler. I decided to experiment by layering carmine over the original Permanent rose/Cobalt blue mix to see what happened. Other than introducing carmine, I used paint that was already in my palette. Practising like this is a good way of using up leftover paint. I used a medium sword liner brush to 'draw' over my original pencil marks, varying the angle of the brush and the pressure to alternate between thin lines and broad strokes in a fluid hand movement.

Step 4: Using a pointed round brush to 'print' leaf edges.

Step 5: Using a sword to maintain a loose, free feel to paint the leaves.

Working over a 'ghost' image provides a good opportunity to practise confident brush strokes; as there is already a line to follow, you can concentrate on your handling of the brush. Working on dry paper, I dropped some extra colour into the wet brush strokes where it seemed appropriate to vary the tone. Although now aiming for a stylized rose, it had to be based on observation of an actual rose to be read as a rose in the image.

The leaf edges gave me the opportunity to practise mark-making with a da Vinci Series 35, size 4 – a very pointed round.

I also deepened some of the tones on the rose with just a few extra light marks to the lower petals, using the sword liner and a mix of Carmine and the other colours from my palette.

Not wanting to be drawn back into tightening up, I continued working on the leaves with my sword liner brush, again varying the pressure. I also practised leaving small areas unpainted while working quickly, which gives a lovely loose effect.

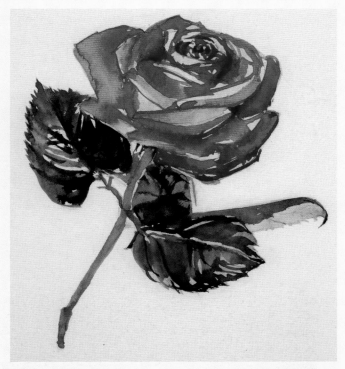

Step 6: Adding finishing touches. Sometimes at this stage, the result is surprisingly pleasing!

A quick check on composition; the red needed to be balanced so I added some to the stem. Finally I softened some of the paler areas by dragging paint across from neighbouring petals with a damp brush, and lastly painted in the stem.

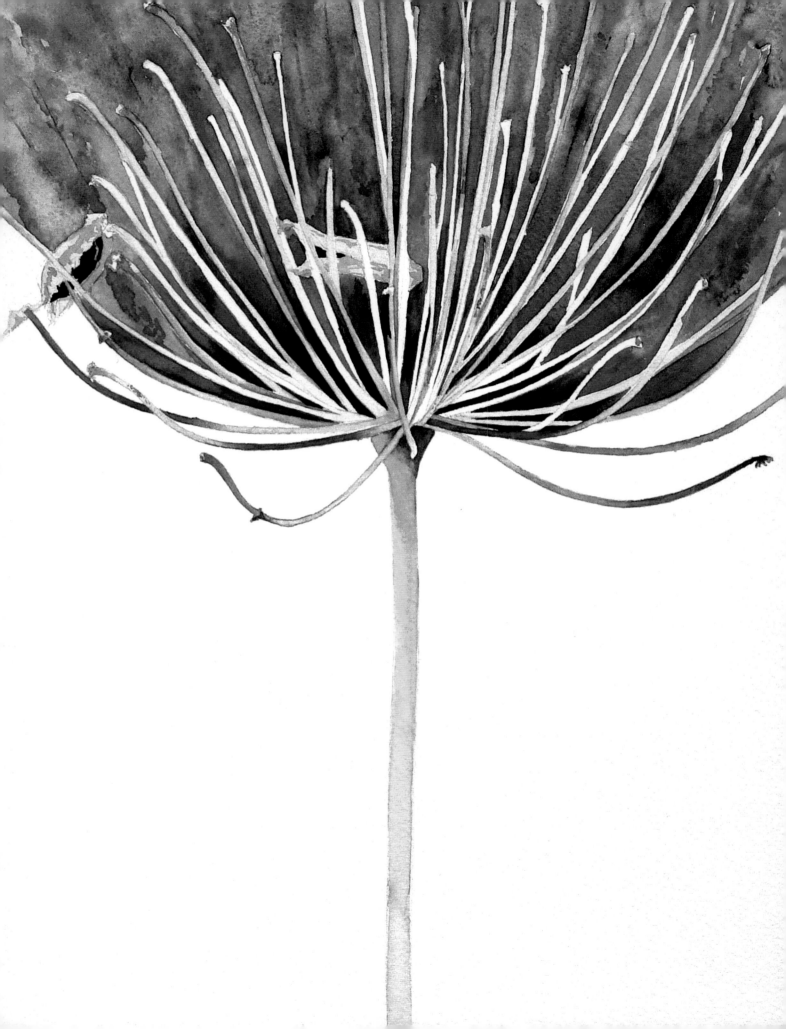

Chapter 5

Gathering information

Artists have a way of noticing things that other people simply do not. An artist can see an exciting painting in the most unlikely subject matter, where other people can look at the same thing and see something quite ordinary and uninspiring. There are obviously talented people for whom this comes naturally, but you do not need to have been born with the ability to spot potential for beautiful paintings in surprising places. Thankfully this is something which can be learned. All that is required is an open, enquiring mind.

In addition to spotting inspiring subject matter, there is a certain amount of information we need to gather before we can begin a painting. This is true, whether you want your painting to be botanical art, floral art or a floral abstract, and wherever your preferred style of painting falls on the tight-to-loose spectrum. While developing an idea and designing an image, a mature artist will deliberately look for tone, shapes, colours and textures; this information gathering process becomes second nature, sometimes so much so that they are unaware of actually doing it. Earlier in your painting career, it helps to focus on these elements deliberately. Later in this chapter, you will learn more about the types of information that needs to be gathered, and some suggestions for how to collect it effectively.

A practised eye can spot inspiration in the most unlikely of places. I spotted this faded agapanthus maintaining a soft glow despite a lack of sunlight on it, and through it I noticed the soft lilac greys of fading lavender. The colour combination was delicious. The crisp lines in the agapanthus were in contrast to the fuzziness of the lavender. Even the tarmac on the road played a part, taking on a purplish hue in the autumnal light. This was essentially a dead plant set against fading plants, against a backdrop of tarmac, an unlikely choice of subject matter. In a true moment of inspiration, I saw the potential for a floral abstract, instantly knowing which colours and painterly techniques I would use to paint it. The ability to spot potential in situations like this comes with experience, through practising observational skills.

In order to gather this information, we need to be able to see it as an artist does. There are various tools at our disposal that help us in our observation of the world around us. Words and cameras both have an important place in learning to see like an artist. But there is one way to improve your observational skills that surpasses all others: drawing.

Through the Agapanthus.

For any artist, irrespective of style or even medium, drawing is an essential skill. Within the art world, it is correctly thought of as a discipline, and with good reason. The depth of visual knowledge and creative understanding you acquire through drawing is immense.

Learn to differentiate between the various reasons for drawing. There is drawing as enquiry, which an artist uses when gathering and recording visual information. There is drawing as preparation for painting, when drawing is used to establish design and style of the painting, and then to 'draw up' the image on to the paper. Finally there is drawing for its own sake, when drawing materials and techniques are used to make a finished piece of art. At the start of each drawing, ask yourself which of the three reasons for drawing applies at that moment, and keep that goal in mind as you draw.

A lack of understanding of the reasons behind drawing leads many people to consider themselves incapable of drawing. This is simply not so. Anyone who can hold a pencil can draw. While not everyone can produce amazing works of art using drawing media and techniques, everyone can draw to improve their observational skills, or to prepare for artwork to be made in another medium.

Today, technology provides us with many easy methods of recording interesting subjects, and there are many devices and tools to help us get an image onto the page before we begin a painting. When an artist with good drawing skills uses these alongside drawings, they can be very useful indeed. However, attempts made to use these devices to avoid drawing result in paintings lacking in depth and sincerity. The knowledge the artist would have gained about the subject or themselves through drawing is missing, and its lack is evident in the finished painting, even to an untrained eye. It seems impossible to overstate the value of drawing. It is the basic skill essential for anyone wanting develop a creative approach to painting.

Drawing can make us see the familiar like we have never seen it before. It can make us think about seeing, as well as simply seeing.

ANDREW MARR, *A SHORT BOOK ABOUT DRAWING* (QUADRILLE: 2013, P41)

What happens when we draw
Think of drawing as active observation rather than passive observation. As a matter of necessity, we move through our world not noticing most of what is around us. Without the ability to filter out the familiar and commonplace, we would suffer from information overload, sights, sounds and smells quickly overwhelming us. This is part of being human; we passively observe the world around us, and we just don't notice most of it.

As artists, we would hope to be more visually aware than other people, but this is only true up to a certain point; we are human too. We notice what is important to us, the visually exciting and moving sights that inspire us to paint. But then our attentional filter kicks in again, and unless we make a conscious effort to note the fine detail, we automatically go back to making assumptions based on our previous experiences and familiarity.

Unless we are careful, it is all too easy to fail to observe detail. For example, we will notice the beauty of the rose, but see it in its entirety, and unless we focus our attention on it, we will automatically filter out the subtleties of the colour change across the petals, or the depth of tone at its heart. When standing in front of an herbaceous border, you may be entranced by the beauty of a clump of delphiniums, but not be aware of the cornflowers next to them.

What happens when we draw is that we force our minds to concentrate on the object or scene in front of us. We need to do this consciously, and the process of drawing helps us to do this in a way that no other method of observation does.

EXERCISE 1

Observational experiment

Take a long, hard look at this photograph, *Pink Roses*, and using words, describe what you see. Try to describe it in as much detail as you can.

Next, try to make a drawing of the photograph, again recording as much detail as you can.

Compare the two methods of observation. You will find a few questions at the end of this chapter which may help you in your assessment, but you will gain more from the exercise if you do not read them until you have completed it.

Pink Roses. Use this photograph with Exercise 1 to investigate how drawing can improve your observational skills.

The process of drawing

The act of drawing focuses our attention on what we are drawing. We look harder, and we notice more. Drawing helps us to define shapes, tones and colours. It helps us to describe the details of the object we are drawing.

What happens on the page is not the most important part of the drawing. When we draw to see, it is the process of drawing that matters. The time spent in active observation forces you to make decisions about where to place a mark on the paper, and also *how* to place a mark on the paper.

Remember that how much detail you choose to include, and the style of the drawing is entirely your choice. If you enjoy the details of botanical art, you might naturally want to make accurate, clean drawings, recording every detail. If your preference is for floral art, or floral abstracts, your mark-making might be looser and more expressive.

Look harder, remember better

The act, the rhythm of drawing involves looking at your subject, then at the paper, back to your subject and back at your drawing. In the small gaps between looking and making a mark, you will be remembering what you have seen. Your drawing will record far more than the subject matter because when you look at it in the future, not only will the drawing itself bring to mind the subject you were studying, but you will also remember the environment, the weather, the sounds, and how you felt at the time. In very subtle ways, all of this will be held within what you produce on the paper. You make decisions about which features are important to you, and which to leave out. In a creative approach to painting, all of this is relevant because if you choose to make a painting of the subject, these observations can inform your decisions for the design of the final image.

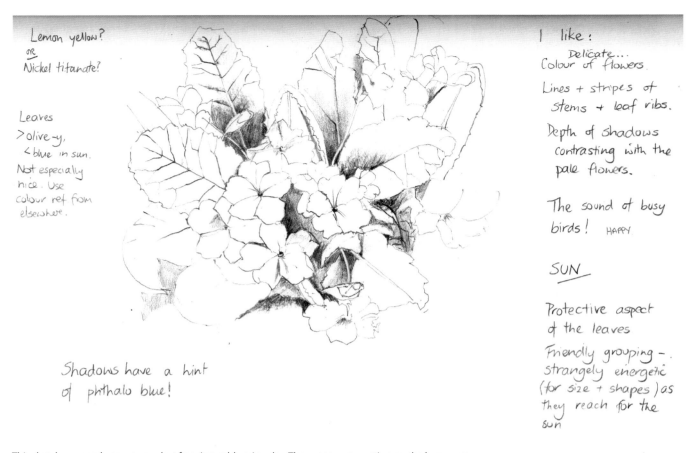

Lemon yellow?
OR
Nickel titanate?

Leaves
> olive-y,
< blue in sun.
Not especially
nice. Use
colour ref from
elsewhere.

Shadows have a hint
of phthalo blue!

I like:
Delicate...
Colour of flowers.

Lines + stripes of
stems + leaf ribs.

Depth of shadows
contrasting with the
pale flowers.

The sound of busy
birds! HAPPY

SUN

Protective aspect
of the leaves

Friendly grouping -
strangely energetic
(for size + shapes) as
they reach for the
sun

This sketch was made on a sunny but freezing cold spring day. The notes commenting on the busy-ness of the birds, the 'strangely energetic' flowers and the odd colours I 'saw' in the shadows will all affect my decisions when designing a painting. The sharp lines in the way the leaf veins were drawn, and my memory of working quickly to get out of the cold, suggests this might become an abstract floral, rather than a figurative portrayal of the primroses.

The time element

The time the drawing takes is important too. While drawing, there is time to analyze what attracted you to the flower or scene in the first place; was it the colour, the shape, the movement, light through petals, or something else? And is that still the most important feature for you? There is time to consider your emotional reactions to what you are drawing, to consider whether it is worthy of being made into a painting, and if so, which style would be most appropriate. The element of time in a drawing, and the enhanced experience it gives you of your subject, is something that photography cannot achieve.

Draw for yourself

Remember that this type of drawing is for your eyes only. You are not drawing to please a viewer, nor to inform them of what you have seen. It is your response to something you have chosen to draw, the environment that subject is in, even to your mood. Considering a viewer will change

your mindset. It will be difficult not to shift your focus from the act of drawing to the image on the page. If too much importance is placed on the finished image over the act of looking, the result is often poorly observed and lacking in direction and integrity.

Consider drawing to observe as being similar to taking a phone message for someone. What you pass on to the other person has to be understandable; the message equates to a final piece of artwork you may choose to make later. What you are currently producing is the equivalent of the quick note you jot down on a scrap of paper, probably not using full words, no cares about correct spelling and almost definitely without grammar. What matters is that you can pass the message on accurately later; what you are producing now is an *aide memoire*.

The long term benefits of drawing to see

As with anything else, practice makes perfect, and the more you draw, the better you will get at it. What you

Note how the pencil marks bear a similarity to the painterly marks, translating easily from one medium to another. Flower painters will find that using the materials expressively at the observational drawing stage will improve their ability to paint more freely.

place on the page will be more satisfying and more useful to you. Over time, you will begin to notice things that you would have missed before.

Obviously this applies to your ability to notice detail while you are drawing, but happily you will also find yourself seeing more in the world around you. You will be more aware of what inspires you, and may be surprised that those things seem to occur more frequently. You not only train your hands and eyes, but your mind too.

Drawing as preparation for painting

Drawing as preparation for painting has a different feel to it. It should rightly come after drawing to see, even for floral abstracts, because when planning a painting, you will be making decisions about what the painting is about, and you will need the knowledge you have gained from observational drawing. This is true for all forms of flower painting, even floral abstracts.

At this stage, it is the finished image of the painting which is in mind, rather than pure observation of the subject. It is about planning the painting, and the drawing is used to clarify your thoughts about composition and design.

There are drawing techniques that are useful when planning a painting that are not used when drawing to see. There may be very quickly made thumbnail sketches, which oversimplify elements in the design, being more

concerned with the overall relationship between them. (Thumbnail sketches are demonstrated in more detail in Chapter 6.) If you are planning a piece of botanical art, it can help to draw flowers onto tracing paper, and move the layers around until you find a satisfactory composition; you may then trace the flower onto the watercolour paper.

A thorough knowledge of the materials being used, both for drawing and painting, enables you to think ahead, and it is possible to develop techniques that 'translate' from one medium to another. By simply pulling, twisting and lifting the pencil in a particular way, you can make a mark that represents the subject, and is also suggesting which brush you will use to translate the sketch into a painting. For example, stippling in the drawing with a pencil might indicate that in the painting, the paint will be applied with a toothbrush; a sweeping mark with the pencil held on its side then lifted to its point as the pencil moves indicates a similar mark will be made with a sword liner brush.

This is useful on more than one level. It is recording something about the subject that is to be included in the painting, describing the nature of it expressively rather than with an outline filled in with tone. Importantly, it is keeping your mind on the image being planned. This means that as you draw, you are considering not only the composition of the painting, but its design in the fuller sense, which includes how to apply the paint.

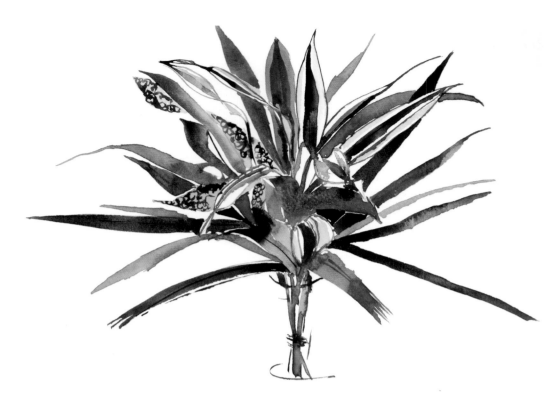

This was very much an observational exercise, made from direct observation of the leaves straight onto the watercolour, using paint and brushes. Should this be described as a painting, or a drawing?

At a more advanced stage of your artistic journey, you will be able to combine these techniques with the original observational drawing, so that you are concentrating on looking hard at the subject and planning the painting at the same time. This can help with the decisions about which elements of the subject you need to observe closely, which ones you need to record and which you can leave out.

Drawing for its own sake

In the context of this book, drawing for its own sake means using drawing materials and techniques to produce a piece of work, which may or may not result in a 'finished' image (that is, one worthy of framing). An artist may choose to draw rather than paint because it seems appropriate for the subject, or for the sheer pleasure of using particular materials.

What constitutes a drawn image is an interesting question. It is not always easy to distinguish between what is a drawing, and what is a painting. Works in graphite are generally considered to be drawings, but water soluble graphite is applied with a brush. Ink studies applied with a brush are called drawings, and images in watercolour can be referred to as paintings or drawings depending on the attitude or purpose of the writer. Works in pastel, in the past referred to as drawings, are now referred to as

paintings. Whatever your personal decision about whether you consider an image to be drawn or painted, it only takes studying an accomplished botanical illustration, or some of the Renaissance cartoons by da Vinci and Rembrandt, to appreciate that drawing is as valuable a process as any other for producing beautiful pieces of art.

Drawing media generally allows for a more spontaneous approach than paintings, and are equal in aesthetic validity. Artists who enjoy making botanical art, floral art and abstract florals should choose a drawing medium over painting if it best expresses their idea for the image.

The process of drawing here focuses on the final image. This is not drawing to see; the intent is different from the outset. While you should not allow yourself to be inhibited by the thought, this type of drawing may be shown to others, and in that respect it is unlike drawing to see or to plan a painting.

There is obvious overlap with observational drawing, especially for artists who work directly from life, painting the flowers or plants in front of them. Even then, by the time you are ready to embark on a drawn image, you should have prepared, either by making observational drawings or planning sketches. For a drawn image to be successful, drawing to see as preparation is a requirement, not an option.

This drawing of roses was made using graphite and water-soluble wax pastel.

LIFE DRAWING

There is a long tradition in the art world of drawing for accuracy, life drawing in particular being highly valued for the way in which it can improve an artist's drawing skills. Life drawing helps because as humans, we are so attuned to the human figure, and the face in particular, that we are aware of any tiny discrepancy in the drawing. Compare life drawing with drawing a flower or plant; if a leaf is slightly misaligned on a stem it doesn't really matter. In fact, whole branches can go 'missing' and no one would notice. But misalign an eye and the model becomes unrecognizable, or put a slight twist on a mouth and a grin becomes a grimace, both unacceptable visually and for the feelings of the poor sitter.

Even though you are reading this book because you have an interest in floral art, there is value in you attending a life class regularly. Back in your studio when faced with your favourite flowers, you will quickly understand why. After just a few life drawing sessions, you will find drawing flowers easier than you did before. The quality of the marks you make will show more confidence, and your decision making about which marks are actually useful will get quicker. The latter is very useful for some flowers more than others, as anyone who has tried to draw tulips next to a window will testify.

USE OF SKETCHBOOKS

A drawing can be made on just about any surface that will take a mark, but sketchbooks have a special place in the hearts of artists. They are precious.

A sketchbook is a very versatile tool. It is a place where moments of inspiration can be recorded, ideas can be thrashed out, where incomplete drawings can reside, and random marks can be made for the fun of making them. It may contain finished drawings, scribbles, colour notes, written notes, and things like photographs or pieces of paper stuck in. It is a place for making mistakes without having to correct them, where you can keep them so that you remember not to do that again.

It is a very personal reference collection of anything which may aid in the development of your creativity. They do not have to be shown to other people, unless you choose to share its contents. Keeping it private means you are *free to use it as you wish*. Showing it means you can share ideas and learn from the feedback before committing to a painting.

In addition to sketchbooks of drawing paper, it is useful to have one of watercolour paper. Observational 'drawings' made with a brush will give you opportunity to test marks and techniques suitable for your subject matter, while you are planning a painting. A sketchbook of the same type of paper that you intend to make the painting on is especially useful, as it will give the same results in texture and colour. This can be especially useful for flower painters, as there are times when it is very convenient to have colour references for certain flowers handy.

Different size sketchbooks are useful in different places. Pocket or handbag sized sketchbooks are very handy for capturing unexpected moments of inspiration. Larger sketchbooks are useful for developing ideas in the studio.

Keep numerous sketchbooks. Build up a library of them. They are an invaluable resource of personalized reference material. Enthusiasm for ideas stored in sketchbooks can be reignited years after the original idea was conceived, ideas just waiting for the right moment to come to fruition. These may have been lost forever if not safely stored in a sketchbook. As you progress on your artistic

A sketchbook is for personal use. This page from my sketchbook shows a series of shapes that were very useful for me as a reference, but meaningless to anyone else. The shapes represent the silhouettes of poppies on the distant side of a field, but without the explanation, it is unlikely you would know that.

journey towards greater creativity, you will appreciate sketchbooks more and more. If a mature artist is asked what would be the first thing he would save from his studio, it would always be the irreplaceable sketchbooks.

Drawing daily

The more you draw, the more relaxed you will feel about it, and the more you will understand its worth to your overall development as an artist. Drawing will quickly become a very natural response to things that excite you visually. You will automatically reach for your sketchbook and pencils, and begin the process of turning inspiration into ideas for paintings. There is a strange circular element to this: the more you practise turning inspirational events into drawings, the more inspiring things you will find. As your drawing improves, your mind is quietly trained to spot interesting subject matter, and the world becomes a more visually exciting place. To use a media analogy, your world is transformed from Standard Definition to High Definition.

Air drawing

If you have nothing to hand with which you could make a mark, you could try 'air drawing'. Air drawing is imagining that you are drawing, a surprisingly useful approach to drawing that is also freeing because there is no record of mistakes. Imagine that you have your favourite drawing tools (pencil) and a sketchbook in your hand, and slowly and carefully imagine yourself drawing the object in front

DRAWING DAILY: BE PREPARED

Drawing is very enjoyable, and the benefits of getting into the habit of drawing daily are enormous. A little organization can go a long way to ensuring drawing daily becomes a very natural part of your life. It would be very sad to miss out on the advantages available to your creativity because a few simple things had not been put in place.

- Remember to ask yourself why you are making the drawing. Are you capturing visual information, planning a painting or creating a complete image?
- Use whatever time you have. Two minutes daily is better than waiting for a free hour once a month.
- Remind yourself regularly 'It is the looking that matters.'
- Keep a pencil or pen in every handbag, coat pocket or the door of your car.
- Buy sketchpads that fit into your handbags, coats or rucksack.
- If numerous sketchpads are not an option, keep folded pieces of paper handy – you never know when inspiration is going to strike!
- Keep a bag of art materials in the car.
- Download a sketching app to your phone or tablet. Use it *before* snapping the scene with the camera.
- Keep a notepad or sketchpad by the kettle; two minutes drawing while waiting for it to boil may not produce a complete sketch in one session, but a few days observing the same object, a few lines at a time, will help you look harder.

of you. Try to match the time element to the time it would take if you were actually doing it. Try to imagine the sound of the pencil on the paper, and how the surface of the paper would feel.

While this might sound a little daft, it has several things to commend it. Firstly, you are looking much harder at your subject matter than you would have otherwise. By not having a pencil in your hand, you may find that you naturally commit more to memory which is always very useful. Thirdly, it can be almost meditative; it is while in a relaxed state that our brains work well at making connections with information it already has, allowing fresh ideas to happen almost spontaneously.

PHOTOGRAPHY

For an artist, a camera is an *excellent* piece of equipment. The discerning artist would not be without one, as used properly photographs can be a first-rate resource. Think of a camera as another item of studio equipment, and the photographs as being an extension of a sketchbook. Small cameras are easy to carry, slip them into a pocket or handbag.

Obviously the better the camera, the better the resulting photograph can be to work with, but as an artist the important thing is that you learn to use your camera judiciously and photographs cleverly, and for this you may find a small pocket digital or phone camera more than adequate.

Many artists declare cameras and photographs to be unsuitable for gathering references for painting; some think of it as cheating. Among artists in general, this view is particularly prevalent amongst those who enjoy painting flowers and plants. This possibly has an historical basis, in part at least to the tradition of botanical illustration. The rigours of this genre of painting flowers rightly demand that the artist works from an actual specimen, photographs simply do not provide enough of the right type of information. For a botanical illustrator, the quality of observation needed is not possible without the plant itself. Since botanical illustration plays such an important role in the history of flower painting, it seems likely that this attitude to the use of cameras derives from this.

For other genres of flower painting, this is not the case, and the camera proves to be an indispensable tool. What matters is learning how to use a camera to gather the right type of information for your preferred style of painting. The type of information you need will determine how you use the camera.

The first important thing to realize is that a camera is not discerning. It captures whatever is in front of it according to its settings. The amount of control an artist has over the settings is determined by whether they are using a manual or digital camera. In the case of the latter, the software will reduce the amount of control the artist has, but as artists are using it to gather information as reference material rather than to take stunning photographs, this is not necessarily a problem, and may even prove to be an advantage. Take time to understand your camera.

Learning to use a camera as an observational tool
Because a camera lacks discernment, it cannot replace sketching as a means of observation. It serves a different purpose, supplementing sketches and providing additional material.

Draw first, photograph second
When gathering information for a painting, the best way to ensure that you have useful photographs is to make a sketch first. Drawing to see will make you look carefully at the subject, and make decisions about what you want to record. Remember, the camera doesn't do the work, you do. Once you have your sketch, you can use the camera to take supplementary photographs. Use the viewfinder or screen to carefully match your sketch as closely as possible. Check for angles, perspective, and lighting.

Later, when you examine the photograph, take time to compare it to your sketch. When learning to use the camera for observation, this is best done when the subject is no longer in front of you because you will be reliant on the information you have gathered, and are therefore more likely to notice missing information. To use a camera effectively as an observational tool, you will need to practise this. A camera can be so useful that it is worth every minute you spend learning to use it to your best advantage.

EXERCISE
Spot the difference

Step 1: Take a photo of a small group of flowers.

Step 2: Make an observational drawing of the flowers.

Step 3: Take another photo of the flowers, this time trying to match it as closely as possible to your sketch.

Step 4: Compare the first photo with your sketch, and then your second photo. Play 'Spot the Difference.'

What have you learned about your camera?
What do you learn about your observational skills?

Dandelion Clock 1. A camera can be extremely useful for capturing a light filled moment in a fraction of the time it would take to draw the same scene.

Snapshots

Eventually, with experience, you will be able to use the camera effectively without actually making the drawing first. You will have learned how to look harder before pointing the lens, and you will appreciate it for what it is, observationally inferior to sketching but very useful nonetheless.

Carrying a camera at all times will then mean that you are able to capture useful information when sketching would not have been possible. If, for example, you spot an inspirational subject in a busy high street, on the way to appointment, or at a social event, taking time to sketch might be inappropriate, but using your camera to take a quick snapshot provides a way to avoid a lost opportunity.

Advantages of cameras over drawing
Capturing light

One big advantage of photography over sketching is its ability to capture wonderful light effects, especially out-doors, or in a naturally lit room.

If working outdoors, the effects of light through petals, or sunlight creating glowing plants and deep shadows in a garden scene, can be fleeting. Here, a camera has a big advantage over sketching. An exciting light-filled moment can be captured with a camera in less time than it takes to get your sketchbook out of your pocket.

If working *en plein air*, it can be a good idea to snap the scene before starting to sketch (although after you have carefully assessed what it is you are going to draw).

Interesting light effects such as the sunlight through the leaves and stems in this photograph are so fleeting that they are almost impossible to capture through drawing.

The nettles in this painting glowed with light, and cried out to be painted.

Cameras are a good option for gathering references of protected flowers, or those from which we need protecting. Nettles, thistles, hogweed, brambles, all are wonderful subjects for the flower painter, but very uncomfortable to pick!

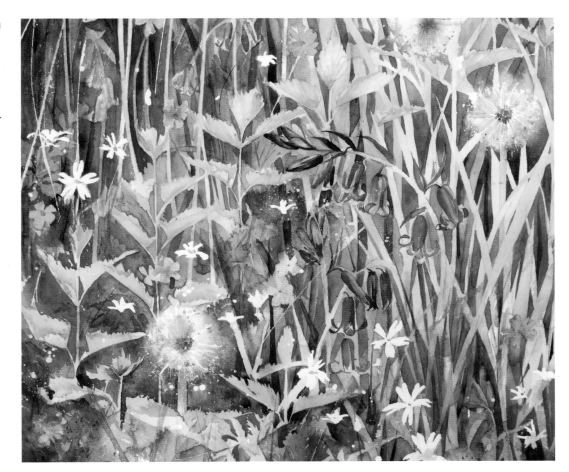

This means you can capture the position of shadows quickly, which will be a useful reference later when they have moved.

This is useful in the studio too. Flower painters, especially those more inclined to botanical art, are likely to set up a still life or floral arrangement and light it deliberately. However, if you are working with natural light, snapping the position of shadows early on is very useful.

Capturing the freshness of flowers

Fresh flowers sometimes do not last as long as you need them to make a painting. Taking photographs of them at the start of the process can take the pressure off having to complete the work before they fade. This is useful if time pressures mean that your sketches are hurried.

There are certain flowers and plants that are particularly phototropic. Tulips, for example, can move towards the light faster than you can draw them. In the case of tulips, I will set up the arrangement carefully, playing with the composition and making quick sketches to 'get my eye in'. I will then photograph the tulips before they have a chance to turn towards the light, and work from

the photograph for the composition of the painting. I will keep the tulips there; it was the tulips that inspired me, not the photograph, so the latter cannot replace my emotional response to the actual flowers. Additionally, having them in front of me will be the best colour reference, and provide the details missing from the photograph.

Cameras can be a huge advantage if you enjoy painting wild flowers. Many are protected, and need to be worked with *en plein air*. Sketching first, and then taking a series of photographs can be extremely useful.

Finding unexpected information

As an observational tool, the camera does have a hidden advantage in that often when looking at a photograph, you will notice something that you did not see when you looked at the subject. If you should find yourself using your observational skills a little later in the process than you would have liked, you may find yourself noticing something useful, important or inspiring. Take the trouble to learn to examine your photos carefully to see what they have captured that you hadn't been thinking about when you took the photo.

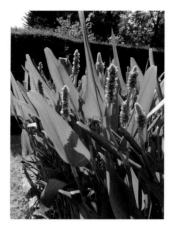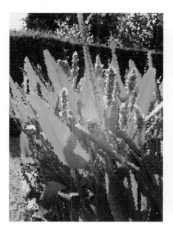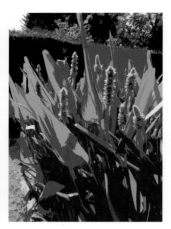

Blue Pickerel. Manipulated photographs can produce some interesting results, becoming primary inspiration for a floral art or floral abstracts.

Using the camera to 'see' what isn't there

Photographs can provide some amazing inspiration in their own right. Some photographic effects are achievable with the camera itself, some need to be discovered by playing with computer software. Editing software on cameras and mobile phones will allow you to alter the colour and tones in a number of ways, as will basic computer software. More advanced software such as Adobe Photoshop will allow you to apply filters to the photo, giving some extraordinary results. Flicking through the Filter menu and applying the filters can be very inspiring. You will see the image in new and exciting ways, which can spark ideas for paintings. Using photographs as a primary reference in this way can be incredibly inspiring for artists interested in the genres of floral art and floral abstracts.

It might be that the effect is worth translating into watercolour. It might be that you are reminded of a painterly effect that you enjoy, inspiring an abstract painting that is a combination of your imagination and the photograph. Initially the manipulated photos will be surprising, but take time to analyze and compare the before and after photographs. You will gradually learn how to apply your own effects, making your artwork more original.

The usefulness of printed photographs

A printed photograph can be used as a reference for drawing up the image onto watercolour paper, using gridlines or tracing techniques.

Using gridlines is time consuming, but, accepting that the photograph has been taken according to the guidelines above, can save time. Complicated designs are often easier to draw up this way. Gridlines also allow for scaling an image up or down, an advantage this technique has over

tracing. Gridlines have to be removed using an eraser, and there is a risk of damaging the surface of the paper while doing this, but there will probably be less erasing than you might do in correcting a free hand drawing of the same photo.

Tracing photographs should be used with caution, as the opacity of the tracing paper usually obliterates detail. Also, the final image has to be the same size as the photograph. However, it can serve the purpose of saving time, and a single tracing can be re-used if you want to repeat the painting or re-use a flower in another one.

Pitfalls of photographs

Apart from the inherent lack of discernment in the camera, there are other sound reasons for taking care in the use of photographs as a reference.

The most common pitfall is being drawn into 'copying' the photo. This is absolutely the opposite of what you want if you are aiming to express your creativity, and many experienced artists and art tutors rightly feel that photos can inhibit creativity if not used correctly.

In terms of observation, do not fall into the trap of thinking that the photo is 'right', so any discrepancies between it and your drawing must be because your drawing is incorrect. It is not, the photo is. A photograph captures a fraction of a second in time, and creates a still image. This is not how we experience the world. We are constantly moving; as we look, our eyes are constantly moving; as we draw, our hands are constantly moving. When we draw, we are capturing an experience over a period of time (which is at least as long as it takes to make the drawing) and responding to an emotion that inspired us to make the drawing in the first place. All of this will

be inherent in your drawing, and its integrity will be understood, albeit unconsciously, by your viewer. If you are prone to making the assumption that the photographic record is somehow more accurate than your own, take the time to remember *why* you are painting. For your work to be honest and creative, remember that you are making a painting, and the viewer is expecting to see your *interpretation* of the subject.

THE FOUR ASPECTS OF OBSERVATION

Successful paintings need to be planned, especially watercolour paintings which can be very easily overworked. Experienced artists can do this automatically but less experienced artists need to plan consciously so that their watercolours will remain bright and fresh. Planning your work will avoid the common problem watercolour painters have of overworking the painting, so that it looks dull and muddy.

Part of the process of planning a painting is to ensure that you have all the reference materials you need. While you are busy sketching and photographing, you need a thorough understanding of the type of information you are going to need to gather. There are four areas to consider: shape, tone, colour and texture. It can be useful to think of these as a checklist to make sure that you have everything you need when you start to design, and ultimately when painting.

Observing shape

One of the most eye-catching things about flowers and plants are the shapes seen in the flower heads, leaves and stems. An obvious feature to be captured in figurative paintings, the shapes of plants also inspire beautiful, sometimes quirky, abstract motifs; think of Charles Rennie Mackintosh's roses.

There are many different ways of learning to observe shape, and to convert the shape of a three dimensional object to a two dimensional outline on paper. Books on botanical illustration are rarely without a section on observing the shape and form of flowers, many of them giving excellent advice on drawing the different flower shapes. Even if this style of painting does not appeal to you, for a flower painter, botanical illustrations can be very useful and informative.

It may help, for example, to think of these in terms of geometry. Two dimensional shapes such as triangles and

As you observe flowers, look for simplified shapes. These may help in observational drawing, or provide a basis for an abstracted version of the flower.

circles are very common in flowers. Three dimensional forms such as cones (snowdrops), spheres (dandelion clocks) and cylinders (stems) are ubiquitous. Cups and saucers are also common. Tulips are an obvious cup shape, while the umbel of cow parsley bears a strong resemblance to an upturned saucer.

It can be very helpful when drawing flowers to look for silhouettes; look for the silhouettes of the flower itself, the leaves and the stems. Look too for the negative shapes, the spaces in between the flowers and leaves, where you often find very angular shapes which can create a lovely contrast with the rounder, more organic shapes of the flowers.

When it comes to observing shapes, the more drawing you do, the easier it will become. Remember to draw confidently, keeping the purpose of your drawing in mind. While you are recording a shape, be aware of who the drawing is for, and the part it is playing in creating a painting. Remember it is not just the shape of the flower in front of you that is important, but how the shapes that you place on the page interrelate within the design.

A Blue Rose. We recognize this flower as a rose, even though it is blue. The colour is arbitrary, because it is a tone that dictates form.

Observation of tone

Shape alone can describe an object, colour can give a painting impact and excitement, but it is tone that will bring the painting to life. It is tone that will create the illusion of three dimensional form, space and depth, giving figurative paintings a greater sense of reality. Abstract paintings are stronger in mood and movement when tone is used correctly. In paintings of all styles, tone can be used to lead your viewer's eye around the image.

The concept of tone can be very difficult to grasp, yet its meaning is very straightforward. 'Tone' simply refers to how light or dark a colour appears to be. The extremes of the tonal scale are white and black, with a gradation of greys in between.

Tone is a vital element in a properly designed composition; when it is correct the paintings has energy and life, when incorrect the image will be flat, dull and lifeless. In fact, ensuring that tone is correct is always more important than using the correct colour. A painting that works in tone will work in colour, but a painting with incorrect tone will not work in colour. We are dependent on tone to identify things in the world around us, not colour. Therefore, it is extremely important to understand how to see and use tone in your work.

Seeing tone

An accepted and well-known method of seeing tone include screwing your eyes up to view the object through half closed eyes. Due to the physiology of the eye, you will see less colour, and the tonal range will be simplified, making it easier to spot highlights and the darkest darks.

Another quick and easy method is to make use of your camera or tablet. Digital cameras and tablets are particularly useful because you can get an immediate result. Take the photograph, then using the editing software, convert the image to black and white, or greyscale. The result will vary according to the app, but you will be able to compare it with the scene you are looking at to assess which is the most useful version.

Taking a photo and editing it to greyscale at various stages of your painting can help you assess whether you are achieving the correct tonal relationships in the image.

Perceptual constancy

Learning to 'see what is there, not what we know to be there' is just as difficult with respect to tone as it is in drawing shapes. In the case of tone, this is due to what psychologists call perceptual constancy, which is because of the way we perceive the world based on our experience

1. Hold the Tonal Indicator Tool at arm's length. This is important to decrease your field of vision through the hole.
2. Close one eye.
3. Look through the hole at the subject.
4. Assess the tonal quality of the spot you are seeing though the hole. Is it a light, mid or dark tone?
5. View different areas of the subject through the hole and compare one to another. It is these differences that you need to put into your painting.

Assessing tones in a Hedge 1. Using the Tonal Indicator Tool to assess the depth of tone in a hedge. Look at the spot of colour seen through the hole, and compare with that seen through the hole in the Tonal Indicator Tool in *Assessing Tones in a Hedge 2*.

Assessing tones in a Hedge 2. Move my arm slightly to assess the tones in a shadowy part of the hedge; the spot of tone seen through the hedge is much darker than that in *Assessing tones in a Hedge 1*.

of it. If we know something is white, we will perceive it to be white, even when the object is placed in dark shadow. Perpetual constancy persists, even when we attempt to overcome it, making the accurate description of tone in our artwork difficult.

It is possible to overcome perceptual constancy by isolating small areas of the subject, taking them out of context. This enables you to see the tone in a new way. No longer associated with a recognizable object, the small area is perceived as something new and your brain assesses it independently of the whole.

I developed a useful little device for making this easy, something I call a 'Tonal Indicator Tool' (T. I. T.). It is astonishingly easy to make one for yourself; simply take a strip of watercolour paper and make a hole in one end using a standard office hole punch. This seems to be a good size hole for this purpose. Follow the instructions in the box to look at your subject.

Before trying this with flowers, it is a good idea to try it first in a room where all the walls are the same colour. Perceptual constancy will inform you that they are all the same colour, so that when you look at the walls in shadow you will recognize that they are darker than the other walls, but your mind will be making an adjustment to modify what you see to conform with what you know. Then try looking again using the Tonal Indicator Tool, comparing an area in the light with an area in shadow. The difference in what you 'see' through the hole and without using it can be quite surprising; the area in shadow will look much darker than you expected it to. Immediately you look back without using the Tonal Indicator Tool, your mind will readjust to seeing the whole subject, diminishing the tonal contrast you 'see'.

The tone that you see though the hole is what you need to use into your painting. Even when you see the tones as they need to be used, it can be very difficult to find the courage to apply the paint as you should, especially if the darks are much darker than you first thought (which is usually the case). There is something about the delicacy and translucency of flowers that makes it particularly difficult to accept that the darker tones really are that dark. But find the courage to do it; it is what the painting needs. Remember that your viewer will see the complete image, and will be as prone to perceptual constancy when viewing the painting as you were when you first viewed the subject. Even if you know that you painted a snowdrop petal dark grey, what they will see is a white snowdrop.

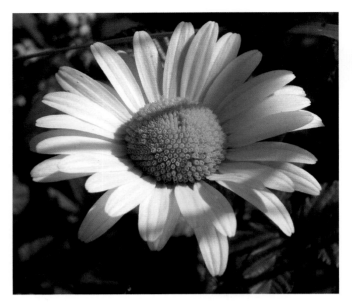

Make yourself a Tonal Indicator Tool and use it to assess the tonal variations across the petals of this daisy. Flowers are delicate and translucent, and it seems counterintuitive to be applying dark tones to describe their form. Acquiring the skills to accurately observe the depth of tone, and the courage to then apply that tone to the painting will be well worth the effort.

The Tonal Indicator Tool can also be used with photographs. It can be used with black and white photographs to assess tone, and colour photographs to help decide on colour. Instead of holding it at arm's length, lay it directly on the photograph to isolate small spots of tone and colour.

A cautionary note on the word 'tone'

It is commonplace for artists, even at an intermediate level, to confuse 'tone' with 'colour' and 'hue'. This is because of the way the words are used in general speech, where colour and hue are interchanged with the word 'tone' when referring to *colour*. It is further confused by some colours being referred to as dark (such as purple and brown) and others being referred to as light (yellow, pink). This is frustrating, as it can inhibit a correct understanding of tone when drawing and painting. Some people can find it immensely difficult to differentiate between the two uses of the word.

'Tone' in the world of art refers to how light or dark something is.

Reserve your use of the word 'tone' for art; when referring to colours, correctly use the term colour, or hue. Tone refers to light, dark and the grey scale between white and black.

Some colours are perceived as dark, even when presented in pale tones. This purple strip of colour (Dioxazine purple) is a dark tone at one end, but a very pale tone at the other.

Differentiate between colour and tone

A colour does not change because it is darker in tone. It simply appears to be darker. In watercolour this is easy to achieve:

Thin paint = light tones
Thick paint = dark tones

When you have reached the darkest limit of the pigment you are using, you may need to add another colour to darken it further; start by trying one from the opposite side of the colour wheel. For rich darks, take care to keep the paint thick and creamy.

This is not an exact science, but a very useful starting point. You will find more information on colour mixing in Chapter 4.

Observing colour

Colour is very exciting, and for flower painters it can be the main inspiration for a piece of work.

It is worth taking time to observe carefully what it is that is exciting you. Is it the range of colours present, or how a colour is altered by tone (as might happen in a shadow), or is it that you can see how the local colour would translate into paint pigments, so that you know exactly which pigments you would use to paint the subject? Maybe it is the way colours blend within your subject, how the stem is bright yellow green at the base and graduates to a glaucous blue-grey near the flower as it does in daffodils and tulips.

When an artist first fully realizes that the colour they use in their painting is completely arbitrary and therefore purely a matter of choice, it can be incredibly exciting and invigorating creatively.

Arbitrary versus local colour

For botanical illustrators, it is scientifically important to

This image was taken in natural light.

Detail from *Attention!*. The petals in this painting were painted with a mix of purples and magentas, with a little green added to produce the very darkest tones. The highlights were painted with exactly the same mix, by simply adding more water to lighten the tone.

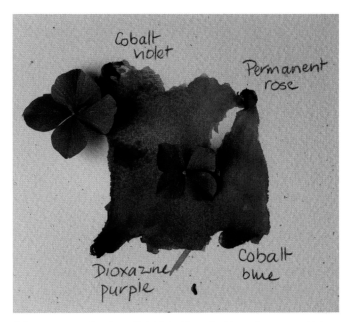

This image was taken in artificial light. Note the blue colour cast, which may have been exaggerated by the digital camera's software.

try to depict the actual colour of the plant they are recording. This is an extremely difficult thing to achieve, because of the vagaries of pigments and lighting that the artist, the plant and the painting are subject to. An exact match is almost impossible to achieve (although the best illustrators can get *very* close).

Local colour refers to the 'actual' colour of something. It is very difficult to decide exactly what the local colour is because colour is changed by the light it is viewed in. It is not simply a case of whether the colour is in light or shadow, but also the quality of the light falling on it. You will be aware of the effect of different light bulbs on your work, and on any flowers you are painting. The pigment in

the flowers might react quite differently to the pigment in the paint, so that what was a good match in daylight can lose its accuracy when viewed in electric light. Botanical illustrators work in daylight to lessen the effects of this as far as possible. Botanical artists who are also very concerned with accuracy should do the same.

However, for painters in other genres, far from being frustrating, this can be very liberating. Since the local colour varies according to how it is lit, it is acceptable to

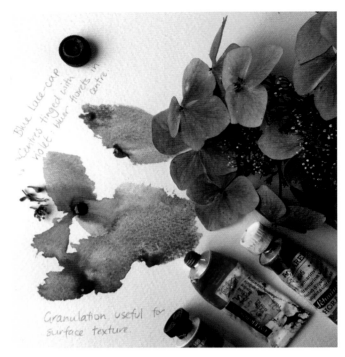

Colour notes made from direct observation of the flower, here made directly onto the type of paper to be used for the painting. Comments are made in pencil about the suitability of the attributes of the paints too, here noting that the granulation of the pigments will be useful in portraying the surface texture of the petal.

Gathering information about texture can be achieved using a range of pencil marks, and also written notes. This page from my sketchbook shows that while I was making the sketches, I was also considering how I would portray the texture using brushes and paint.

choose an arbitrary colour. Observe what is there, note why it has interested or excited you, and choose your pigments and colour mixes accordingly.

Colour notes

Whether you choose to stay close to the local colour or to use an arbitrary colour in your paintings, it is a good idea to make colour notes. Colour theory, being based on the visible spectrum of light, does not translate well into terms of pigment, because the spectrum relies on the purity of the primary colours. There is no substitute for making your own colour notes from your own observation of the world.

Colour notes can be made while gathering information in preparation for painting, or simply to make a record of an interesting colour combination you have come across. You can make colour swatches, holding them up to a specimen to assess the colour match, or try out some arbitrary colour mixes while you still have the specimens or scene in front of you. Do this by painting swatches onto the same type of paper as you intend to use for the painting. Watercolour papers vary in colour, and since watercolour is a transparent medium, the colour of the paper will alter the perceived colour of the paint.

If you are very familiar with your studio palette, you may know which colours you want to use in the painting. Make a written note of them next to your sketches in your own sketchbook.

Use of cameras to record colour

Cameras are not really suitable for making accurate colour notes. Different light settings for the camera will give different results. Digital cameras can be adjusted to respond to a number of different light scenarios, and each will give a different result. Added to that, there is the fact that there are four points at which the colour might be changed by the photographic process: the camera settings, the computer settings, the printer settings and finally the type of paper it is printed on. To record colour successfully, if it is the colour that is inspiring you, you *must* make colour notes, whether written or painted colour swatches.

However, if verisimilitude is not essential, the colours that appear in photographs can be inspirational in their own right. Some wonderful effects can be achieved by deliberately altering the settings, which can inspire extraordinary and creative choices for colour combinations in the artwork.

Observation of texture

The texture of a plant, flower or bouquet is often a good starting point for a painting. Think of frothy gypsophila, silky tulips, fluffy dandelion clocks and spiky chrysanthemums, where the texture of the flower expresses their character. To paint flowers like these without capturing these attributes would be to miss some great opportunities for expressive paintings.

In this abstract painting of a lace cap hydrangea, notice how the variety of complex and simple textures are placed against each other.

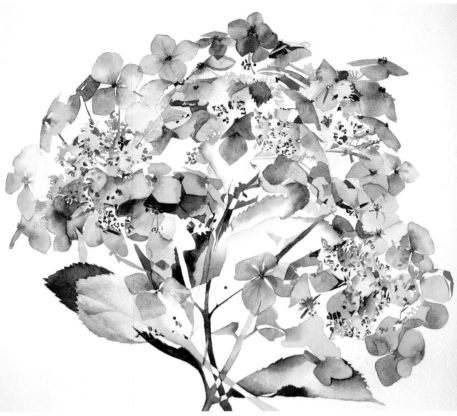

Noticing the presence of texture is not at all difficult, but without a thorough knowledge of your materials, recording it can be. Flat shiny surfaces can be drawn (or photographed) quite easily, but something like the complexity of a bunch of gypsophila can be daunting.

The secret is in knowing which marks to make as you draw that carry enough of the essence of the flowers to remind you later what was important to you. Chapter 4 looks at how to build a dictionary of marks in various media; having this depth of knowledge about your materials is incredibly freeing and enabling. As you sketch, you are then able to choose pencil marks that are appropriate for the texture you want to record, using marks that imply the texture rather than recording every tiny detail of it. Having your own dictionary of watercolour marks means you will be able to think ahead to the painting, planning how you will apply the paint to imply the textures. It can be very useful to make written notes of your thoughts about which paint techniques might work. Even better is to develop your own shorthand of sketching marks that translate into brush marks.

As you observe, take a few moments to consider if there is anything helping the texture to attract attention, emerge from the background or to be highlighted in some way. Florists and gardeners are good at arranging plants to bring out features like texture, which may have helped to draw our attention to it. As with floristry and gardening, the arrangement of plants in your painting is important; some of the more complex textures are more easily painted against simple ones. Making a note of this at this stage can inform your decisions when designing the painting.

EXERCISE

Questions for observational experiment – Pink Roses

Having described and drawn the photograph of *Pink Roses* as suggested earlier in this chapter, compare your two methods of observation. It may help your assessment to consider these questions:

- How does your perception of the photograph change between verbal description and drawing?
- When did you notice the lower rose bud?
- When did you notice the lost edges at the top of the paler

rose in the foreground?
- Did you bother to draw the roses in the background, or were they a pink blur?
- When did you notice the lack of a clear focal point in the image?
- Which method of observation helped you to observe more closely?
- Which felt easier?
- Using which method did you notice the finer details more quickly?

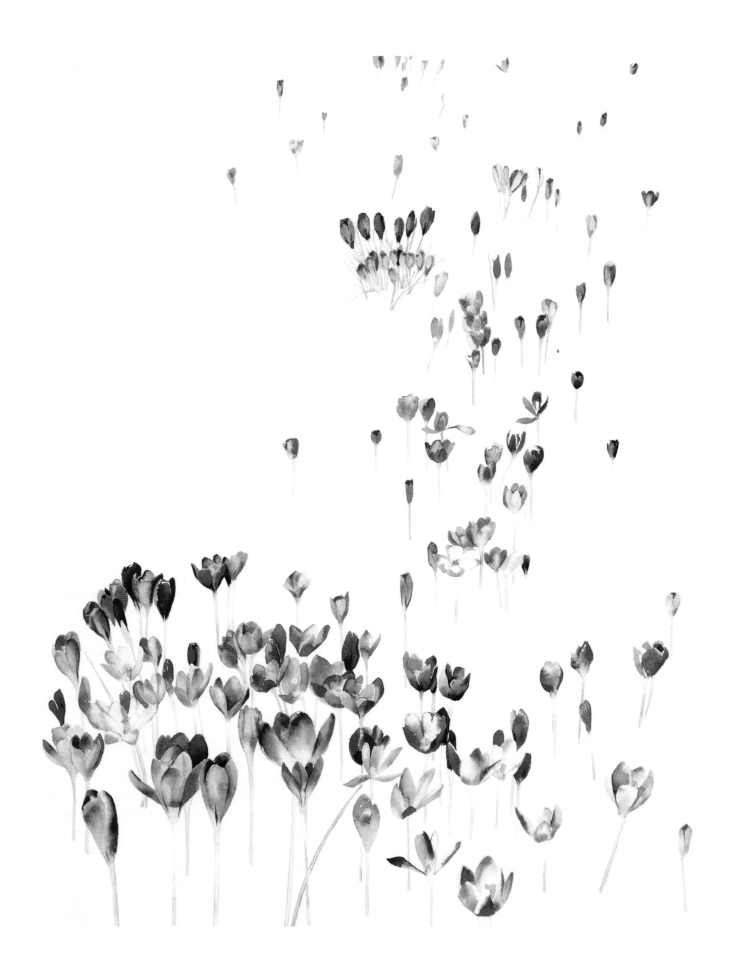

Chapter 6

Designing a painting

The first stage in making a painting is the inspiration, a moment of excitement or interest that causes an artist to want to capture the subject in a drawing or painting. The inspiration is rarely accompanied by a mental image of the finished work, it needs to be translated into an idea for a painting through thoughtful deliberation. As the idea develops you will have addressed important questions.

What inspired you about the subject? What do you want the painting to be about? Do you want to be descriptive, or do you have a story to tell? Do you want to share your emotional response to a moment of inspiration, or have you seen something that reminds you of painterly marks and you have a need to celebrate the joy of painting?

These questions answered, the process of developing an idea moves on to considering *how* you will apply the paint (or other medium) to the paper. The ethereal thoughts and feelings become more tangible, and begin to take shape. The practical application of the ideas is the stage at which the painting needs to be designed. Designing an image well means the difference between a poor, a good or an amazing piece of work.

The initial inspiration for *Floating Crocuses* was seeing them meandering down a gently sloping lawn, and enjoying the colours, in particular the silvery stems. When I designed the image, I found myself considering Elizabeth Blackadder's work, where flowers are seemingly randomly placed across a page. I also had in mind Magritte's *Golconda*; are the businessmen floating upwards, or downwards? My design was influenced by both.

I choose to use the word 'design' rather than composition quite deliberately. In common usage, 'composition' usually means the way objects are placed within the image. Using the word 'design' causes a shift in attitude. It implies a greater depth and broader scope than just the layout of objects on the paper. Design also takes into account decisions about tone, colour, and texture, all of which are important in portraying the intent of the artist and leading the eye around the image. Design includes decisions on style and genre. Design is so much more than 'composition' in its common sense, and includes the finer details of how the painting is planned and carried out.

Designing a painting involves making deliberate, practical decisions about how to convey your idea to your viewer. It is during the process of designing an image that you will appreciate the significance of the sound foundation built during time spent playing and experimenting with your materials, as the discoveries you made are put into practice.

PAINTING STYLE

Finding your style

This book is about helping you to develop your own personal style. In experimenting with your materials, you will discover which marks you enjoy making, your favourite pigments and colour combinations, and which papers you enjoy working on. As you increase your visual awareness through observation, you will raise your awareness of what inspires you. As you develop your ideas, you will learn to understand more about your intentions behind each painting you make.

Daisies painted in a descriptive style, on a white background. This is a painting *of* the daisies.

This daisy is painted in a much looser style. The painterly marks and the brighter colours create energy within the image.

There is something slightly whimsical about this daisy painting; the simple background evokes a gentle mood.

All of this feeds into the way you design an image. The background work you put in and your past experience culminates in a set of very personal techniques that enable you to produce creative, original images in your own 'style'. For each painting, continue to ask pertinent questions, so that you know what you are trying to convey through the painting.

What do you like looking at? Remember to 'start at the end', and aim to paint the picture you want to see hanging on the wall.

What is important to you to include in the painting? Is it something physical, like a flower, a vase, or elements of a garden scene? Or is it more important to you to share your feelings with the viewer, or to imply a narrative?

How do you like to paint? Do you enjoy allowing the watercolour to contribute to the painting, just adding water and letting the paint work for you? Or do you prefer to have control, using your brushes to guide the paint to exactly the right spot?

These few questions are just a starting point. The idea is to define what your intention is for the painting, so that you have a firm basis on which to make design decisions.

If you want to develop your own style, improve the standard of your painting, or become more creative; this type of questioning is important. The answers to these questions cannot be taught, because they are very personal. Without doubt, you will know which paintings you enjoyed making, and are pleased with. You will also have failures, but learn from these too. Constantly question your intent, the appropriateness of your use of the medium in your work, and analyze the results. As you become practised at this, you will find that you are gradually more able to create images that are creative and original.

A small, neat, delicate flower, it seems to require painting in a tight, precise manner to capture the essence of its nature.

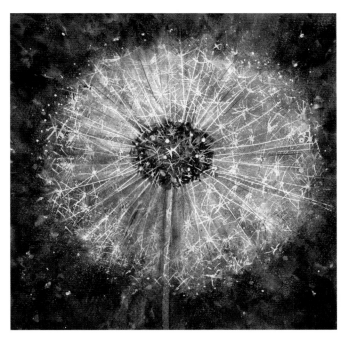

Dandelion clocks are so fluffy it is almost impossible to paint them in a tight fashion, unless it is for botanical illustration as in a coloured diagram. Painted tightly, they lose the sense of movement, and along with it the essence of their fluffy, floaty character.

Style and subject matter

Whichever style of flower painting you are most inclined toward, it is a good design decision to allow the flowers to suggest how they are to be painted. As time goes on, you will probably find yourself inspired by the subjects you enjoy painting most. One informs the other, and your personal style develops further.

THE PRINCIPLES OF DESIGN

Whichever style or genre of painting you are most comfortable with, to make an interesting painting there are certain fundamental principles that should be considered. These principles are about perception, the way the viewer reads the image. To design an interesting painting, an artist needs to be aware of these principles, and to understand how they might influence a viewer's response.

As you adopt this method of working, take care not to be overly influenced by people around you. As I mentioned in the Introduction, I find it sad to see an artist's enthusiasm dampened by their perception of what is expected of them. Every genre of flower painting is as valuable as the others. If you feel you enjoy painting 'tightly' because you like to have control, then that is what you should do. Do not allow yourself to be persuaded that you should paint loosely. The converse is also true; a highly detailed, figurative depiction of a flower focussing on verisimilitude is not 'right', if what you want to do is use expressive marks to articulate how joyful seeing that flower makes you feel. If you allow yourself time to play and explore the media you use, you will develop the confidence to paint in your own style.

1. Dominance

This concerns identifying the focal point of the painting, or, if there is no obvious focal point, what needs to be emphasized.

2. Movement

This refers to how you want the viewer's eye to move around the image. How will you direct the eye along the paths you want it to go? What is the rhythm of movement and resting along these paths? What are the transitions from one part of the painting to another?

3. Variety

There needs to be variety in tone, colour and texture across the painting.

4. Unity

An image needs to have a sense of the whole, achieved by considering the harmony and balance within it.

The aim is to create an image in which the dominant feature is obvious, in which the eye is drawn into the picture and moves around, enjoying the journey and resting on parts of the image the artist wishes to draw attention to. During the journey, the viewer experiences variety (essential for holding attention) and unity, so that the painting is perceived as a whole.

In practice, these cerebral principles take the form of the physical elements of layout, tone, colour and texture. When designing an image, each of these four elements should be considered consciously. In understanding the principles of design, the artist is aware that there is a purpose to making careful decisions about how these elements are used within a painting.

The design principles and the physical elements are not separate, but work together. An harmonious relationship between them will result in a well designed painting. How the elements of layout, tone, colour and texture are used will have an effect on what appears to be the focal point of an image, how the eye moves across it, the variety within it and the viewer's ability to perceive the image as a whole. The principles guide how these elements are used, giving reasons for why the elements are used as they are. When the principles and elements are considered simultaneously, the prospect of the design being a good one increases enormously.

THE ELEMENTS OF DESIGN

Studying the elements of design

An awareness of ways in which layout, tone, colour and texture can be useful in the design process is helpful. There are guidelines, but no rules.

While the basic design principles are fundamental, the use of layout, tone, colour and texture will be individual to every artist. The way the drawings, lines, colours and marks are made and laid out in a painting will define the artist's style, and the decisions made are very personal. The resultant images will be very different, covering every type and style of work across the entire spectrum of flower painting.

Studying the way other artists design their paintings will be very informative. It might be difficult when standing in a gallery in awe of a painting to remember to take a moment to analyze it in terms of design principles, but it will be worth the effort. This can be especially important if your own background has led you to be enslaved to 'compositional rules'. Analysis of the painting you are in awe of may show you that although design principles are at work, the so-called 'rules' have been ignored. And yet the painting is wonderful. Understanding this is one way of loosening up, freeing yourself from rules and regulations to explore new ways of designing your own images.

Using the elements of design

When designing a painting, I have found it useful to work through each of the elements consciously, and in a particular order. I begin with layout, because it is the most obvious (and traditional) way of establishing a focal point. The other elements work in support of this. Tone comes next; a well designed image will *always* work in greyscale. This is true even for the most subtle of abstracts. I then consider colour; sometimes it is difficult to leave considering it until this stage, because it is often the inspiration for a floral painting. Capturing the beautiful colour of a flower is one of the most joyful parts of being a flower painter. However, technically it doesn't matter what the colours are if the tones are wrong, and placed in a purely random fashion they would describe little, so a little discipline is required to wait before making decisions about it. Finally I considered texture, and how it will provide variety and unity within the painting.

To give an insight into how this works in practice, the demonstration projects in the later chapters include a section describing how each of these practical elements were considered as I designed the painting, keeping the design principles in mind throughout.

Layout

Layout is essentially about using lines and shapes to organize the image. In most cases, this is with a view to establishing an obvious focal point. The lines and shapes are positioned to lead the viewer's eye on a journey through the image to a particular point.

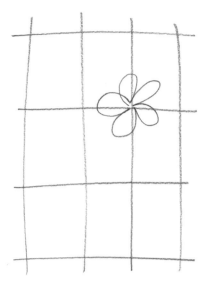

A conventional compositional device is to divide the image into thirds horizontally and vertically, placing the focal point on, or near, where the lines intersect.

Sunlit Cosmos. Look at how the lines in this painting all lead the eye to the central flower. The petals of the white flowers either side point towards it; even the one on the left has an almost arrow shaped negative space, pointing inward. The white petal bottom left acts as a 'stopper' by cutting across the path of a line leading out of the picture. The lines of the table and the shadow on it all lead directly back to the centre of the image.

An alternative compositional device is to divide the image into quarters, making one quarter busy, one quiet, and the other two transitional.

The overall shape of the bouquet and vase reflects the shape of the flower, and sits almost centrally in the image, again directing the viewer back to that central flower.

There is a well-known and proven method of guiding the placement of shapes using grids, which can be helpful when first learning to design. Using the grid systems is not an exact science, just a guide. Use them as a starting point, but allow intuition to overrule them; if it feels right, it probably is. The point is you are making a conscious decision, not leaving the layout to chance, so it will be pleasing to your eye.

In some paintings there is no obvious end to the visual journey, in which case the lines and shapes are positioned to keep the eye moving from one resting point to the next.

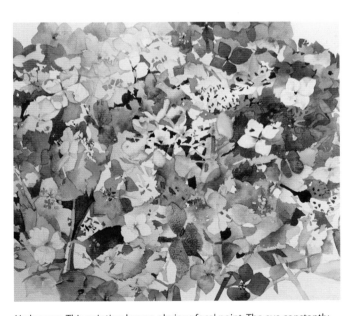

Hydrangea. This painting has no obvious focal point. The eye constantly moves around the image, resting on various elements along the way. Try focussing on each colour in turn to experience a different path around the image. Notice how the subtle arrangement of colour and shape keeps the eye from straying out of the image.

Pennywort 1.

Pennywort 2.

Tone

Tone can be used very effectively to lead the eye around a painting. Look again at the painting of the cosmos. Lines within this painting lead the eye to the magenta flower, but so does the dark triangular shape of the shadow across the table.

Consider also the arrangement of tones behind the central magenta flower. The very dark background causes the very white flowers to glow with light, which in turn draw attention to the much darker magenta flower at the centre.

Consider also the two sketches of pennywort. The second is a tonal sketch made from a tracing of the first, so the layout is identical. As you compare the two, be aware of how you notice different parts of the sketch; the eye moves to different positions within the drawing. Since the sketches are otherwise identical, this is due entirely to the placing of tone within the image.

Colour

Colour is a common source of inspiration for flower painters. Response to colour is very personal. I have one rule, which is an absolute rule that I do not break. (Everything else is a guideline, useful tools but not to be obeyed). If you do not like the colours you are using, it is highly unlikely that you will like the finished painting, no matter how interesting the subject nor how well executed it is. Only use colours you like.

Do not allow other people to dictate your choice of colour. In the demonstration projects in later chapters in this book, I have given the list of colours used in each. These were included so that anyone wishing to follow the step-by-step paintings knew which colours I had used, and had access to a list of colours that would work for each painting. However, they are included only as a guide. If you do not like them (or do not have them), choose your own substitutes. You will be much happier with your results.

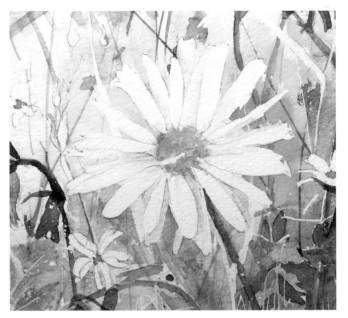

Cool Blue Daisy (detail from *Spring Hedgerow,* Chapter 1).

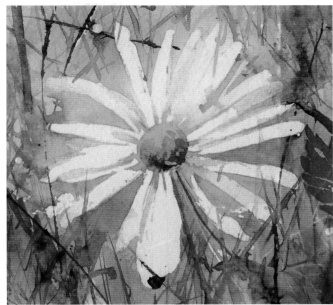

Warm Autumnal Daisy (detail from *Second Flush,* Chapter 1).

Colour and emotion

There has been a great deal of research into human emotional response to colour. If the artist's intention is to portray an emotion, then there may be some value in referring to this research. There is no doubt that many people find bluebell woods stunningly beautiful, but while they might enjoy it in nature, the psychology of colour theory tells us that living with a blue painting on their living room wall might leave them feeling cold. On the other hand, if blue is their favourite colour, it might make them smile each time they look at the painting.

It might be a better idea to express your own emotions through your own responses to colour, rather than trying to second-guess how your viewer will respond. The painting will have greater integrity, and is therefore more likely to elicit the required response in your viewer.

Choosing a 'per-painting' palette

In designing each image, the artist needs to decide on the colours to be used. One very easy way to unify a painting is to work with a limited palette. This means choosing as few colours as possible to work with for each painting. I call this my 'per-painting palette', because a new palette has to be chosen for every painting. This should be done before painting begins, as part of the design process.

The starting point for each painting will be the dominant feature, choosing as few paints as possible. You then need to choose paints for other areas of the painting, adding just one paint at a time to the colours already chosen. Each time you add a paint, make sure that you are not able to mix an acceptably similar colour from those already chosen. For example, do not add an orange if you have already chosen a yellow and a pink that make an acceptable similar colour. Ensure that you are able to mix a good range of tones from the palette you have chosen, in particular the rich darks.

In theory, a 'per-painting' palette could consist of just three paints, but for flower painters this is almost impossible to achieve, especially where a close similarity to the colour of the flowers themselves is required. It is more achievable with five colours, but for a flower painter a per-painting palette of seven or eight colours is more likely. By the time number nine is added, it is often possible to mix an acceptable alternative to the new colour for those already chosen.

The colour wheel

Some knowledge of the colour wheel helps in making design choices for colour. The colour wheel can act as a guide for colour mixing. In my opinion its use for this purpose is limited, and can even cause confusion. Theory and practice are too often at variance, due to the chemical nature of pigments and the physical nature of the media in which they are suspended.

For example, red and blue should make purple, but in practice the majority of reds mixed with the majority of blues give a range of purplish-browns. By far the best way to learn how your paints mix is to experiment for yourself.

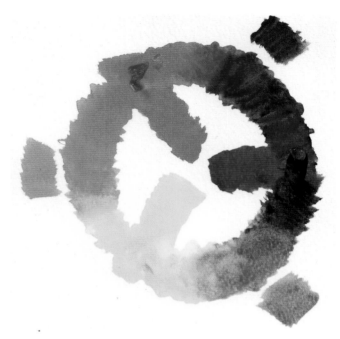

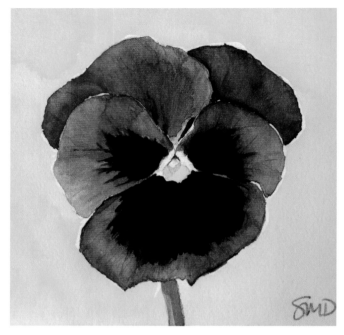

Purple pansy with complementary background.

Making your own colour wheels will help you to get to know how your pigments interact with each other. Take a red, a yellow and a blue and then create the secondary colours by making gradated mixes between them, as shown. The middle range of each mix will give you the secondary colours possible with your chosen mixes, and also visualization of the harmonizing and complementary colours achievable within the mix.

The colour wheel is more useful when it comes to making design decisions. Colours that are close to each other on the wheel are known as harmonizing. Harmonizing colours are restful on the eye. If the intention is to produce a tranquil painting then harmonizing colours should be chosen.

Colours that are opposite on the colour wheel are known as complementary. Complementary colours can create vibrancy and energy in an image, and can even produce sensations of movement.

Placing colour in a design

As with tone, the placement of colour within the design can be used to lead the eye around the painting. Look again at *Hydrangea* earlier in this chapter. Try focussing on different colours, and notice how your eye is led around the image to different resting points. The path you follow when selecting white flowers will be subtly different from the path your eye follows when selecting the purple pigments. In the same way, follow the greens and blues, and notice how the path changes.

Colour can be used to balance an image, as well as to lead the eye. In flower paintings, this can be easily

achieved by balancing the arrangement of flowers. However, it can be more subtle than that. Look again at *Sunlit Cosmos* earlier in this chapter. If the only magenta was in the flowers in the centre, they would appear out of context, as though they didn't really belong in the painting. On closer examination, you may notice tiny dots of magentas in the dark area above the flowers, hints of magenta in the reflection in the glass, and some obvious magentas in the shadow on the table. As well as providing unity within the painting, the hints of magenta are also a visual link with the central flower, and play a part in leading the viewer right back to the focal point.

Colour is used in a similar way in *Spring Hedge*, in Chapter 8, where a seemingly random patch of pink was added in the bottom right corner. This served two purposes. The first was to create a visual link between that corner and the Herb-Robert; without a viewer, focussing on pink would simply jump diagonally from one Herb-Robert flower to the other. This patch draws their attention to the corner for more visual treats amongst the foliage. Being a red, it is also a complementary colour to the greens of the foliage, and adds a little energy to painting, depicting a spring hedgerow bursting with life.

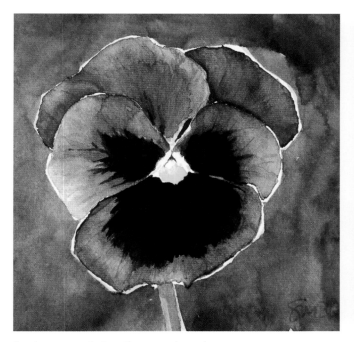

Purple pansy against another secondary colour.

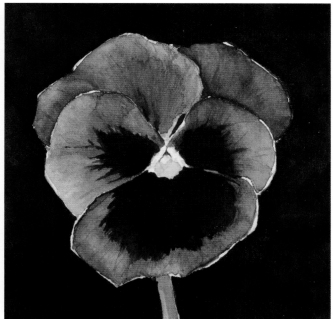

Purple pansy against a harmonizing background.

TEXTURE

Texture is an excellent way to create variety within a painting. Inspiration for how it is to be placed within the design can come for the subject itself, or be a device used within the design purely for the purpose of providing variety.

The subject matter will imply which marks are appropriate. While watercolourists can have great fun playing and experimenting with the paint, a successful image uses only those marks which are pertinent to the artist's intent behind creating the image.

The balance of textures within a painting can create movement, and lead the eye to the focal point.

In the painting of Japanese anemones, the lines of the stems clearly lead the eye into the picture bottom left, then upwards towards the flowers. The textural marks cause a visual movement in the same direction. Busier and heavier at the bottom left, the hard edges decrease as they move up the painting, eventually fading out to the lost edges of wet-in-wet colour. Additionally, the splatter of masking fluid at the start of the painting implies movement within the mass of foliage.

In designing a painting of this Eryngium, the artist must decide whether to capitalize on the busy-ness and energy of the background created by the rest of the plant, or whether to bring it into clearer focus by placing it against a calmer, smoother background. The former might provide an opportunity for some lovely, loose mark-making, and a textural unity throughout the image. The latter, however, might actually provide more variety.

Salt dropped into wet paint creates some beautiful textures, but would be wholly inappropriate in depicting this very smooth tulip. Salt might, however, be appropriate for the Forget-Me-Nots in the background.

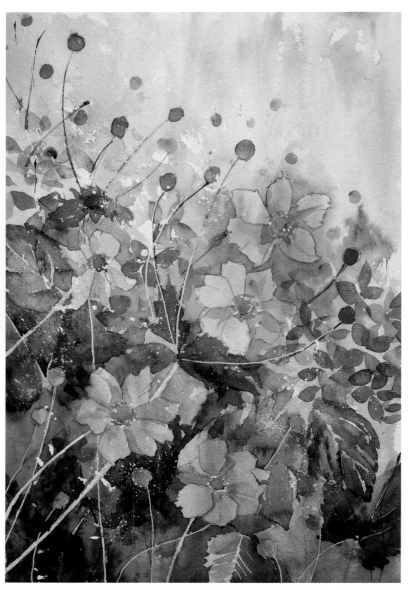

The textural marks in this painting of Japanese anemones play an important part in leading the eye to the focal point.

OTHER CONSIDERATIONS

The use of thumbnail sketches

Thumbnail sketches are a very useful device for quickly visualizing emerging ideas. The trick is to *keep them very simple*. Reduce flowers to geometric shapes, leaves and stems to simple, single lines. These are part of the thinking process, not drawings. They can be scribbled so quickly that as the idea emerges, it is quicker to scribble on top of the current drawing or to make another thumbnail than it is to start rubbing out.

Although called 'thumbnails', they can be any size you are comfortable with. It is more important for the hand

to move fluidly to aid your thoughts than to squash your ideas into a tiny space before they have even developed. I often do mine on scraps of paper rather than in a sketchbook because they are messy, and I find the scribbles offensive between drawings I have spent time on. Once the design moves on to the next stage, they can be thrown away.

Note that in the example of thumbnail sketches shown here, geometric shapes replace flowers, lines replace stems. Lines also suffice for the vase and table. Once the shape of the drawing was established, I added a few lines to experiment with the shape of the image.

A sheet of quick
thumbnail sketches.

Shape of the image

Flower paintings can be any shape, in any orientation. Let the subject matter dictate the shape for you.

Once you have considered why you are making the painting and decided what must be included, get your sketchbook and start making some thumbnail sketches. Do not worry at this stage about placing the arrangement within a rectangle. Rather than force a design into a conventional grid, it sometimes works better to design the overall shape, and to then place the boundaries of the image around it, all the while keeping the balance of the image (including negative spaces) and conventional guidelines in mind.

Once you have a pleasing arrangement, you can experiment with shape by drawing rectangles and squares around it. It will probably not sit quite right within the shape, so make a few more thumbnail sketches until you are satisfied with the result.

Scale

Botanical illustrators are bound by depicting the plants life size, even using callipers to measure accurately. Other flower painters have no such restrictions. Ask again why you are making the painting, and let your answer guide you in deciding on scale.

Does the character of the flower suggest a large scale, or would a tiny painting draw the viewer in to examine detail? Which marks do you want to use? The size of the brushes you need might dictate the scale. Even your mood may suggest the correct scale to work to.

Work at whatever size feels comfortable.

THE IMAGE AS A WHOLE

As a tutor, I am often asked whether I paint the flower first and then the background, or the other way around. I cannot conceive of them as separate entities. Do not think of the flower and the background as being separate, they are not. Always design the image as a whole, and plan the painting of it as a whole, working over the whole image as you go.

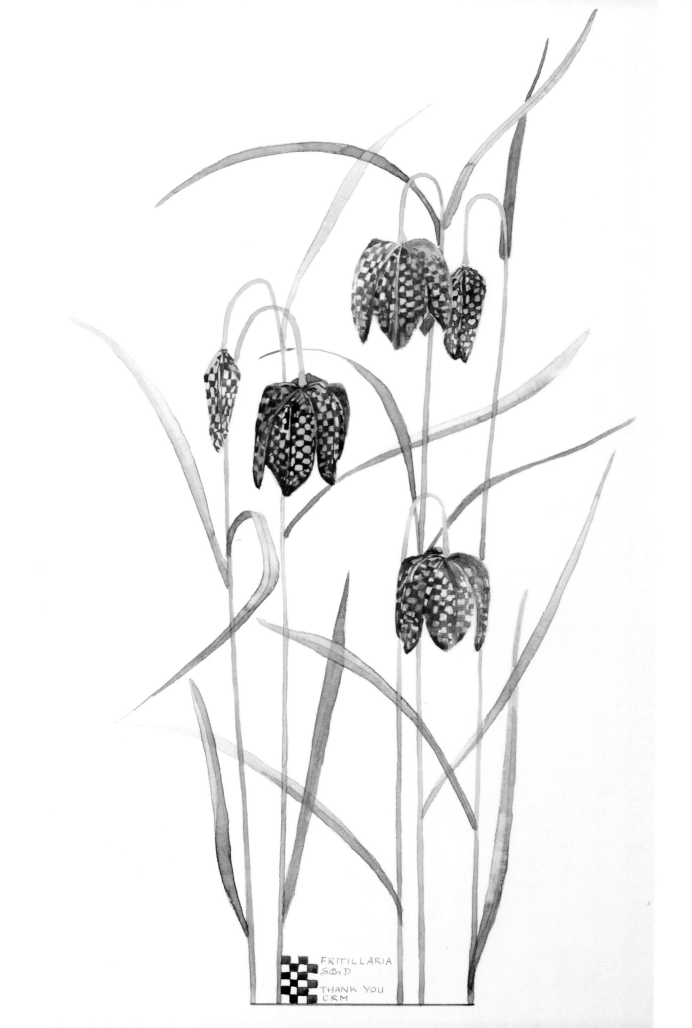

FRITILLARIA
SnD

THANK YOU
CRM

Botanical art: paintings of the flower

B otanical art has its roots in botanical illustration, and at one end of this category the influence of botanical illustration is very evident. Some botanical artists have an inherent interest in botany; for others the enjoyment of carefully portraying the flowers motivates them to learn more about plant structure and life. The paintings in this category are illustrative, recording morphological characteristics of the flower. However, the strict rules of botanical illustration do not apply to botanical art. Artists are free to choose a specimen which may be imperfect; leaves with holes in, or flowers with bent petals can add interest to the image.

There is scope for the artist's personality to show through; the artist is free to paint interpretations of the flowers, depicting what is important to them, exaggerating size of the plant, or emphasizing colour or shape. Some art in this category could be seen as botanical portraits, not just describing the flower but also capturing their characters and personalities. In this sense botanical art can be expressive.

Stylistically, botanical art is detailed and figurative. Often the plants are presented on white backgrounds, but as the genre moves towards floral art they may begin to resemble a simple still life. The description of the flower takes precedence over the medium, although that does not mean that the medium is merely a tool. There is room to explore the medium too, but in a way that does not detract the viewer from the flower itself. Botanical artists can be very creative, presenting the plants in unique or

Thank You, CRM!

Attention! These tulips, standing in a row, reminded me of the guards at Buckingham Palace wearing their bearskins. Although painted quite figuratively, the colours in the stems have been altered to emphasize the colour of the flowers.

interesting ways, perhaps aiding the viewer to notice something they might have otherwise missed.

Many of my own paintings fall into this category, because I enjoy its cleanness and clarity. The act of painting a piece of botanical art is calm. It is not just the art's personality that comes into play when choosing how to paint a particular picture, but also their mood. Although the plant may be complicated, the paintings are not. There is something fresh about white paper, and the negative spaces carefully created in good design can be soothing and restful, while guiding the eye straight back to the star of the show, the flowers.

Thank you, CRM!

The Inspiration. Tip: If the flowers you want to photograph are amongst a great deal of foliage, obscuring a 'clean' reference photograph, it can help to place a sheet of card behind them. Chose a colour against which they will stand out.

The inspiration

The snake's head fritillary is a plant I find fascinating. The checkerboard pattern on the flower is entrancing, inviting close inspection. The flower itself is undoubtedly the outstanding feature, but the delicate stems and elegant leaves are just as worthy of attention. They tend to grow in small groups, so that the leaves of one flower overlap the stems of another, almost forming a ladder for the eye to climb. The negative shapes are interesting too; I am reminded of cathedral windows, which are also delicate and elegant, and also support what appears to be an excessive amount of weight for their size. Fritillary flowers always seem oversized for the apparently fragile stems.

Developing the idea

In painting this plant, I want to draw the viewer's attention to the details of the flower, and the delicacy of the stems and the shapes of the negative spaces. It calls for a descriptive painting of the plant, where nothing interferes with these features; the device of placing the plant on white paper and arranging it to draw attention to the negative spaces should work well.

There is a well-known and inspirational painting of fritillaries by Charles Rennie Mackintosh; making a painting of fritillaries is an excellent opportunity to study his work, and to learn from his genius. I am very inspired by Mackintosh's treatment of this flower. He picks up on the essence of its character, drawing attention to the salient features of the plant form. At the same time the image draws the eye in and around, using not just the shapes but the way he uses the pencil and paint. This he does delicately and confidently; his use of watercolour is clean and crisp, and his confident pencil lines imply the strength in those all too fragile-looking stems. His painting entices me to look harder at the flowers in front of me, which he achieves through attention to detail.

Learning from and emulating another artist means taking time to decipher what they have achieved, which practical methods and techniques they used, and, importantly, learning how to adapt your findings to suit your own hand, style and intent.

Emulating the painting by Charle Rennie Mackintosh, the stems and leaves are arranged to emphasize the way the natural growth habit has an architectural feel, but I have included a hint of the arches found in church, a favourite shape of mine that is well suited to this subject matter. The pencil lines are an integral part of Mackintosh's painting, but an adaptation more appropriate to my own style would be to replace them with deliberately painted, extremely fine, hard edges.

There is a strong tradition of learning by copying, and the step-by-step demonstration below is designed to help you to 'copy' my painting. However, in the context of this particular demonstration, it also provides an opportunity for you to consider which elements particularly suit how you would like to paint, and which you will need to adapt.

Designing the image
Layout

The flower heads are the focal point, and should be arranged to sit comfortably together on the page, paying attention to the negative space around them. A triangular arrangement, familiar to flower arrangers, works well. The negative spaces are very important in this arrangement, as is ensuring that the lines are arranged to encourage the eye to move around the image.

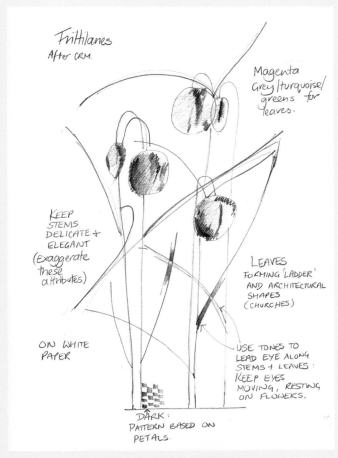

The planning sketch for *Thank You, CRM!* in my sketchbook.

Tone

The tones will be used in a way subtle way to emphasize the path the eye should follow. The flower heads will be darker because of the colours, but also to draw the eye to the focal point.

Colour

The colour will be based on the fritillaries. As I am not too concerned with matching the colour exactly, I will find paint mixes that approximate the colours of the flowers and leaves, but also take into consideration how well they work together in the image. The magentas of the flowers naturally complement the grey-greens of the leaves. The hint of spring green based on the colour of the bud will further complement the magentas, which was included because of its colour.

Texture

Fritillaries are very smooth, so paint will be applied with subtle gradations to suggest this feature of the plant. However, lines are also important in this image, so areas of colour along the leaves will be flooded so that the leaves and stems have very fine, hard edges. To suggest the elegant delicacy of the fritillaria, the paint will be applied delicately, in simple washes with as few layers of paint as possible.

Techniques to practise

Make deliberate hard edges, by painting an area with damp paint, then add more water or paint so that the pigment is washed to the edges of the wet area. It will dry in hard crisp lines, looking like a very finely drawn line.

Painting the image

This image calls for careful, precise application of paint. Remember to allow one petal (or leaf) to dry before painting the adjacent petal to avoid paint flowing from one to the other. The first layers of paint, especially on the leaves and stems, are very important, as there is very little adjustment made in subsequent layers.

Materials

Suggested palette:
- Lemon yellow
- Sap green
- Cobalt turquoise
- Permanent magenta
- Dioxazine purple

Paper:
- Fabriano 5 HP

Brushes:
- Round (sable), size 4
- Round, size 2

Other:
- B pencil
- Eraser
- Kitchen roll
- Tracing paper

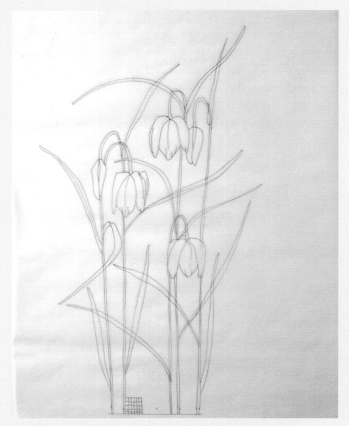

Step 1: Lightly draw up the design onto watercolour paper.

Step 2: Apply an under wash of pale yellow to the flowers.

Step 1: Draw up the design on the paper using a B pencil. Keep the pencil marks light. This is a delicate painting and you do not want any graphite to muddy the paint.

Make sure that you place the leaves properly according to the design, so that the eye flows around the painting, moving along the length of one leaf which leads to the tip of another.

It is a good idea to make a tracing of the image at this stage. A complicated or precise image can take a while to draw up correctly. Making a tracing means that if the painting goes wrong you can re-draw it more easily.

Step 2: Red pigments look beautifully vibrant when wet, but tend to dry much duller. One way to avoid this is to paint an incredibly pale layer of a bright yellow over the area first. This glaze will reflect back though the red, helping to keep the finished colour vibrant. Using a staining yellow will mean you can paint over it without it lifting and mixing with the colour laid on top.

Using lemon yellow, apply a *very* thin glaze to the flower heads. Within the yellow layer the tone can vary, being a tiny amount darker where you know there will be thicker red paints on top. It is essential that the amount you use will not visibly change the colour of the paints to be used over it.

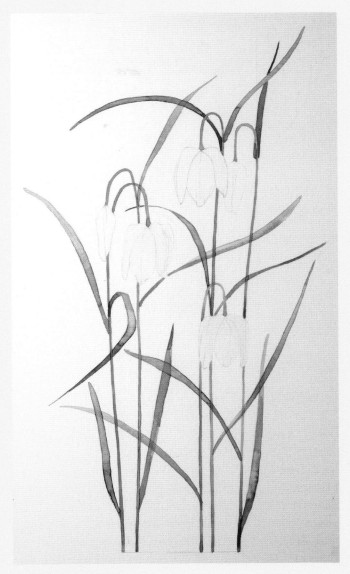

Step 3: Paint in the leaves.

Step 4: Paint in the stems.

Step 3: Paint in the leaves. Using a size 4 round, load the brush with a watery pale mix of Cobalt turquoise and Sap green. With one confident stroke, apply the paint to the leaf, varying the pressure so that the shape of the brush varies with the shape of the leaf. Do not rush, a confident mark can be made slowly. The aim is for unbroken edges to the leaves which is more difficult to achieve with lots of small marks.

While it is still wet, you can drop in a little more paint to vary the tone in places. If the painting is drying too quickly for the hard lines to develop, drop in a little water to help it along.

Work across the design to maintain a balanced feel. Vary the mix slightly from the turquoise end, then mix towards the greener end of the mix, balancing the colour across the design as you work.

Step 4: Working in a similar way, paint in the stems. Taking a cue from Mackintosh, do not worry too much about breaking a flowing hand movement to paint around leaves; close observation of his work shows layers of paint where leaves cross.

In colour theory, yellow and purple are complementary colours, as are red and green. In this painting, there are very yellow greens, and magentas (purple-red). Placing the magenta flowers against yellow green stems is a design decision based on theory. This will give the painting more energy and the magentas will seem more vibrant than if they are placed against the bluer greens.

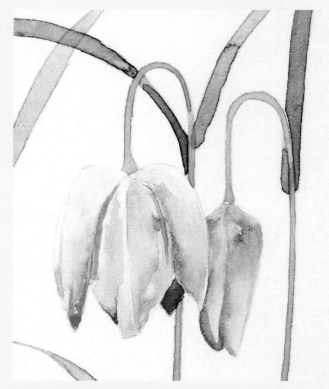

Step 5: Begin to build up tone in the flowers' heads.

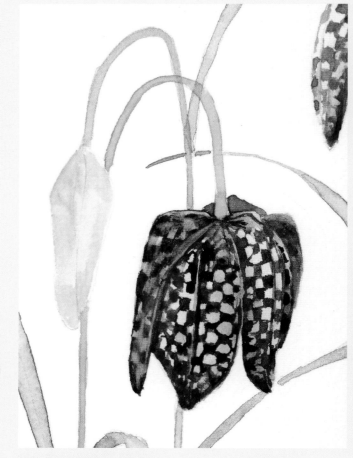

Step 6: Add details to the petals.

Step 5: Begin to build up form on the flower heads. Vary the tone across the flowers to give them shape, but keep the mixes pale, as these washes will form the paler 'squares' in the checkerboard pattern.

Make up a mix of Permanent magenta and Permanent rose, then take some of this mix and add a touch of Cobalt turquoise and Sap green to make slightly greyer colours.

Lightly wet the whole of the flower head. Drop in paint, varying the tone to build up form; working wet-in-wet allows you to gently push the paint around to where it is needed.

Vary your choice of colour too. It is tone that will give the flower form, not colour, but the greyer colours will be better in shadowy areas, and will recede slightly. Use the Magenta and Rose mix where the flower head comes forward.

Use a mix of yellow-green to build up form on the bud on the left of the image.

Step 6: Create some deep Magenta colours using Permanent magenta and Sap green. Add some Permanent rose to the Magenta to create some warmer colours.

Using these two mixes, paint in the pattern on the flowers. Match the tone to the shape of the flower.

How detailed you want to be depends on whether you prefer to depict the plant accurately, or whether you feel that it is not necessary as long as the requirements of the design are met, that is, the flower is easily recognized as a snake's head fritillary. Charles Rennie Mackintosh chose to emphasize the checkerboard pattern, exaggerating the squareness of patches of colour.

The choice is yours; neither way is right, neither wrong. In terms of understanding how your painting style will develop, this is an opportunity to discover whether you find this relaxing and satisfying, or whether it tries your patience.

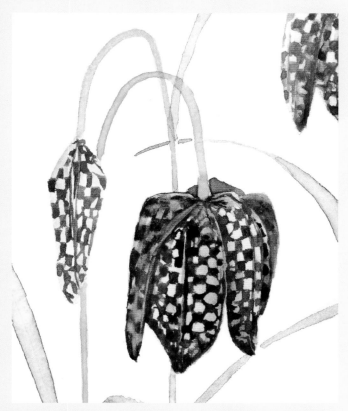

Step 7: Make subtle adjustments to soften the edges of the patterns.

Step 8: Add finishing touches to the leaves.

Step 7: When the patterns are dry, make any subtle adjustments needed to the flower head by drawing a damp brush across the patterns, moving a little colour and softening the edges.

Any final alterations of tone or colour can be made in the same way.

Step 8: Using the same green mixes as in Steps 3 and 4, and pale tones, finish painting the leaves. This should be done very carefully, so as not to disturb the hard edges made earlier.

On some of the leaves, create a mid rib, by applying paint to only one half along the length of the leaf, or by painting a fine line down the centre.

Stand back and assess the tones over the whole painting. Now that the flowers are painted, some adjustment may be needed to restore tonal balance across the image. Apply a second layer of paint using the method described in Step 3.

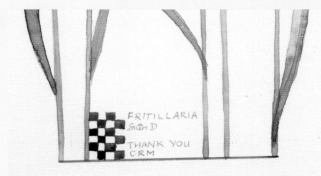

Step 9: Rule a line across the bottom of the stems and paint a checkerboard pattern.

Step 9: Load a mapping pen with green paint, and rule a line across the bottom of the stems, stopping at the outer stems.

As an homage to Charles Rennie Mackintosh, add a small checkerboard pattern against one of the stems. Using a pencil, add the words 'After Charles Rennie Mackintosh'.

The finished painting is shown at the beginning of the chapter.

PROJECT
Hydrangea

The inspiration

The inspiration for this painting was uncomplicated, a pure enjoyment of the colours of hydrangea flowers and the need to capture those colours in paint.

Developing the idea

A hydrangea bush in full flower is a mass of colour, but the variety within each flower is only fully appreciated when studying individual florets close-up. Great balls of reasonably homogenous colour reveal themselves to be made up of a myriad of colours, gently blending in to each other. The range within one flower can be quite stunning, especially in the autumn as the flowers begin to fade. At this level, the beautiful shapes of each petal can be appreciated too, and an overwhelmingly complicated flower head is naturally simplified.

Information gathering

The main purpose of this painting is to describe the colour of the flower, so information gathering should start with making colour swatches directly from the flower. In general, this is more accurate than working from photographs, which are always subject to the vagaries of camera and computer software.

The colour swatches here were made directly from the flower at the time it was picked, but the painting will be made from the macro photographs of the florets taken at the same time. Cameras, when used wisely, can be useful for providing reference material out of season, and in cases like this, can help to simplify a complicated subject. By focusing on the part of the flower to be painted, the floret is seen without the visual distraction of the rest of the flower.

Observation through sketching is always useful, in this case to clarify the shapes of the florets, the position of shadows and the range of tones within the latter. In the absence of the flower itself, sketching from the photograph will still be beneficial.

Designing the painting

Layout

When taking photographs for reference, the composition can be thought through during the photography session. Using the grid on the camera itself can help, as can changing the ratio of the image. A successful photograph can then be used to paint from directly without further adjustment. In this case, I have decided to work with the photograph as it is. Although ever so slightly out of balance, this implies something of the nature of hydrangea flowers, a glorious mess of colour. This image has a very obvious focal point, with both tone and colour supporting the layout.

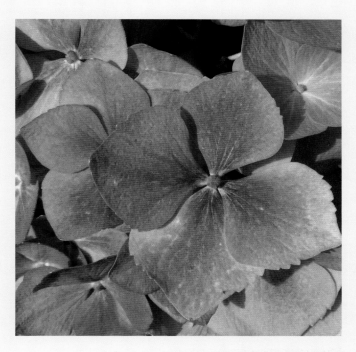

Lilac-Blue Hydrangea.
Photographic reference for
Blue Hydrangea.

Making colour swatches
directly from the flower.

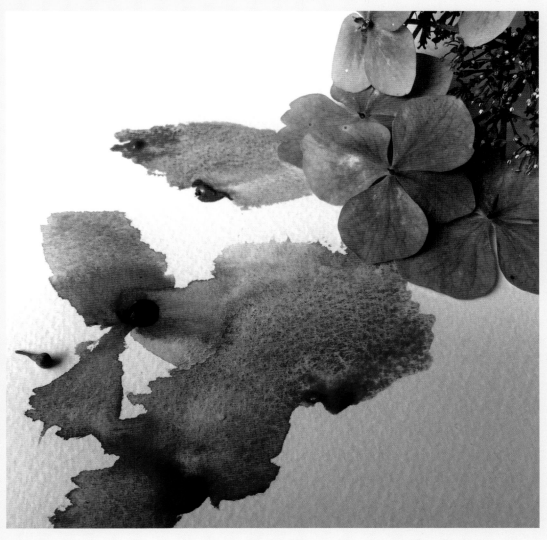

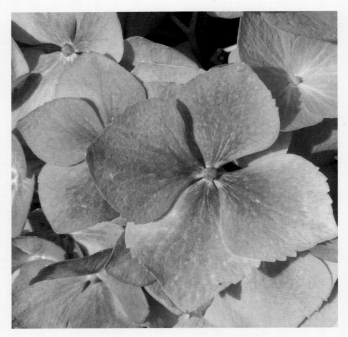

Converting the photograph to greyscale can help with gathering information about tone.

Tone

Another use of photographic reference is the shortcut to observing the tones within the image by converting the photograph to black and white.

Unless you are very experienced, do not be tempted to use this instead of doing a tonal sketch; you will learn much from making your own sketch and comparing it with the black and white version of the photograph.

Colour

Gathering information for this painting involved making decisions about which paints to use. Before beginning the painting, check the qualities of the paints which give the best match for granulation, opacity and staining, and make any necessary changes which you anticipate will be needed, according to how the paint will be laid down.

In this case, Cobalt violet was a closer colour match than Dioxazine purple, but the former granulates incredibly, to the extent where it is difficult to use as an under wash because

it moves. There are tiny pink spots on the floret, which are matched well with Permanent rose. A mix of Permanent rose and Dioxazine purple will be a good enough substitute for the Cobalt violet, and avoid the problems anticipated with it.

The variety of colour across even a single hydrangea floret is one of the joys of the plant, and the palette chosen ensures a similar range of hues.

Texture

To ensure the smooth gradation of colour and crisp edge to the petals, the paper will be a smooth, cold pressed paper. Hydrangea petals have a slightly bumpy surface, which can be adequately implied by using granulating paints. Cobalt violet has been replaced with Dioxazine purple, which does not granulate, but both Cobalt blue and Ultramarine do, and will provide enough texture without needing to employ a range of brush marks, even on a smooth paper.

Painting the Image

Materials
Suggested palette:
- Permanent rose
- Lemon yellow
- Dioxazine purple
- Cobalt blue
- French ultramarine, Daniel Smith

Paper:
- Canson Fontenay 300 gsm CP, stretched

Brushes:
- Round (sable), size 4
- Round, size 2
- Flat (one-stroke) ¾ inch

Other:
- 2B pencil
- Eraser
- Kitchen roll

Step 1: Lightly draw the design onto watercolour paper.

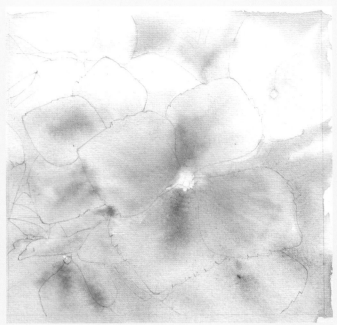

Step 2: Lay down the first washes.

Step 1: Draw the design on to the watercolour paper using a 2B pencil. Using lemon yellow, paint a pale wash around the flower centres. Work outwards from the centre, blending out to an open edge.

Step 2: This step needs to be worked quite quickly, so in the palette, make up mixes of Cobalt blue, Ultramarine and purple, creating a good range of colours. Have plenty of paint ready; mixing more as you work will cause delays, and may result in cauliflowers or unwanted hard edges.

Wet the image all over, and then, choosing colour according to the reference photograph, drop colour onto the image. While retaining some control about where the colour is placed, also allow the colour to bleed across from one petal to the next. The aim is for gradated patches of colour in roughly the right place, not to paint in the individual petals. This will give the painting an underlying unity. Allow to dry thoroughly.

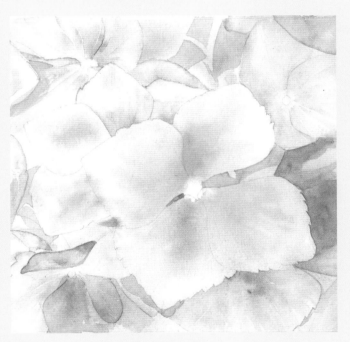

Step 3: Begin to establish some of the mid tones.

Step 3: Using the same mixes of paint, begin to add some mid tones in the areas that will be dark, creating a tonal map that begins to define the shapes. Tone is more important that the choice of colour at this stage; this step is about creating variation and a depth of colour through glazing, which gives a richer result than just one layer of very dark paint.

There are many occasions on which it is fine to go straight in with a very dark tone rather than build up too many layers.

More than one layer will always be richer but can result in a painting becoming overworked. In this case, there are subtle nuances of darks within the shadows that will give depth to the flower.

Step 4: Adjust yellows at the centre of the floret.

Step 5: Begin to add detail to the petals…

Step 5: …working wet-in-wet and manipulating the paint to where you want it.

Step 4: Check the yellow at the flower centres. Due to the deeper tones that have been added, they may now appear to be paler than expected. If necessary, add more yellow paint.

Whenever paint is added to one part of a painting, it affects our perception of colour and tone over the whole image. Checking the balance of tone and colour throughout the progress of a painting should become a habit.

Step 5: Using the photograph for reference, begin to build up detail and colour on the individual petals.

Work carefully on one petal at a time, and avoid working on adjacent petals while they are still wet. This stage is about defining the shapes of the petals with crisp edges, so paint bleeding from one petal to the next would be a disadvantage.

Where possible, work with the petals quite wet to encourage granulation.

It is a good idea to start at the outer edges of the images and work inwards, 'practising' on the petals on the periphery before attempting the central floret, which is the focal point of the image. This also gives an opportunity to balance tones around it, ensuring that the surrounding petals push it forwards.

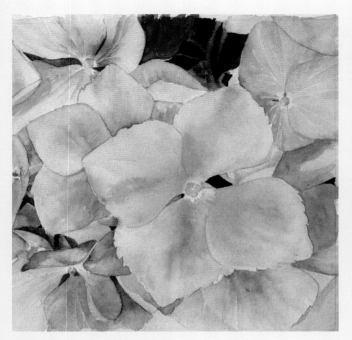

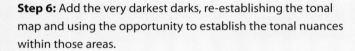

Step 6: Add the very darkest darks.

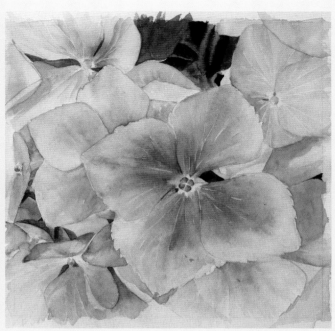

Step 7: Add detail to the central floret.

Step 6: Add the very darkest darks, re-establishing the tonal map and using the opportunity to establish the tonal nuances within those areas.

Step 7: Now work on the central floret. Add the second wash of paint, paying close attention not only to your colour choice (based on the photograph) but importantly to the tones across its petals. Making the centre darker than the edges will give it a sense of depth, leading the eye into its very centre.

Step 8: Add detail to the outer petals…

Step 8: …leaving fine lines unpainted for the veins…

Step 8 continued: …and soften with a damp brush if necessary.

Step 8: Add detail to the outer petals. Using a size 4 or a size 2 round brush, place the colour carefully, working from the outside edge of the petal to the inner edge (or the opposite) rather than across the petal, so that lines in the paint run in the correct direction.

Leave very narrow gaps in the paint to suggest the more obvious veins; if they appear to be too harsh, soften with a damp brush when they are dry.

Step 9: Add detail to the centre floret. Paint in the tiny spots of Permanent rose. Veins can be implied by painting with a very finely pointed brush, and also by lifting out some lines with the edge of a damp, flat brush.

Paint in the centres of the florets with a size two brush, varying the tone to give slightly rounded shapes.

Step 10: Finally paint in the strong shadows. Use mid and dark tones, choosing colours to match what is already there (blue colours on blue petals, mauve on mauve petals). For it to be effective, the tones have to be dark enough and applied confidently, to keep crisp edges and to avoid disturbing the underlying paint. Check the photograph regularly. After working on the image for a few hours, this will require some bravery, but the tonal map established earlier on should help.

Step 9: Add final detail to the central floret.

Step 10: *Hydrangea*. The image is completed by adding the strong shadows.

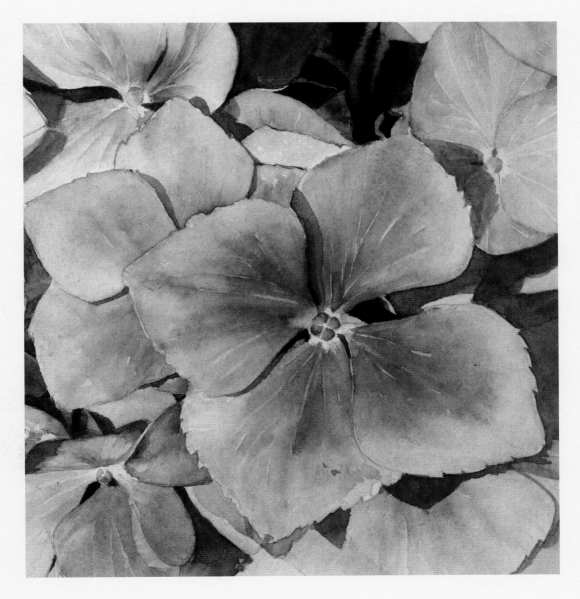

THE CHALLENGES OF WHITE AND YELLOW FLOWERS

White is a difficult colour to work with for a number of reasons. The first is due to perceptual constancy, a system our brain employs for making sense of the world. If we know something to be white, we will perceive it as being white, or at least very pale, even if it is in dark shade and a rich grey, purple or blue. As artists we need to record what is there, by-passing what we *think* is there, and learning to observe what is actually in front of us. This is not an easy task!

One way of learning to do this is to use a photograph of a white flower, and to isolate small dots of colour and tone by placing a Tonal Indicator Tool directly onto the photograph, then matching that tone with paint. (A Tonal Indicator Tool is a small hole in a piece of paper the size of a standard office hole punch.) It initially produces some surprises, but with practice, an understanding develops, which over time can then be applied directly to the subject, enabling the artist to perceive the tones as they are.

Once the artist has come to terms with just how dark a white can be in the shade, at times being almost black, the next challenge is to learn to decipher how the shadow has altered the colour. The 'dark whites' will often reflect the colours around them, which for most flowers will be the greens of the leaves and stems, or may be a colour from another flower in a bouquet.

In watercolour, white is rendered using the white of the paper; working from light to dark means that the whites have to be darkened. Fortunately this can usually be achieved by mixing a range of tones, often but not always

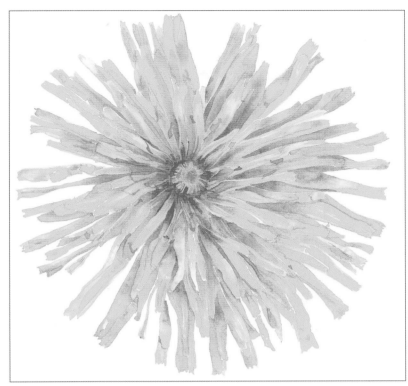

Dandelion Sun. Swathes of dandelion flowers in a patch of grass are so sunny. Although they flower all year, they are at their best in spring, just as the daffodils fade, replacing the slightly cooler spring yellows of the daffodils with their warmer summery yellows. This dandelion flower was painted from a close-up photograph. Looking at the flowers from this angle reminds me of the way children paint the sun.

Yellows are notoriously difficult to work with; the deeper tones have been achieved by observing the slight orange hue of the flower, and adding a little orange to the creamy yellow mix.

greys, using the colours already being used in the painting. Using the Tonal Indicator Tool on a photograph can help you to learn to see this, by looking first at the photograph, and then comparing it with the subject itself.

Applying the correct tone to the painting may seem difficult at first, as it usually needs to be darker than a fledgling artist is comfortable with. Remember though, that the viewer is subject to the same perpetual constancy as the artist, and will continue to perceive the flower as white, possibly not even noticing that parts of the flower have been painted dark grey.

In many ways, yellow flowers are more difficult to paint than white ones. There are the same challenges of perceptual constancy, and the same lessons to be learned about correctly perceiving the colour of the shadows.

The real difficulty comes because of the nature of yellow pigments. Yellow pigments used alone are not capable of achieving dark tones, so have to be mixed with other colours. While the white of the paper remains constant, reflecting through the colours that are laid on top of it, yellow pigments interact with the colours they are mixed with. Since most yellow pigments are overpowered by the colour they are mixed with, it invariably causes a complete change in colour: add a red and it becomes orange, add a blue and it becomes green. The trick is to maintain the correct balance within the image so that the viewer still perceives the flower as yellow.

Impurities within the pigments and in the media means that yellow rarely obeys the guidelines of colour theory. In theory, a dark yellow could be made by mixing a yellow with a purple. In practice, this produces a range of muddy browns, depending on which paints are used. In a landscape, this might add to the overall effect; for flower painters it is a disaster. Flowers with a hint of brown are often dying, which is probably the opposite of what the artist wanted to capture in a bouquet of bright, fresh flowers.

It is therefore very important to learn to observe the actual colours of 'dark yellows', and to take time to discover the mixes you find acceptable. Like whites, they will reflect the colours around them, and in a bouquet or garden this will often be the greens of the stems and leaves, so this is the best place to start your search.

Of course, colour theory also informs us that placing complementary colours next to each other in a painting will enliven the vibrancy of the image. Yellow and purple when placed next to each other can impart an energy to the painting.

The following step-by-step demonstration shows one way of dealing with the issue of yellow in shadows, and also plays with the use of complementary colours. As a painting of flowers, it could be described as botanical art: the use of colour suggests a hint at floral abstraction!

Yellow Tulips

The inspiration for *Yellow Tulips* was a delightful vase of flowers on my kitchen table.

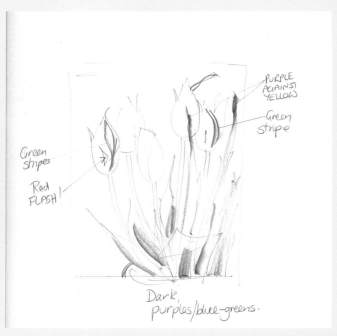

The thumbnail planning sketch for *Yellow Tulips*. Although delightful sitting in the vase, the tulips did not translate well into a 2D image just as they were. This simple thumbnail sketch was made to make some minor adjustments to the arrangement of the flowers.

The inspiration
This vase of tulips made me feel happy. The yellow colour was bright and fresh, and I liked the pointed ends of the petals. I loved the odd green stripes, and the one, single red flash on just one petal of one tulip. Plonked unceremoniously on my kitchen table, they refused to be ignored; when a shaft of sunlight shone directly through them, they positively demanded to be painted. Sometimes flowers have to be painted just because they are there.

Developing the idea
I knew the colour would be a challenge, but I wanted to capture the green stripes and the red flash against the yellow of the petals. When the sun had shone through, I had known immediately which paints I would use to make the greens of the leaves, and this included a deep purple. Although this painting was primarily about the flowers, not the paint, I wanted to exaggerate the colours I would use for the leaves, giving me the opportunity to place the purple next to the yellow. The spikey shape of the petals seemed to require the extra energy that this use of colour would bring to the image.

Information gathering
This was through direct observation of the vase of tulips. I spent a *long* time looking at them, watching the play of light as the sun shone through and onto the leaves. Finally I took some photographs. Tulips are a favourite subject; I have drawn them many, many times. This is an example of how the method of working that I am suggesting in this book moves from being a very conscious process to becoming second nature. Familiarity with the subject means I am free to let the creativity flow, conscious of the subject but able to enjoy it with ease.

Designing the painting
Layout
I did not want to paint the whole vase, but wanted to draw attention to just the salient features of these particular tulips that attracted me. I made a quick thumbnail sketch of the most interesting tulips in the vase placed in an arrangement that would work in a painting, making sure I had included the green stripes and the red flash.

Tone

While the sunlight had caused the leaves to glow, it had deepened the shadows at the bottom of the arrangement. This gave weight to the bottom of the image, balancing the fact that the flowers seemed to be sprouting wings. I also placed dark purples against the very light yellows of the flowers, empathizing the contrast in tone as well as colour, and balancing the weight at the bottom of the image.

Colour

I wanted to keep the yellows bright and fresh, so the purple and yellow could not be allowed to interact while wet. I also felt I wanted to exaggerate the colours in the leaves, by bringing out individual colours from the paint mix. The movement through this painting is largely vertical. Keeping a few of the horizontal leaf edges yellow against the darker greens and purples will encourage horizontal movement across the image to the next tulip.

Texture

Although tulips are very smooth, I was happy to allow the paint to contribute to the painting; if cauliflowers and runs appeared while I worked, I was happy to let them.

Painting the Image

Materials

Suggested palette:
- Permanent rose
- Lemon yellow
- New gamboge
- Cobalt blue
- Dioxazine purple

Paper:
- Canson Fontenay 300 gsm CP, stretched

Brushes:
- Round (sable), size 4
- Round, size 2
- Flat (one-stroke) ¾ inch

Other:
- 2B pencil
- Eraser
- Kitchen roll

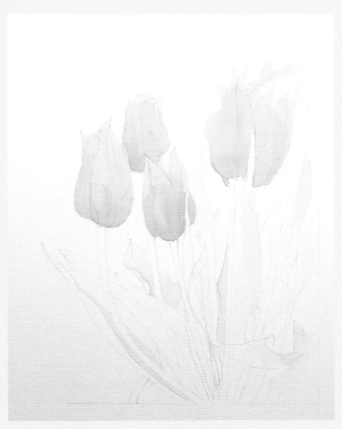

Step 1: Draw the tulips and add the first pale yellow washes.

Step 1: Draw up the tulips using a 2B pencil to apply a light under wash of Lemon yellow to the flowers, varying the tones to start to give the flowers form.

Also apply this to the tops of the leaves where they were catching the light. When this wash is dry, apply a creamier wash of New gamboge, a deeper yellow, to the darker areas of the flowers.

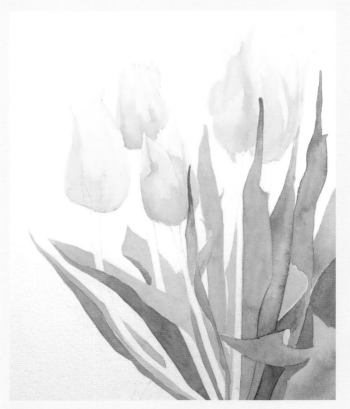

Step 2: Lay down the first washes of greens on the leaves.

Step 3: Add a layer of subtle greys to establish tonal variation across the flower.

Step 2: Create mixes of Lemon yellow and Sap green, and Sap green and Ultramarine.

Lay down the first washes on the leaves, using yellow-greens for the lighter leaves, and the blue-greens for the leaves that will be darker.

Make sure adjacent leaves are different in both tone and colour. This painting is of the flowers; the stems and leaves are the supporting act, and the colours and tones positioned accordingly.

Step 3: One way of achieving tone in a yellow painting is based on a technique called 'grisaille', where an underpainting in grey is laid down before applying colour over the top. Usually used in oil painting, it can work in watercolour too.

It is usually laid down as the first layer, establishing tones and therefore form, before adding the colour.

Here it is used as the second layer, which I find helps to ensure that the yellow is the dominant colour, and reduces the risk of the grey overpowering the yellow.

Make a grey by mixing the purple with the Cobalt blue, then adding a touch of Sap green to produce a subtle green-grey colour. Apply as a light tone to the flowers to develop the form. Allow to dry completely before continuing.

Step 4: Using creamy yellow paint, deepen the yellows.

Step 5: Paint in the leaves.

Step 4: Using Lemon yellow and New gamboge, deepen the yellows, using the Lemon yellow in light areas and creamier mixes of New gamboge in the shadows.

Notice that the grey colour becomes greener as you glaze over it with the yellow.

Step 5: Next paint the leaves. Use the mixes described in Step 2, and another mix of Cobalt blue and Purple, with just a tiny touch of Sap green.

Play with the colour! Follow the design laid out in Step 2, strengthening the tones and exaggerating the colour mixes. Be careful when applying the purple that it does not accidentally mix with a yellow-green and turn muddy. Work on the leaves in sections, seeing them as shapes based on leaves. Allow the paint to contribute to the painting, mixing colour as it flows and leaving cauliflowers and other marks to develop.

Step 6: Add detail to the flowers, painting in the green and red stripes.

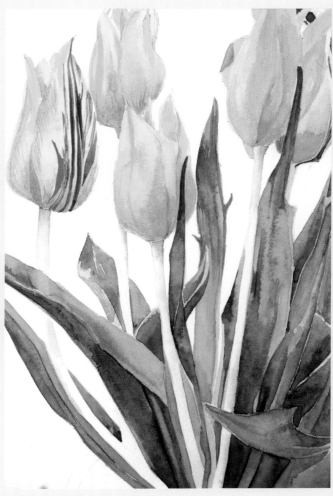

Step 7: Add shadows and deep tones to the leaves. Adjust colours using pale greens and purples.

Step 6: Add detail to the flowers, carefully painting in the stripes and the red flash.

Step 7: To paint the stems, wet them along the whole length. Load a round brush with purple paint, then holding it at an angle of about 45 degrees, lightly touch the edge of the water; the paint will flow into the wet area, gradating tone across the stem.

When this is dry, add a pale wash of yellow-green.

The finished image.

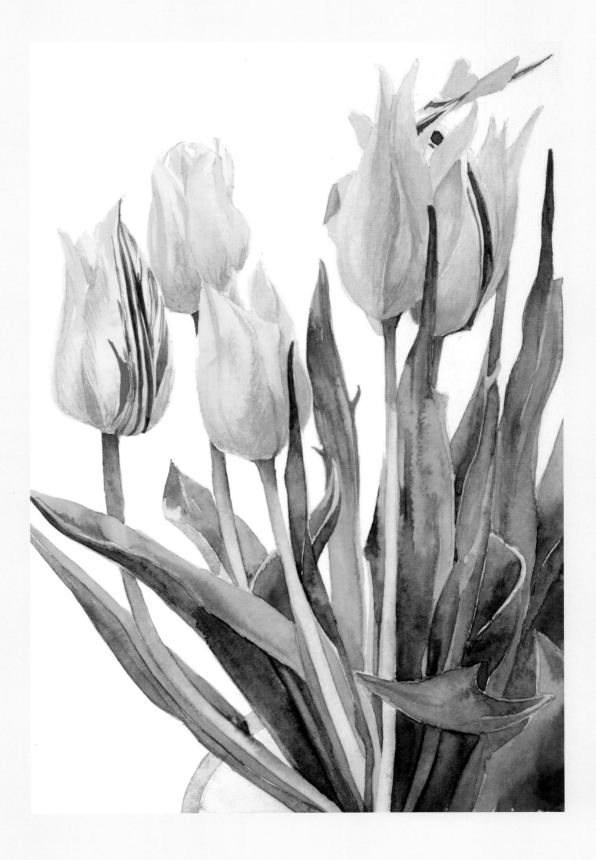

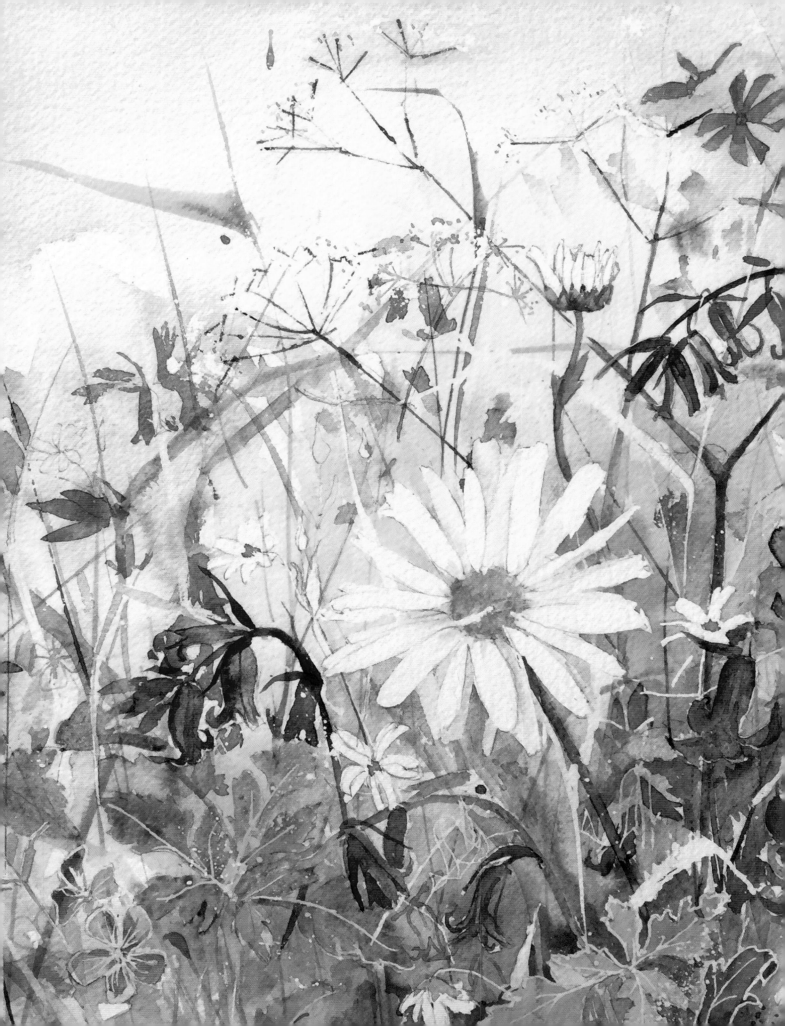

Floral art: paintings about flowers

For the artist, flowers can be quite breath-taking. Visually they are amazingly exciting; the colours, the shapes, the patterns, the movement, the play of light on and through petals and leaves, their characters and personalities are all potential starting points for exciting and interesting images, and the floral artist is free to respond as they wish. The personality of the artist plays a big part too, as the artist is free to respond to both the subject matter and the medium in whichever way they choose. In floral art there is plenty of room for artistic expression, play and experimentation.

Considering where floral art sits on the spectrum of flower painting, at one end of the category the paintings are very figurative, while at the other end there is a definite move towards abstraction.

The floral artist does not feel the need to accurately describe the physical characteristics of the flower in botanical detail, but it is still important that the flower is easily recognizable. The essence of the flower is more important than a true likeness. This allows a great deal of freedom in the way the painting is made.

Flowers are often part of the overall image, rather than being the only elements. Still lives, garden scenes or surreal images are all exciting possibilities. Images can be calm and simple, or busy and complex.

This detail of a larger painting shows how textural marks are used to imply foliage, and to give a sense of energy and movement.

In floral art, the artist is free to decide on the purpose of their paintings, and while the flower will play an integral part, depicting the flower itself may not be of primary importance. For example, there is a tradition of flowers having meanings, and being used to send messages. This was particularly popular in Victorian England. (There are many lovely books on this subject, for example, Kate Greenaway & Rose Marsh, *The Language of Flowers*.) The floral artist is free to carry on this tradition through their paintings. Alternately, there is the opportunity for

Spring Hedgerow (detail).

narrative within the image, or delivering a political or ecological message. The image may be of flowers, but your intention may be that the viewer simply admires an attractive painting, or is enticed into a conversation or a train of thought.

In floral art, there is ample opportunity for the medium to play an important role. Watercolour techniques and mark-making can be used, explored and experimented on with artistic abandon. Floral artists can enjoy applying paint energetically, with large, loose splashy marks waiting to see what the paint will deliver. The subliminal message in these paintings implies the energy in living plants, which is understood by the viewer. (This is something not so easily achieved in botanical art.) This usually means letting go of some of the detail of the plants, but it produces some incredibly exciting paintings. Somehow these paintings are noisier than those we might describe as botanical art.

Letting go of detail in the painting in the way the plant is portrayed in an image does not mean letting go of understanding which are the essential characteristics of the flower being painted. Close observation and lots of drawing will help the artist to understand which elements are essential, and which can be dispensed with. A yellow triangle is unlikely to be perceived as a daffodil without its curly edge; bluebells will not be recognized without using their distinctive colour. A common question when faced with a complicated subject is 'How do I simplify it?' An answer is more quickly arrived at if the question is reversed: 'Which are the essential elements to include?'

The projects in this chapter are designed to cover different aspects of floral art. They are all based on wild flowers, which in itself is a message. Behind my painting is a desire to encourage people to be more ecologically aware. I do not paint posters, but I do hope to instigate conversations.

I have included references which you can use if following the step-by-steps out of season, or if the flowers do not grow in your area, but what I hope is that you will take your sketchbook and camera and gather your own references locally. Whichever you choose, the paintings include watercolour techniques that you can appropriate for your own use.

PROJECT
Spring Hedgerow

The inspiration

The hedgerows where I live are a constant source of inspiration, at all times of the year, but particularly so in spring. In spring, they literally burst into bloom, starting with snowdrops, then primroses, violets, dandelions, stitchwort, bluebells, ox-eye daisies, campion, cow parsley and so on. The problem is not finding subject matter, it is deciding where to start.

Bluebells are particularly inspirational for a number of reasons. The obvious one is their beauty; the colours of the bells, the tubular bells with their curled petals hanging from delicately drooping stems, and the way they sway in the wind are all features worthy of capturing in a painting.

For ecological reasons they are worth painting in some degree of detail to encourage people to learn to identify them correctly. There are many reasons for wanting to make a painting, and this is as good as any other. Floral art may have a wider appeal than more specialized botanical art, or botanical illustration, and though these art forms would give a more accurate description they are, sadly, found less often in popular art prints. In other words, this painting carries a message, and hopefully will initiate conversation, as well as drawing the viewer in to examine bluebells more closely.

Of course, it is perfectly acceptable to paint bluebells simply because you love them!

Developing the idea

This painting is inspired by:
- A love of bluebells
- The energy and abundance of life in a Devon spring hedgerow
- An ecological message.

Sometimes developing an idea can be a challenge, and it is what an artist means when they talk about solving the 'problems' in a painting.

Time spent walking the hedgerows, drawing, sketching and photographing is time well spent, and very enjoyable. Looking for an image which fulfilled all of the criteria, I came across this photograph in my huge 'Bluebell Reference' folder. The single bluebell gives an opportunity to include some detail, and, if the artist is concerned about the future of this delightful flower, speaks also of its declining numbers. The photograph is packed with stitchwort, grasses, and

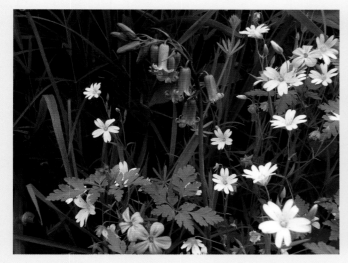

Along with sketches, this photograph provides ample reference for a painting of a spring hedgerow; fortuitously, there is much about the layout in the photograph that will work well in a painting.

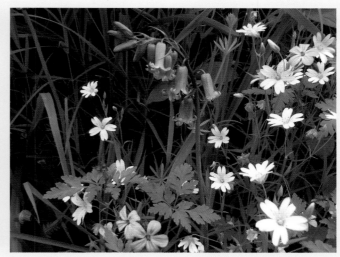

The greyscale version of the photograph reveals an artistic 'problem'; making the rich blue of the bluebell stand out would be easier against a paler background.

Herb-Robert. The latter has the prettiest leaves, which lend themselves readily to some enjoyable paint techniques.

Information gathering

Before beginning the painting, it is useful to spend some time making some observational sketches of the bluebells, stitchwort, Herb-Robert and leaves. Quick sketches of individual specimens will be enough to observe the shapes and forms well enough to understand which are the essential features. For example, look at the way the petals curl back on the bluebells, the shapes of the lobate leaves of the Herb-Robert, or the finest of the stitchwort stems and the way they divide.

Designing the painting

Layout

Although the bluebell is centrally placed, the composition of the photograph feels balanced, based on the design principle of dividing the image into quarters. A squarer format draws the eye to the bluebell, which is definitely the focal point of this image.

Tone

Care needs to be taken to ensure that the bluebell does not get lost against the grasses due to being similar in tone. The common bluebell should be rich in colour, so it would make sense to lighten the tones of the grasses behind it. To ensure that the hedgerow remains rich and green, and so that the bluebell appears to be growing out of abundant spring foliage, the tones in the bottom right corner should be darkened. This is almost the opposite of what is happening in the

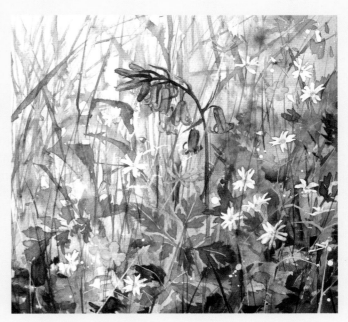

This greyscale version of the finished painting shows how the 'problem' was resolved.

photograph, but suits the purpose of the image better. Variety in the tones used will add to the fullness of the foliage.

Colour

The colour is all about the bluebell. The palette for this painting will be based on the colours chosen for the bluebell, and the greens will be based on the blues used. Hedgerows contain an overwhelming number of greens. In floral art, the concern is an harmonious image, not with depicting each green exactly as it is found in nature, and this is achieved by

limiting the palette for the painting. With the addition of a yellow and a green to mix with the blues, the palette can be limited and an acceptable range of greens produced.

Colour theory comes in useful here; yellow and purple are complementary colours. Placing the bluebell (purple-blue) against the yellow-green grasses will help it to stand out, and be more vibrant than if it were placed in front of blue-green grasses.

Texture

This painting will need to be simplified. The thought of drawing every blade of grass is daunting, and would mean the final image losing some of the energy that will be inherent in loose, free brushstrokes. Since the energy is one of the inspirational factors in this image it makes sense to use energetic techniques to paint it. It is amazing how the viewer will pick up on the way the paint has been applied.

Painting the image

Materials

Suggested palette:
For the bluebell:
- Cobalt blue
- Ultramarine
- Dioxazine purple

For foliage and other flowers (mixed with blues):
- Sap green
- Lemon yellow
- Permanent rose

Paper:
- Bockingford 300 gsm NOT

Brushes:
- Medium sword liner
- Round (sable), size 4
- Round, size 2
- Flat (one-stroke) ¾ inch

Other:
- 2B pencil
- Eraser
- Mapping pen
- Colour shaper
- Kitchen roll

Techniques to practise

Printing shapes with a round brush used for leaves. Sweeping brushstrokes for the grasses, keeping them long and fine.

Sweeping brush strokes with a sudden change of direction (bent grasses).

If you have a sword liner brush, these grass shapes can be made easily with that. Otherwise try a rigger, or a very pointed brush.

Take care to avoid bendy, curved shapes – snake-like grasses should be avoided, they do not grow like that.

Step 1: Draw the bluebell, stitchwort and Herb-Robert, and carefully mask them using masking fluid before applying the first washes.

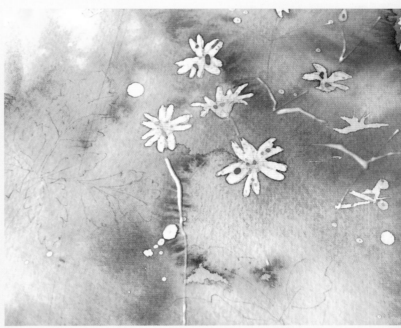

Step 2: When the first wash is dry, draw stitchwort stems with masking fluid.

Step 1: Draw the bluebell carefully, placing it fairly centrally and dropping gently to the left. Draw some with stitchwort and Herb-Robert flowers; these do not need detail, so a silhouette is enough. Using a mapping pen, apply masking fluid to the flowers and the top of the bluebell stem. Splatter a few drops of masking fluid randomly over the painting. These little spots of white will enliven the finished image. It doesn't matter what they represent; they will add to the overall feel of a busy hedge, and in this image, might be read as stitchwort buds. It doesn't really matter – be loose and free and add some sparkle.

When the masking fluid is completely dry, mix up a range of yellow-greens using the Sap green and Lemon yellow. Wet the image all over, and apply the paint, varying your colour choice from the mix as your work. Use more yellow colours behind the bluebell and top left. Where there are grasses (top left), use vertical hand movements. Where there are leaves, apply the paint in patches.

Watch the surface of the paint. As it begins to dry, and changes from a glossy surface to a semi-gloss or slight sheen, drop in more wet paint to encourage cauliflowers to develop. These will form a lovely, leafy texture as a back drop for the leaves.

Step 2: When the first wash is completely dry, load a mapping pen with masking fluid and draw in some fine stems and leaves to represent the stitchwort.

Notice that in a mass of leaves it is not possible to follow a particular stem from top to bottom, so it is perfectly all right to apply these randomly across the image as seems fit. A few random lines might help here too.

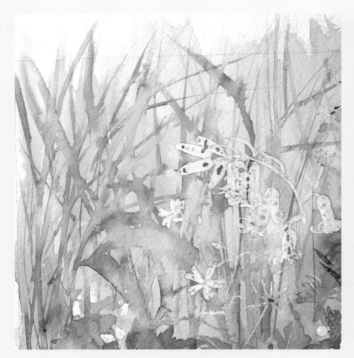

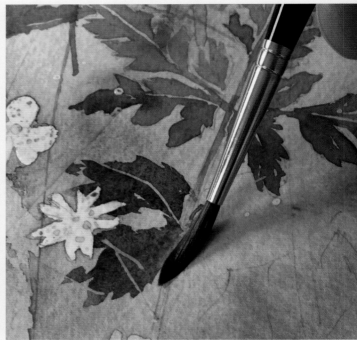

Step 3: Using a swordliner brush, paint some grasses.

Step 4: Using the shape of a round brush, loosely 'print' in leaf shapes. Using a damp brush, create a mixture of lost and found edges as you work.

Step 3: Mix up some slightly creamier greens (make enough for the next two steps).

Working in the top left quarter and behind the bluebell, lay down the first layer of grasses.

Using a sword liner, 'paint' some grass shapes with water. Before these have the chance to dry, choose a variety of greens from the mix and paint in some grasses. Allow the paint to run into the water marks, and into each other. Vary the colours as you work.

Notice that I have extended my brushstrokes beyond the edge of the painting. Loose, free marks cannot be made in a restricted space. While some have to be finished within the painting, most extend beyond the boundary.

Step 4: Use the same mix of greens as in Step 3, and also make a mix of blue greens. Using the round brush and a 'printing' brush movement, paint in some leaves, moving the brush to create the leaf edges. Begin with the yellow-green mix, and as you work, begin to introduce some of the blue greens, especially down in the bottom right quarter.

In the image above you will see that I have carefully placed the brush to leave some of the under washes showing through as veins. Only do this on a few leaves to make the central leaves slightly more figurative. In other areas of the painting, the under washes showing through have appeared because I have, deliberately, ignored the finely masked lines placed in Step 2.

Similarly, only the leaves at the centre of the painting have full edges. In other areas of the painting, 'print' one edge of the leaf, then using a damp brush, pull the other edge out to leave an open edge.

Work fairly slowly for this stage of the painting. As some leaves dry, layer others across them, building up an appearance of layers of leaves in a hedge. Balance lost and found edges across the image.

When you are satisfied you have enough leaves, print a few random marks with both the round and the sword liner.

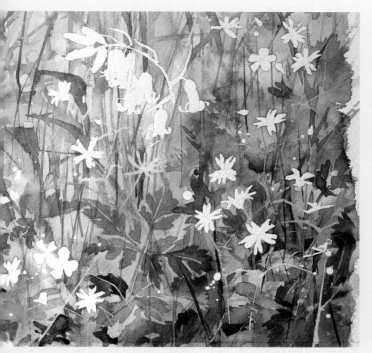

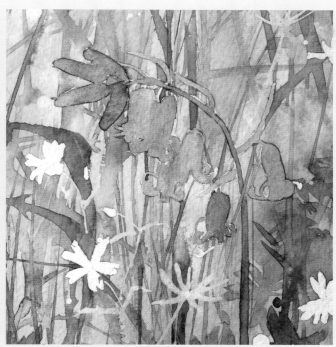

Step 5: Remove the masking fluid, assess the balance of tones, and add more darks if necessary.

Step 6: Lay down the first blue-purples of the bluebell flower.

Step 5: Wait for the marks made in Step 4 to be completely dry before removing the masking fluid by gently rubbing it off with your fingers.

Seeing the white paper will alter your perception of the tonal range you have achieved. Stand back to assess the painting, and if necessary add some more dark tones.

This can be done by either painting new leaves, or, if you feel you have enough, carefully adding more paint to what you have already.

Step 6: Make a mix of blue-purples using the Cobalt blue, Ultramarine and purple.

Lay down the first washes on the bluebell, altering colour and tone to begin to build some form.

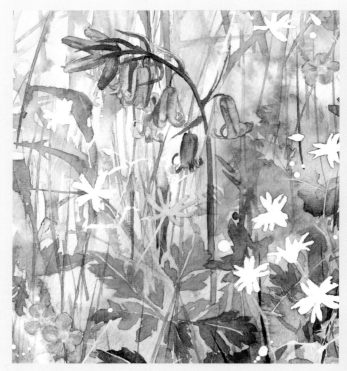

Step 7: Add detail to the bluebell flowers; paint in the Herb-Robert and add a little rose paint to the foliage.

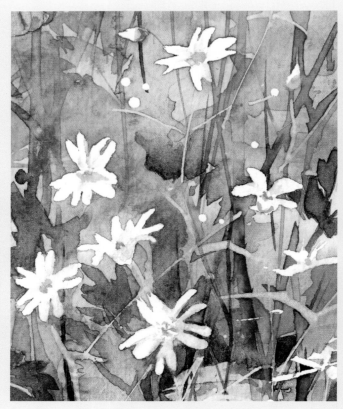

Step 8: Soften the whites of the stitchwort, and add some grasses and leaves across the flowers to give added depth.

Step 7: Paint in detail on the bluebell bells, using the photograph as a reference.

Then paint in the stem. Wet the stem with clean water all the way down, ending at the edge of a leaf. Drop in some purple at the top, and some green halfway down, then pick up the painting and rock it to encourage the two colours to mix.

If they refuse, you may need to give them a helping hand with a brush, but try to avoid becoming too tight.

Using Permanent rose, add some colour to the Herb-Robert flowers. Also, dampen a few patches of the painting in the bottom right quarter and drop in a little rose paint. A few subtle patches of colour will help to balance the colour across the painting.

Step 8: Loosely soften the whites of the stitchwort flowers by dragging a little paint across them from the surrounding area, and then add a touch of yellow to the centres.

Finally, using some of the darker greens, paint some more loose free grasses across the image, cutting across the flowers to give a slight sense of depth.

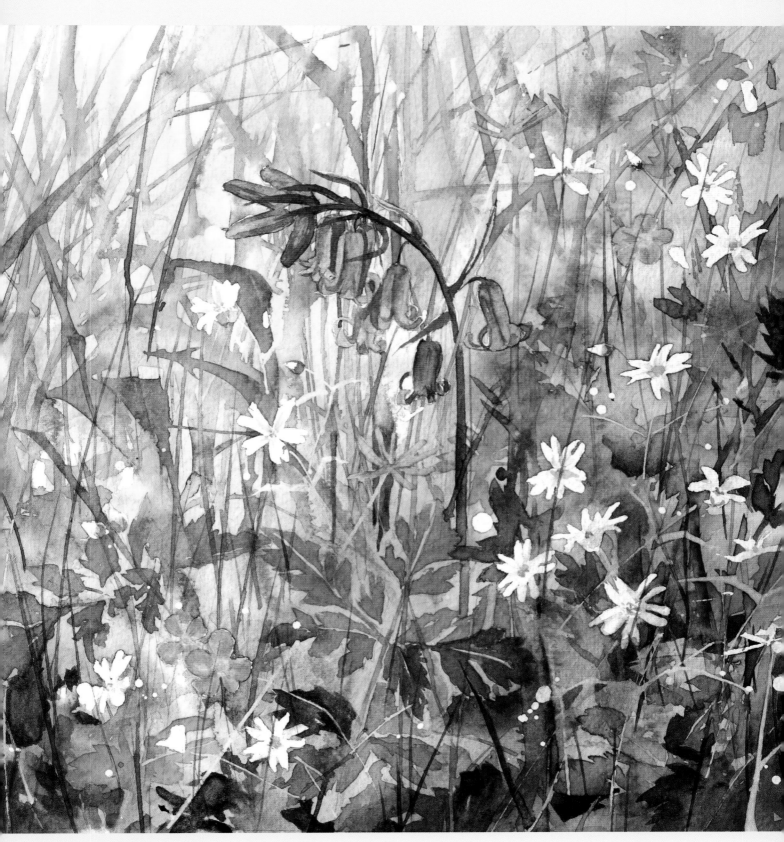

Spring Hedgerow, the finished painting.

Bluebells are a much loved flower in the UK, the native species filling broad-leaved woodlands with a sea of blue and the most delicious scent. Britain's bluebell woods are a real joy, a favourite of artists and walkers alike. Also found in hedgerows, bluebells are frequented by bumblebees and other insects, and are an integral part of our native eco-system.

Unfortunately the native bluebell, *Hyacinthoides non-scripta,* is under threat from *Hyacinthoides hispanica,* a plant introduced from Spain and commonly grown in our gardens. It is more vigorous than our native bluebell, and crossbreeds with the native bluebell to produce fertile hybrids. This is a problem, as the more vigorous *H. hispanica* and the hybrids are diluting the characteristics of the native bluebell. A study has shown that one in six of the UK's broadleaved woodlands now contain hybrids. Concern for the loss of *H. non-scipta* is so strong that it is protected by the Wildlife and Countryside Act 1981, making it a criminal offence to remove the bulbs of bluebells from their native habitat.

It is not difficult to tell the difference. *H. non-scripta* has narrow leaves. The flowers are deep blue, tube-like with the tips curled right back, mostly on one side of a slightly dropping stem. *H. hispanica* have broad leaves, an upright stem, and much paler, conical flowers with spread out tips. The native bluebell is scented, the Spanish bluebell is not. An identifying characteristic is that the anthers of *H. non-scipta* are cream, while the anthers of *H. hispanica* are blue.

To avoid the demise of the native bluebell, we should do what we can. We can stop growing *H. hispanica* in our gardens. And we can use our art. Art, even paintings of flowers, can carry a message. We can paint bluebells (sketching and photography done *en plein air*) to initiate conversation to spread the word. How fortunate that artists have the opportunity to make an ecological difference while doing something as pleasurable as painting a beautiful flower.

DANDELION CLOCKS

Dandelions: A useful resource

Most artists have their favourite subject matter which they return to paint time after time. One of mine is dandelions. Dandelions are considered to be a weed, and as a gardener I can understand why they can be a problem. They will grow almost anywhere, are extremely tenacious due to their long, strong tap roots, and produce thousands of seeds in a manner which entices children to play with them, spreading them even further around the garden.

But as an artist, one of the things that I like to attempt with my art is to draw attention to beauty where it is overlooked. Dandelions are usually spotted and attacked in much the same moment, with no time given to really look at the plant and discover its beauty. Dandelions are both gorgeous and interesting. I paint them because I want other people to notice not only how lovely dandelions are, but also to realize that there is so much beauty right under our noses that we miss on a daily basis.

Dandelions offer many opportunities for artists of all abilities and inclinations. Their very nature has inspired children's games, poetry and folklore which carry a sense of fun. This immediately gives an artist permission to have fun with a painting. This can be very freeing, as there is no pressure to produce a 'serious' piece of art. That does not mean that the execution of the painting will not require some effort and concentration, but for anyone who wants to loosen up, it can help to choose subjects that are inherently light-hearted.

Artists new to painting can have some real fun with dandelions, as they lend themselves so readily to experimenting with techniques. It is not difficult to capture aspects of their character, and to produce a variety of successful paintings while practising techniques.

Alternatively, dandelions provide some real challenges for those who want to study them in detail. Their flower head is incredibly intricate, being a composite flower made up of ray flowers. Given their sunny nature, this seems entirely appropriate. To make matters even more challenging, they are yellow, which is notoriously difficult to use when tonal variation is essential for describing form. Observational studies have to be done outdoors, because the flower head closes in the shade, and almost immediately if brought indoors; this is one situation where good macro photographs are very useful. The extremely delicate seeds heads are white, an enormous challenge if painted without a background. It is no wonder that so many artists choose to paint them in a loose manner.

Time to Mow the Meadow?

Time to Mow the Meadow? The grass verge smothered in dandelions that inspired this painting; reference photograph 1.

Time to Mow the Meadow? Reference photograph 2.

Time to Mow the Meadow? Reference photograph 3.

The inspiration

The inspiration for this painting was a wide grass verge absolutely smothered in dandelion clocks. When I first spotted them, they were aglow with sunlight coming straight through them. When I got back with my camera the light had changed, but as I got close to the ground to take some photos, I noticed the way the white of the clocks stood out against the hedge behind them, almost like an horizon. I enjoy this type of tonal contrast; also, it is easier to paint the light clocks against a dark background. I also like the way the stems have a little red in them, nature kindly injecting a complementary colour. I liked the way the dandelion clocks were standing up tall, almost like meerkats peeping back at me. When I thought of the millions of seeds about to be released into nearby gardens, I couldn't help wondering whether it was time to mow the meadow.

Developing the idea

The ideas that had arrived with the original inspiration could easily be incorporated into a design for an image and I wanted to paint it almost as soon as I had seen it. I quickly decided that this painting called for a loose style of painting to reflect the unruliness of the grass verge. Working through the design process to ensure that the scene would work as a watercolour image was all that was needed.

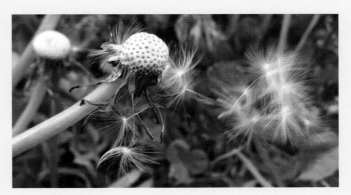

Time to Mow the Meadow? Reference photograph 4.

Information gathering

This painting was based on a series of photographs. The dandelions in the foreground of the painting have more detail. These photographs are included so that you can make your own observational drawings before beginning the painting.

MASKING FLUID
applied finely with pen,
and toothbrush.

toothbrush
splatter

VERY DARK,
PATCHY, NO
WHITES.

Fluffy, pale
greys

Swordliner
grass
+
dagger
shapes for
leaves.

DARK, STRONG
SHAPES.

Clover leaves,
balance clock shapes.

Daisies

Designing the painting

Layout

Basing the layout on the traditional 'rules of thirds', I chose a small group of dandelions to act as the focal point. Adding several more across the page along with some dandelion leaves 'filled' the bottom third, forming the foreground. The 'horizon' of dandelion clocks runs along the line of the upper third.

The flying seeds would direct the eye across the picture to the line of dandelion clocks against the hedge; moving objects seem to occupy more space in an image and draw attention to them, despite their small size in such a busy picture. These seeds are almost arrow like in shape, white areas pointing the viewer's eye back in to the picture. However, any gardener is likely to experience a sense of tension, wondering where they will land next.

Tone

Exaggerated darks were needed across the top of the painting to emphasize the 'horizon line' of dandelion clocks at the base of the hedge. The dandelion clocks themselves needed to be light, so anything behind them had to be dark enough for them to stand out, but to imply a sense of distance there needed to be a reduction in tone from the bottom of the painting to the bottom of the hedge. Increased contrast also brings things forward in a painting, and the very dark top third needed to be balanced, so some darks were added to the leaves in the foreground.

Colour

This is already a very busy painting. Restricting the palette would avoid colour vying with texture for attention, and create a sense of unity.

Texture

The texture of the grass and wild flowers can be achieved by layering a selection of marks in a variety of colours and tones. Leaves 'lost' in the grass can be painted using an 'open edge' technique. This painting demands a sense of movement, which can be achieved through fast, loose lines, applied with a sword liner.

The dandelion clocks would require several treatments. In the foreground, the more detailed clocks would need masking by using a mapping pen to draw lines to give enough detail, and splatter from a toothbrush. In the middle distance, the masking fluid could be applied with the toothbrush, while in the far distance the fluffiness could be implied using cauliflowers.

Painting the image

Materials

Suggested palette:
- Permanent rose
- New gamboge (hue)
- Lemon yellow
- Sap green
- Cobalt blue
- French ultramarine
- Burnt sienna

Paper:
- Bockingford 300 gsm NOT, stretched

Brushes:
- Medium sword liner
- Dagger
- Round (sable), size 4
- Flat (one-stroke) ¾ inch
- Toothbrush

Other:
- 2B pencil
- Eraser
- Mapping pen
- Colour shaper
- Kitchen roll

Techniques to practise

Masking techniques: This painting uses several different ways of applying masking fluid. It also employs a way of using water as a 'mask'; the method is described in Step 6.

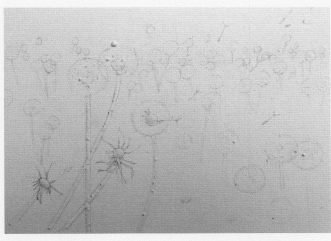

Step 1: Apply masking fluid. Use a mapping pen to draw fine lines, a colour shaper for the stems, and splatter loosely from a toothbrush to create a fluffy texture.

Step 1: When the masking fluid is dry, re-shape the foreground dandelion clocks by rubbing masking fluid with a colour shaper.

Step 1: Draw the design onto the watercolour paper. Mark the dandelion clocks as circles, with a dot indicating their centre. Draw in the leaves in the foreground, and a line to mark the bottom of the hedge.

Adjust the marking pen to produce extremely fine lines, and use it to carefully draw from the centre of the dandelion clocks towards to the edges. Work around the edges of the dandelion clocks, making small crosses.

Splatter masking fluid over the dandelion clocks from a toothbrush. Load the toothbrush and begin with the dandelion clocks in the foreground. As the masking fluid in the toothbrush is used up, it delivers a finer spray – use this to mask the clocks in the mid-ground and distance.

When the masking fluid is dry, reshape the dandelion clocks by rubbing off any excess with your finger or a colour shaper.

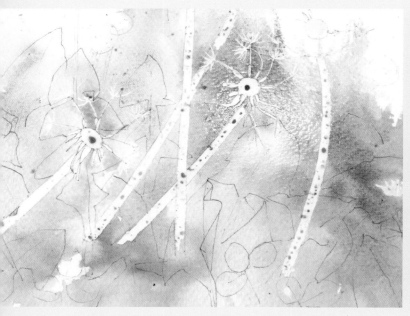

Step 2: Apply a varied wash of yellow, green and blue over the lower part of the painting, up to the bottom of the hedge.

Step 2: As you work, dab paint off the dandelion clocks with kitchen roll.

Step 2: Make up pale mixes of yellow, green and blue. Thoroughly wet the paper all over. Using a large brush, drop on colour, using yellower mixes in the foreground and bluer mixes as you go up the page. Stop applying paint at the bottom of the hedge; it will bleed up slightly across the line.

As you work, use kitchen roll to dab paint off the dandelion clocks; this technique, rather than painting around them, will give a lovely soft edge.

Allow to dry.

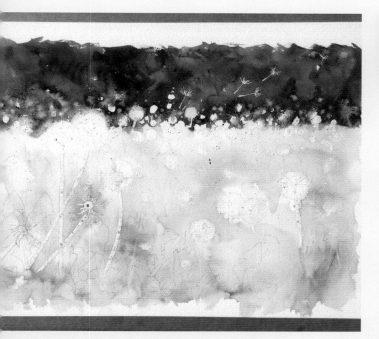

Step 3: Apply a varied dark wash to the hedge. Before it dries, deliberately create cauliflowers at the lower edge.

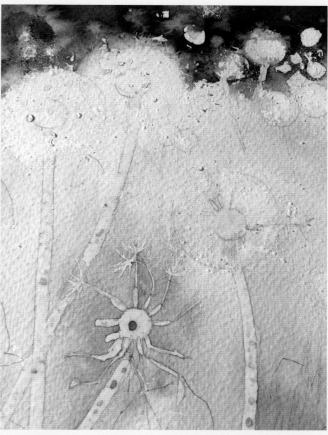

Step 4: When dry, use a toothbrush to apply more masking fluid over this layer of paint to create varied tones in the reserved marks.

Step 3: Mix up some creamy darks, using Sap green, Cobalt blue and Ultramarine. Using a large brush and varying the colour as you work, apply paint across the hedge. Work quickly to avoid adding too much detail. Allow some tonal differences to develop.

When the paint dries to a mid sheen, use a small brush to drop in some clean water at the lower edge of the hedge to allow cauliflowers to develop.

Allow to dry thoroughly.

Step 4: Using the toothbrush, apply more masking fluid along the line of the hedge and around the dandelion clocks. This will vary the pale tones reserved and create a more fluffy texture.

Step 5: Using loose, free marks, work quickly to paint in the grasses.

When you come across a leaf, do not restrict your movement. Paint right over it…

…and immediately use kitchen roll to dry the leaf.

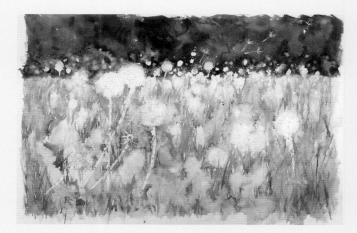

Work across the whole painting using these techniques.

Step 5: This next step involves working from one side of the page to the other in stages.

Use a sword liner brush and quick, confident movements to paint grasses. Make longer, wider strokes at the bottom of the image, getting shorter and narrower as you go up the page.

Use deeper tones in the foreground, and paler bluer tones as you work into the mid- and back ground. Allow colours to bleed in to each other.

So as not to restrict your movements, when you come across a drawn leaf in the foreground, use a round brush to wet the leaf before painting around it. Continue using the sword liner to paint grasses, working right across the leaf. As soon as you have painted the grasses, take some kitchen roll and carefully dry the leaf. This should enable you to paint the grasses freely, and retain a pale leaf to work on later.

Step 6: Paint in some leaf shapes as shown…

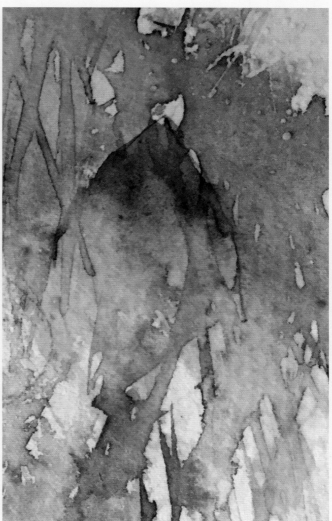

… and then pull the paint into a lost, soft edge.

Step 6: Once the previous layer is dry, paint in the tops of some leaf shapes as shown, then, using a damp brush, pull out the colour at the lower edge until it disappears into the grass.

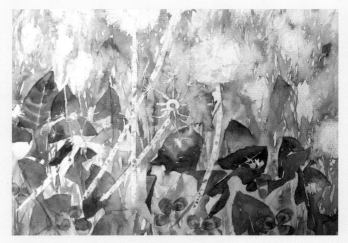

Step 7: Paint in the leaves in the foreground.

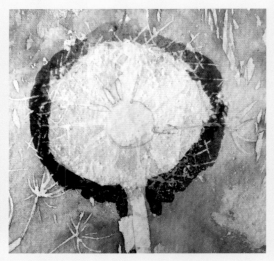

Step 8: Subtly increase tone around the dandelion clocks. Paint a line around the dandelion…

… and soften with a damp brush to the inside of the shape…

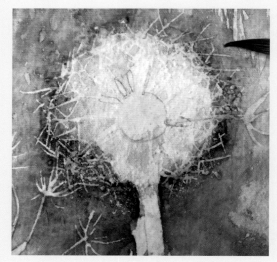

…and then around the outside.

Step 7: Paint in the leaves in the foreground. Use mid tones, and introduce some bluer greens to balance the colours in the hedge. Being careful not to add too much detail, indicate some veins on the leaves. This can be done by leaving gaps in the paint or lifting some paint out while the paint is still wet.

I added some clover leaves at this stage; the painting seemed to call for some rounder shapes at the bottom to balance the dandelion clocks.

Note: in spite of thorough planning, you should always assess the painting as it develops, and be prepared to make any change that might improve the final image.

Step 8: To ensure that the dandelion clocks stand out from the background of grasses, you will need to adjust the tones around them. Add an outline of paint around the dandelion clocks. Use a tone that is darker than the background the dandelion clocks sits against. You can vary the colour of it; here, I have used yellower greens at the top, and bluer greens underneath.

While the paint is still wet, use a damp brush to soften the inner edge; it is possible to adjust the tone to create a spherical shape. Try not to pull in too much paint. Around the outside, use the brush to dampen the area around the dandelion clocks and drag the paint into it until it disappears.

Step 9: Create some softness in the dandelion clocks by lifting out paint.

Step 10: Lift out a stem using the edge of a damp flat brush.

Step 9: Create some softness in the dandelion clocks by lifting out paint. Work when the paint is dry, and use a damp brush to carefully lift the paint. A flat works well for this; too soft a brush does not remove enough paint, and too stiff a brush removes the masking fluid prematurely.

Use this technique to create softness along the lower line of the hedge and towards the mid-ground.

Step 10: Using the techniques described in Steps 8 and 9, create some stems.

Check back with your design to make sure you place the stems at interesting angles that aid the viewer's eye to travel along the correct pathway around the painting.

Establish a crisper edge by applying paint…

…and pulling it out to a soft edge amongst the grasses.

Step 11: Using a round brush, define the lower edge of the hedge.

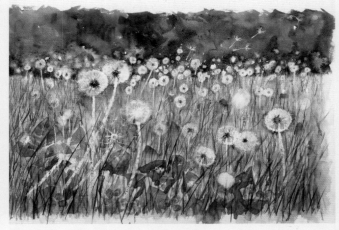

Step 12: Add colour to the dandelion clocks.

Step 11: Using a size 4 round and dark, creamy mixes of paint, define the lower edge of the hedge. The lower edge can remain distinct; blend the upper edge into the hedge.

Step 12: Add some colour to the dandelion clocks. Be careful! You need to add enough colour so that the lines of the seeds will show when the masking fluid is removed, but you do not want to lose the lightness. Vary the colour you use, using both play greens, blues and pale yellowy-greens. Add dots of brown paint to the centres of the clocks, smaller dots in paler tones in the distance, larger dots in deeper tones in the foreground.

Paint more grasses. This time begin in the distance, using mid tones in blue-greens, increasing the size of the brush strokes and the depth of tone as you move towards the foreground.

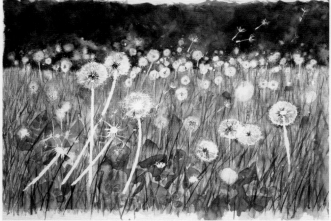

Step 13: Stand back to assess the painting. Adjust tones if necessary.

Step 13: Step back to assess the painting.

I decided that the hedge in my painting was not dark enough, so working carefully not to paint over the dandelion clocks in the distance, I added another layer of dark, creamy paints.

When everything was completely dry, I removed the masking fluid by gently rubbing it off with my fingers.

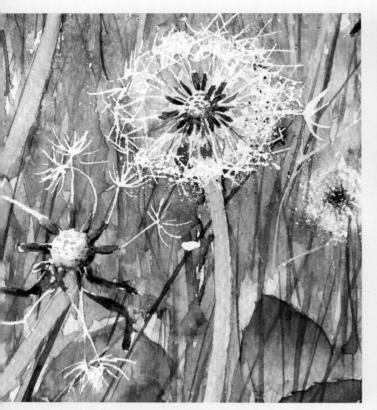

Step 14: Using a small round brush, paint in details of the dandelion clocks.

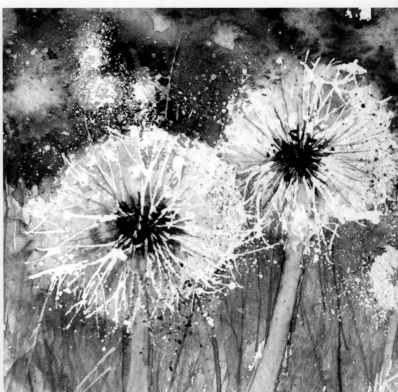

Step 14: Use the photographs as a reference.

Step 14: Finally, using small brushes (a size 4 round), paint in the details, using the photographs as a reference.

Add more details to the dandelion clock centres, using a dark brown made with Burnt sienna and Ultramarine. Exaggerating the depth of tone at the centres of the dandelion clocks, set against the whites revealed by removing the masking fluid, will draw the eye.

Paint in a few lines of colour to emphasize the shape of the dandelion clocks.

Wet the stems, drop in mixes of pale yellow-greens and then add some reds.

Do not forget a few spots of bright yellow in the daisy centres, or the touch of brown at the base of the flying seeds.

Time to Mow the Meadow?, the finished painting.

PROJECT
Wayward Daisies

The inspiration

Ox-eye daises are one of my favourite flowers. They have such character. They are happy, cheeky flowers which seem to have a real sense of fun, and it always brightens my day to see them dancing in a breeze.

On a visit to RHS Rosemoor in Devon, a garden famous for its rose collection, I noticed a small clump of wild ox-eye daisies at the base of a tree. While Rosemoor plants cover swathes of land and attract insects and wildlife, these were growing at the edge of one of the formal gardens. I am sure they had been spotted and deliberately left there, but I found the idea of them purposely sneaking into the formal garden very amusing. For me, the situation epitomized the character of these flowers. I painted them as an *aide memoire*, and the painting still makes me smile at the memory.

Developing the idea

The daisies themselves were of paramount importance in this painting, but it was their character that inspired me more than their physical attributes. I also wanted to capture the freshness of the day and the clarity of the scene. Rather than painting a very figurative image with a great deal of detail, I felt this subject called for a simplified image, emphasizing only those features that were relevant to what had initially inspired me. To keep it fresh and clean meant designing an image that was leaning towards abstraction.

As well as capturing the character of the flowers, there were other things about the scene that were visually interesting that would translate very well into a painted image. The contrast between the deepness of the shadows under the tree, and the way the sun is reflecting off the whites of the flowers could be emphasized, as could the way the sun catches odd blades of grass in the hedge. The sharpness of these shards of light contrasts with the softness of the flowering grasses, and the soft, lost edges of leaves in the shadows of the hedge.

Information gathering

The quickest way to understand what gives these daisies their character is to observe them. I have watched them and drawn them many times. These two photographs are included here so that you can spend some time making your own drawings and colour notes.

The inspiring clump of daisies under a tree in a formal garden.

Wayward Daisies.
Reference photograph 1.

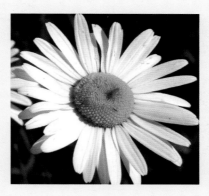

Wayward Daisies.
Reference photograph 2.

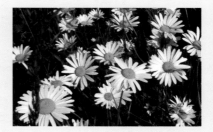

For this painting, it is the personality of the daises that is important, rather than an accurate depiction of their form. Note the quirkiness of the petals, including the bendy shapes, the bumpy ends and the gaps between them, which are all part of their cheekiness, as they seemingly defy what we are told about the mathematical patterns to be found in nature. To bring out the character of the daises in this painting, you might choose to exaggerate these features.

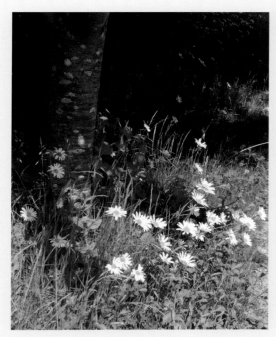

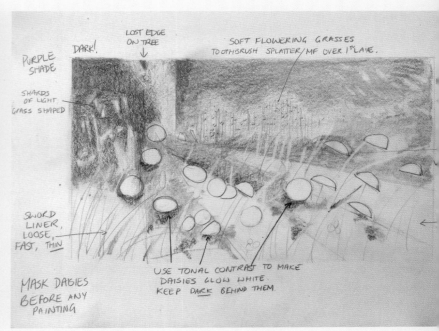

A photograph taken carefully, to capture the salient features of the scene.

The planning sketch for *Wayward Daisies*.

Note also the range of colours in the white petals, yellow near the centre where the colour is reflected from the centre of the flower, and a range of green-greys in the shadows where the light is reflected from the surrounding leaves and stems.

During my visit to Rosemoor, I did not have an opportunity to sketch, so using my camera, I took several photographs from different angles to find a composition that would work well in a painting. This photograph recorded most of the salient features I wanted to remember.

Designing the painting

Layout

A landscape orientation seemed to work better than the portrait orientation of the photograph. Other than that. the layout is based heavily on the photograph with a few minor tweaks. Not all the daisies are included, and those that are have been positioned and angled to ensure that the viewer's eye is led into the painting in the bottom left, through the patch of flowers to the softer whites top right and back along the shards of lights in the hedge to the starting point.

Tone

The tones added to the layout sketch are based on my observations at the scene, and designed to emphasize the path of the viewer's eye through the painting.

Colour

The weather was bright and crisp, with fresh spring greens glowing in the sun and the centres of the daisies a bright yellow. Taking these as the starting point, I decided on deep purples for the dark shadows, the darker greens using purple in the mix rather than just blues. This decision was made partly because yellow and purple are complementary colours, which will help give the painting a vibrancy, but also, and this is just as relevant, because I like the combination of yellow-greens and purple.

Texture

The foreground requires crisp marks and a sense of movement; this suggests making fast lines using a sword liner brush. The geometric shapes found in the shadows between blades of grass could be positioned to emphasize this movement. A technique I enjoy is to use paint to flood areas bounded by masking fluid, and these geometric shapes provide a great opportunity to use it. Remember that your viewer will pick up on subtleties; if you enjoy the mark-making, it will show in the painting, and this painting is essentially about fun. The fluffy softness of the flowering grasses needs lots of tiny random marks, easily achieved by spraying fine marks from a toothbrush.

Painting the image

The order in which the paint and marks are made is quite important in this painting. It is obvious that the whites need to be reserved, but also because using yellows and purples in this painting could lead to muddy browns if not applied judiciously and carefully.

Materials

Suggested palette:

- New gamboge (hue)
- Lemon yellow
- Dioxazine purple
- French ultramarine
- Sap green
- Burnt Sienna

Paper:

- Bockingford 300 gsm NOT

Brushes:

- Medium sword liner
- Dagger
- Round (sable), size 4
- Round, size 2
- Flat (one-stroke) ¾ inch

Other:

- 2B pencil
- Eraser
- Mapping pen
- Colour shaper
- Kitchen roll

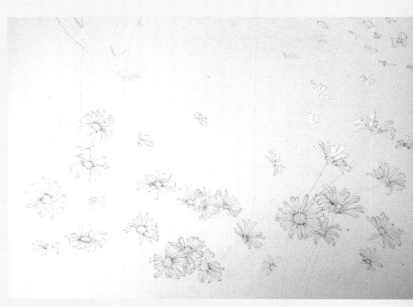

Step 1: Draw the daisies onto watercolour paper, then 'paint' them in with masking fluid.

Step 1: Using a 2B pencil, draw up the outline of the daises and the tree. Carefully apply masking fluid to the daisies using a masking brush or colour shaper, filling the shapes but staying within the outline. It can help to think of the masking fluid as white paint, imagining that you are painting the daisies white, rather than simply reserving white paper with a rubber solution.

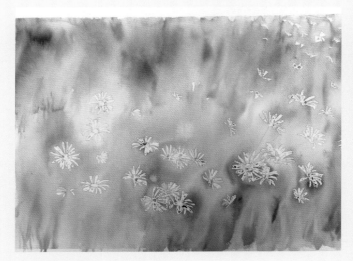

Step 2: Apply the first wet-in-wet washes.

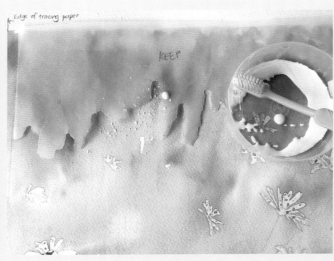

Step 3: After masking the top of the image with paper, splatter masking fluid finely from a toothbrush along the line of the grasses.

Step 2: The first layer of paint, the under wash, should be varied in colour according to the design, with purples top left and yellow-greens bottom right. To perform as a good base for the grasses and flowers, this layer needs to be varied in colour and tone.

You will need to work quickly for this layer, so that the paper stays wet and the colours blend together. Begin by preparing several paint mixes in the palette. Make one mix with Lemon yellow and Sap green, another with Sap green and Ultramarine, and a third with Ultramarine and purple.

Wet the paper all over using a large brush (a sword liner) and clean water, including the tree trunk. Even though you are not using colour, apply it with vertical strokes as though you are already painting grasses. This will allow the paint to flow in the right direction.

Starting at the bottom, apply the yellow-greens, always using sweeping up-down movements. Vary the colour by choosing different parts of the mix. Continuing to vary the colours, move up the page using more of the Sap green/Ultramarine mix. As you reach the top third, start to use the Ultramarine/purple mix. (Take care here not to allow any of the wet yellows to mix to a muddy brown with the purple). Drop in a few shadowy colours under the daisies.

If the paper dries too quickly, simply re-wet with clean water before applying paint. Do not be concerned if cauliflowers develop, they will add texture. You might even want to encourage a few.

Step 3: Wait for the first layer of paint to dry completely. Lay a sheet of tracing paper over the image, and draw a line roughly along the top edge of the flowering grasses. Cut along this line, and lay the tracing paper lightly on the painting, allowing it to lift a little in places. This will act as a mask to protect the darks at the top of the hedge.

Using a toothbrush, apply fine splatter along the line of the grass flowers. The few spots that find their way under the tracing paper will prevent too hard an edge.

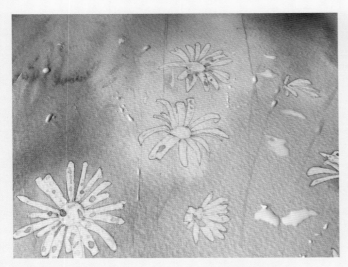

Step 4: Using a mapping pen dipped in masking fluid, draw in daisy stems and grasses.

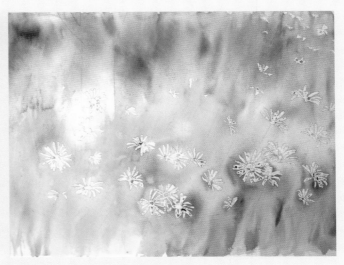

Step 5: Build up colour with glazes of paint.

Step 4: Using a mapping pen, draw grass stalks as single lines over the line between the grass and the hedge. Also draw some grass stalks on the sunnier area in the foreground. Make sure you vary the angle of these lines, and that they cross each other. To capture a sense of movement, think of grasses blowing in the wind, all waving in different directions. Long, confident strokes made quite quickly will also imply movement.

Use the pen to apply masking fluid to 'draw' the important shards of light to the left of the tree, and a few leaf shapes in the same area.

Remember that one purpose of the light tones being reserved in this stage is to keep the viewer's eye moving over the image, subtly linking light tones top right with light tones top left. Make sure that you apply enough masking fluid to achieve this.

Step 5: Repeat Step 2. Use this layer of paint to build up glazes of paint, which are visually more interesting than single layers and add depth and interest.

Keep the marks light and fresh. I have added warmer colours in the foreground, and slightly greyed the hedge which gives a slight sense of distance.

You can use the opportunity to adjust the colours, tones and textural marks. These are adjustments, not corrections. Notice how the eye-catching cauliflower that developed on the right side of the image in Step 2 has been incorporated as a more subtle texture during this stage, simply by applying a light wash over it.

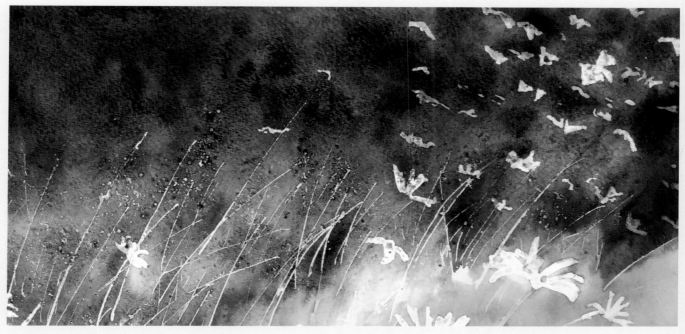

Step 6: Paint in the rich darks of the hedge.

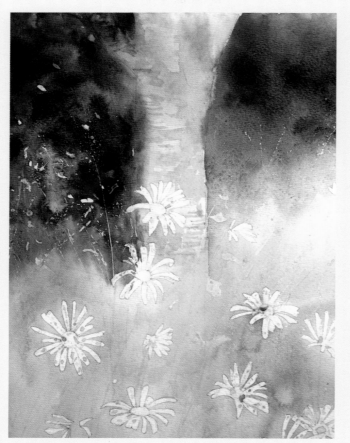

Step 7: Paint in the tree trunk.

Step 6: Prepare creamy mixes of purple, Ultramarine and Sap green for the rich, dark areas of the hedge.

Wet the top half of the painting, making sure that the dry edge is well below the bottom edge of the dark area to ensure you leave a soft, open edge. (You do not want a dry horizontal line across the image.) Apply the creamy mixes wet-in-wet, using marks that you might use to paint leaf shapes. These will get lost as the paint blends together, but will give the impression of a hedge rather than random blobs of paint, and any marks that make contact with a dry patch of paper will be the right shape.

Step 7: Using a thin yellow-green mix and a flat brush, paint a pale horizontal band across the tree trunk. Work onto dry paper, and use some wet and some dry brush marks. Leave some of the purple under wash showing through.

Wait a few moments to allow the paint to partially dry. Using the flat straight tip of the brush, 'print' some lines into the damp paint to increase the bark like texture.

Working from the left (dark) side of the tree, adjust the tones using a thin wash of shadowy purple colours, matching the left edge to the tones of the hedge and partially losing the edge of the trunk.

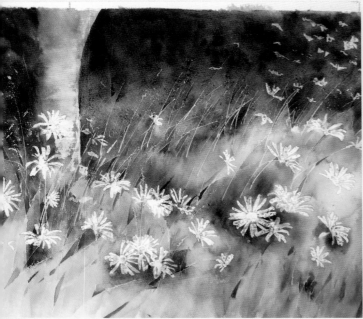

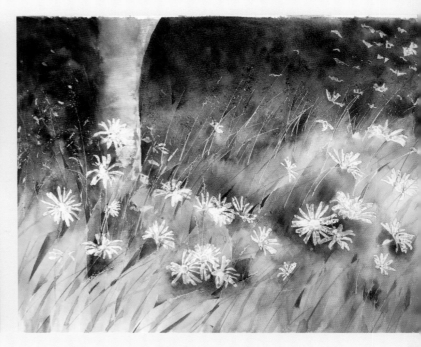

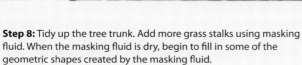

Step 8: Tidy up the tree trunk. Add more grass stalks using masking fluid. When the masking fluid is dry, begin to fill in some of the geometric shapes created by the masking fluid.

Step 9: Paint in a few foreground grasses to add texture.

Step 8: Apply more masking fluid to the dark areas, adding more grass stalks and toothbrush splatter as described in Step 4. This will reserve a variety of colour and tones.

Repeat Step 6, using this layer to tidy up the right edge of the tree trunk. This is the last layer of paint in this area, so make sure it is dark enough. It is the depth of tone here that will make the daisies appear to be in bright sun. (Applying another adjustment layer is possible but you risk losing the freshness.)

Begin to add some darks to the foreground, filling in some of the geometric shapes made by the masking fluid. I have added some purples and blues amongst the yellow-greens, and some yellow-greens amongst the blue-greens at the bottom of the hedge.

Step 9: Add texture to the grasses in the foreground. Using some paler tones, apply the paint with a sword liner brush, using the edge of the brush and a little pressure to give some wide marks. Keep your hand movements fluid, and not too slow. Then, using darker tones, the tip of the brush and rapid hand movements, paint some shorter strokes for fine grasses.

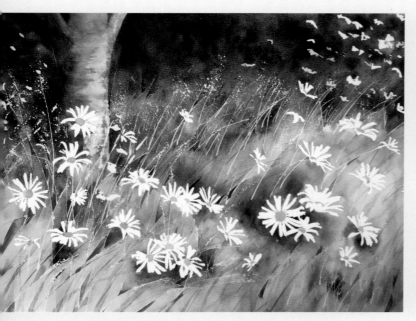

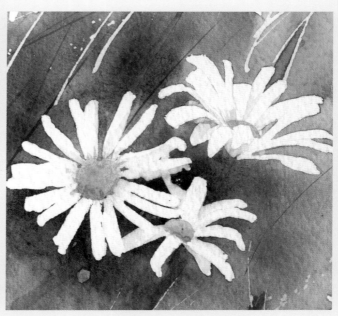

Step 10: Remove the masking fluid and paint in the daisy centres.

Step 11: Add some very subtle detail to the daisies.

Step 10: Ensuring that the painting is completely dry, carefully remove the masking fluid by rubbing gently with clean, dry fingertips.

Using a mix of New gamboge and Lemon yellow, paint in the daisy centres, with minute touches of green at the edges. The flower centres are the most detailed part of the painting; they attract the eye, hold it briefly and, along with the petal shapes, imply daisies rather than a different white flower.

Step 11: When I first saw these daisies, the detail was bleached out by the glare of the sun, making them stand out very white against the dark shadows. In the context of this painting, leaving them unpainted is too stark, but any detail added must be very subtle to avoid losing the freshness. Consider the overall shape of the flower head; individual petals and shadows are not necessary here.

Using a damp size 2 brush, gently take some colour from around each daisy and drag it across the flower to give some gentle shape and shading. Similarly, with a clean brush, take some yellow colour from the centre, working outwards along the petals. If this does not give enough shading, choose a colour from the palette to match the colour behind each daisy and add a tiny amount of paint.

Step 12: Take a step back to assess the painting.

Make any minor adjustments. You may decide to add a few more geometric shapes between grasses, or to add a few more grasses. The daisies in the hedge (top right) should be in shadow; if they appear to be too bright, soften them by dragging paint across them from the background using the technique described in Step 12.

Finally add a few more fine grasses across some of the daises.

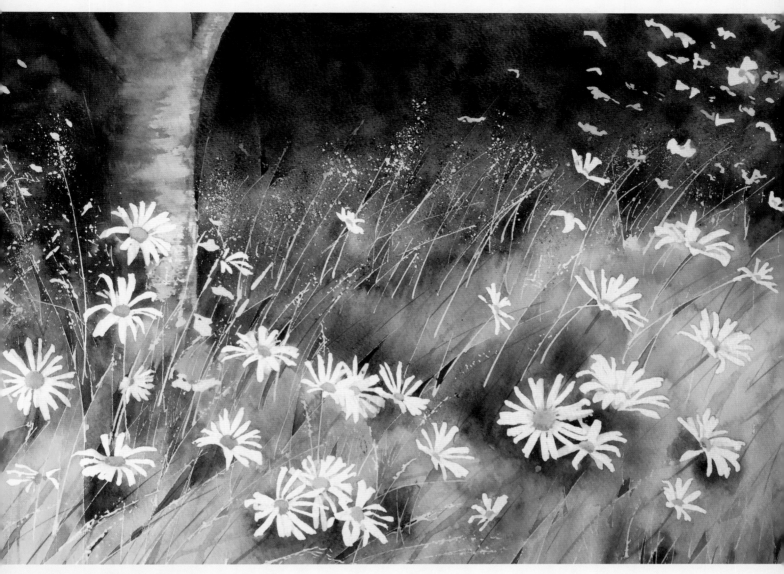

Wayward Daisies, the finished painting.

Moving towards floral abstracts

Floral abstracts are paintings which sit in that grey area between the figurative and the abstract, but are still recognizably inspired by flowers. The painting is inspired by, *not of*, the flower.

Many floral abstracts are loose and expressive, and may be a response to the way the paint moves, colour, or even an emotion, as much as they are a response to a flower. A floral abstract may also be a crisp design, based for example on the architecture of a plant; a pattern observed in its petals or zooming in on part of a plant to the extent that context is lost, leaving an image of seemingly random shapes.

To paint a successful abstract, an artist needs to have a thorough understanding of the medium, and acute powers of observation. Experience of the medium is necessary to enable it to be used fluidly and intuitively, and an ability to spot opportunities for interesting images is borne of well-developed observational skills.

Self-awareness is important too, in understanding how, as an artist, you want to respond to the subject or medium. It is generally the domain of expressive, responsive, experienced artists, who understand the depth of knowledge required to achieve an abstract painting that will engage the viewer and require a response from them.

Green Globes.

The projects in this chapter step gently from floral art towards floral abstracts. The first was inspired by the details of tiny florets, but one would need an intimate knowledge of the plant to identify it from the painting. The second was inspired by brush marks, and playing with paint, with just enough detail to give context to the rest of the marks. The third uses a much more controlled way of applying the paint, showing how I use shapes derived from flowers to produce paintings that are as much about the colour as they are about the flower.

Sweetpeas.

Cow Parsley

Cow parsley bursts into bloom in April and May, and fills the country lanes near where I live with a foaming froth of tiny white flowers. The flowers grow as umbels, and the branching stems give it a lace-like appearance, which accounts for its alternative name in the UK, Queen Anne's Lace. It is a very popular plant with many artists, as there are so many aspects of it that are visually interesting. Its architectural qualities in particular have been the source of inspiration for many artists in many media; as well as paintings and drawings, it has been beautifully incorporated into designs by ceramicists and textile artists.

The inspiration

I also enjoy painting these flowers at various stages in their life cycle, but on this occasion I was absorbed by the fact that these billowing white clouds were created by such incredibly tiny flowers. The entire umbel is only 3cm to 6cm across, and consists of a myriad of secondary umbels, or umbellets, each bearing a floret. And each floret is so pretty! The name umbel comes from the Latin '*umbella*', which means parasol, and is clearly very descriptive. The flowers seemed to burst forth from a central point, reflecting the way the plants *en masse* burst from the grass verge.

The inspiring macro photograph of a single umbel of cow parsley.

A PROBLEMATIC BEAUTY

As beautiful as it is, cow parsley can be a problem. Being vigorous, it smothers smaller wild flowers, causing monocultures to develop, which is not good for the other wild flowers or the wildlife they support. It is notoriously difficult to remove once it is established; as it is a biennial, it produces a huge number of seeds, and can be invasive. Think twice before introducing it into your garden.

When I reviewed my macro photographs of the cow parsley, the light had caught almost translucent pedicels (individual flowers stalks) and the white of the flowers against a dark green background; this photograph inspired a design for a painting in which I wanted to capture the minute detail, a sense of the architecture and energy of this pretty plant.

Developing the idea

To establish what was important to the picture, I compiled a list of things to include:

- To draw attention to the shapes of the individual flowers, which are usually 'lost' in the mass when we admire a bank of cow parsley.
- A sense of movement and energy.
- The contrast of the white flowers against the grass green verge and hedge.
- The translucent greens of the pedicels, which gave a sense of airiness.
- An impression of the umbrella like form of the florescence, with the flowers bursting out from a central point.

To achieve this, I decided the individual flowers had to be drawn fairly carefully, as did the positions of the flower stems; a drawing that was too loose would simply lose the detail again. This ran the risk of becoming too rigid, and losing the sense of energy, so I decided that if I masked the flowers individually, I would be able to emphasize the contrast of white against green, and paint the 'background' very loosely, allowing the paint and mark-making to imply movement. The blades of grass would be ignored; they would add an unnecessary layer of fussiness and detract from the laciness of the inflorescence.

Information gathering

The photograph itself was a major source of inspiration for the painting, and hence the main source of reference material. These flowers move too much to record this sort of detail *en plein air*, and can wilt quickly when picked, so sketching would have been difficult. Close observation in the field, a good hard stare and deliberately committing the shapes to memory also helped.

Designing the Painting

Layout

The flower needed to sit centrally within the image, with a small 'border' of green to allow room for painterly marks moving outwards from the centre to extend beyond the flower, increasing the sense of movement.

Several turns of the image were made before deciding which was the top. The floret which seems to stand more alone seemed 'lighter' while the row of three closer together seemed to add 'weight' to the bottom of the image.

Tone

The balance of tone in the original image was good, as seen by its conversion to greyscale. The way the shadow plays across the inflorescence is interesting, and gives shape and depth to the umbel, and is more appropriate than fussy shadows on every individual flower. This play of light draws the viewer's eye across the image.

Colour

The palette for this painting was simply white, and a variety of greens. The paler greens could be yellower to imply some sun and warmth, while the deeper tones could be bluer.

Texture

Several layers of paint, wet-in-wet and wet-on-damp, made with loose movement from the centre outwards, would be enough to provide interest without over complication of the texture. Laying the paint down in this direction will give a sense of the umbel moving towards the viewer.

Painting the Image

Materials

Suggested palette:
- Lemon yellow
- May green
- Sap green
- Ultramarine blue

Paper:
- Bockingford 300 gsm NOT

Brushes:
- Medium sword liner
- Round, size 2

Other:
- Pencils, 2B and 4B
- Biro
- Eraser
- Mapping pen
- Colour shaper
- Kitchen roll
- Tracing paper

The photograph was converted to greyscale to assess tonal values.

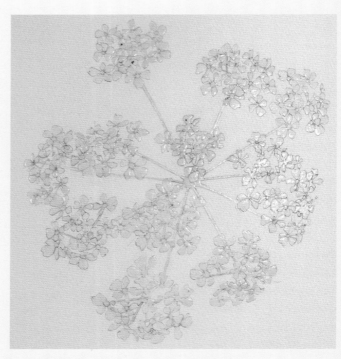

Step 1: Using digital media to find the edges of a flower can be a useful alternative to tracing.

Step 2: Taking care with details, apply masking fluid.

Step 1: Although I wanted to depict the individual flowers reasonably accurately, I did not want making this image to be laborious; this may result in tightening up and losing the energy and movement. I decided to trace the flowers as a guide. Tracing would not be accurate enough if used alone, but by using it as guidance for a more accurate drawing made from the photograph, it would save time. I printed the image at the size I wanted to paint it before beginning. (You may either trace the flower directly from this book, or photocopy it and enlarge it before tracing it.)

TIP: An alternative to tracing
In a photo editing programme, manipulate the photo to give a clear outline. I used Adobe Photoshop, choosing 'Filter', then 'Stylize' from the drop down menu, then 'Find Edges' to produce the image shown here. I printed this onto thin paper, and used this instead of a tracing. I used soft graphite pencil on the back of the paper, placed the image right side up on the watercolour paper, and drew over the outlines with a red biro.

Once you have a rough outline on the watercolour paper, remove any excess graphite by gently dabbing with an eraser, then draw in extra detail using the photograph as a reference.

Step 2: Very carefully, apply masking fluid to the flowers and the stems using a fine tipped tool such as a mapping pen, chisel shaped colour shaper or a small masking brush.

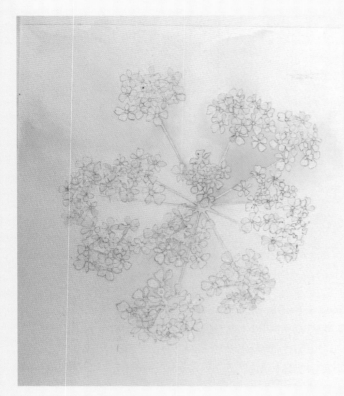

Step 3: Apply first place washes.

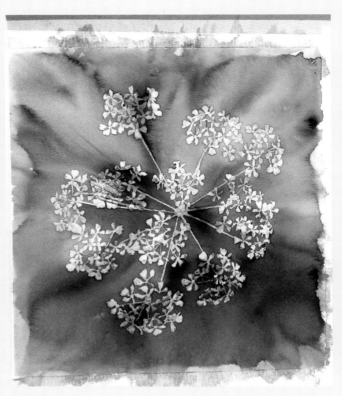

Step 4: Working from the centre outwards, apply greens using fluid brushstrokes.

Step 3: Apply the first wash of May green. Wet the whole page, and apply where you want it to glow through subsequent layers. Brush strokes should begin at the centre each time, and move towards the edges fluidly. Allow to dry completely.

Step 4: Wet the painting over, and apply a second wash in the same way as the first, this time using varying shades of green. Keep the design in mind, with yellower greens top left and bluer greens bottom right.

Keep your brush strokes fluid and fairly quick, but allow a little time for cauliflowers to develop for texture.

Note that my brush strokes flowed beyond the edge of the painting. Staying within the boundary will restrict your strokes and lose the sense of freedom of movement.

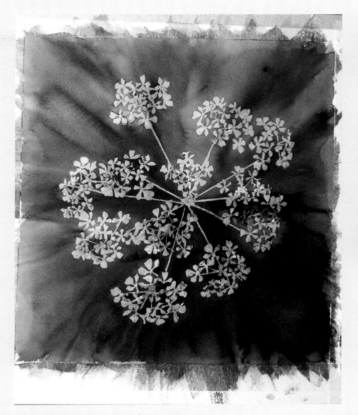

Step 5: Add another layer of green glazes.

Step 7: Add dots of colour to the floret centres.

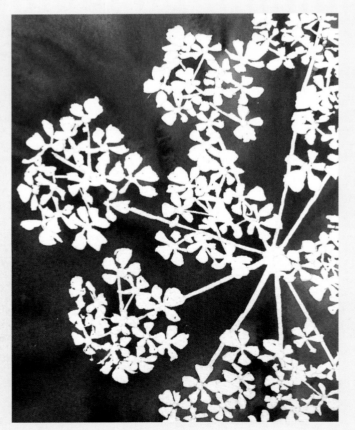

Step 6: Remove the masking fluid.

Step 5: Repeat this process a third time, strengthening colour and tone. Glazing layers of paint adds richness, depth and more interesting textures than a single layer. This is the final layer of paint, so make sure the darks are dark enough, and there are no florets against a pale area.

Step 6: When the paint is completely dry, remove the masking fluid by rubbing it off gently with your fingers. Take care that your fingers do not pick up any paint and smudge colour over the flowers.

Step 7: Using a size 2 brush, add dots of colour to the flower centres. Use very pale mixes of greens, ranging from almost very yellow-green to a slightly blue-green. Use the yellow colours in the light, and the bluer colours in the shadowy areas.

Step 8: As you work through this step, keep the whole inflorescence in mind. This step is about adding shape to the entire umbel, achieved by applying paint to individual flowers and the pedicels.

Using a damp size 2 brush, drag a little colour from the background across the flowers and pedicels. Do not lift enough paint to leave a 'lift mark' in the background. Take care to vary the tones on the flowers as you do this, in particular being careful to leave whites. There is no need to attempt to paint each petal, this is working loosely on tiny areas with a small brush.

Remember that creating shadows is due to depth of tone and the quantity of paint you add than it is to the colour. If you find you cannot lift enough paint without it affecting the background, add a little paint from your palette. Keep stepping back to assess the overall shape of the inflorescence.

Step 8: Add shadows across the entire umbel.

Cow Parsley, the finished painting.

PROJECT
Hawthorn

The inspiration
The inspiration for this was the colour I saw in a spring hedge-row on a very bright sunny day. The sunlight was catching the leaves, and making them shine in the bright colours of recently opened leaves. The shadows were a rich, dark, deep contrast. As I stood looking, I began to think about the palette I would use for a painting, and found myself exaggerating the vividness of the colours. I wanted to use Winsor blue, and Viridian, and Permanent rose, beautiful but quite unnatural for foliage. The white flowers were startlingly bright accents, which glowed.

Developing the idea
This painting was never going to be about the hawthorn. It was about vivid paint colours. The hawthorn was merely going to serve as a device, or motif, to hang them on.

Information gathering
I studied the shape of the leaves, which I was already familiar with, and considered which brush strokes might be appropriate to make marks which approximated those shapes.

Photographs served as reminders, rather than a direct reference.

I took some photographs, which I planned to use as a reminder of what I'd seen, although I knew that the colours in the photographs would be muted compared to what was in my head. I made a mental note not to allow the photographs to influence my colour choices. I would also use the photographs to quickly observe the silhouettes of the flowers.

Designing the painting
Layout
Despite the desire to work with random marks, the composition still has to be considered. Considering the guideline of dividing the image into thirds, I placed the flower silhouettes roughly on the cross point, intending to maintain enough white to use this as the focal point. To remain loose and free when painting, I made a mental note that these might get lost; this could be dealt with if it happened (see Step 1). I also decided to keep a twig to lead the eye into the painting.

Tone
The photograph above served as a guide for a band of lighter tones in a diagonal across the painting, with dark to mid tone, top left, and the very rich dark tones bottom right. This would ensure that the more figurative leaves would be dominant, necessary to give context to the abstract marks.

To keep the eye moving around the image, I made use of the shards of light falling in the leaves, and placed a few lights amongst the dark using masking fluid.

Colour
The inspiration for the image! Bright unnatural greens and blues. A few splashes of the complementary colour, a red, would help to increase the energy level. A wash of these colours used over the whole image in the first layer will unify the colours used in subsequent washes.

Texture
After colour, this painting was about patches of colour and mark-making with brushes. The focus for texture was on the paint, not the hawthorn. To maintain a sense of unity within the painting, I had to be careful that in adding detail to the central leaves and flowers, I did not become too figurative.

Painting the image

Materials
Suggested palette:
- Permanent rose
- Hansa Yellow
- Sap green
- Viridian
- Winsor blue, green shade
- Ultramarine
- Dioxazine purple

Paper:
- Bockingford 300 gsm NOT

Brushes:
- Medium sword liner
- Round (sable), size 4

Other:
- 2B pencil
- Eraser
- Mapping pen
- Colour shaper
- Kitchen roll

Techniques to practise
Splattering paint using a toothbrush.

Printing shapes with a round brush: used for leaves.

Rolling a brush loaded with paint to produce vague leaf shapes.

Any other mark-making that seems appropriate for the subject matter that suits the way your hand works. Be experimental. Do this on some spare watercolour paper not long before you use the marks. Using the waiting time while paint dries gives you the chance to test the drying times for the day, which will be useful to know in Step 4.

Step 1: Loose outlines drawn and traced for future use.

Step 1: With practice, this sort of painting can be painted without the need to draw up first, but if you are just beginning to work, this way is a good idea to give yourself a few guidelines.

I drew the design in a sketchbook, and traced it onto the watercolour paper, marking out only the essential parts of the image that will provide context for the loose random marks.

Another reason to trace while you are learning is that there is a reasonable risk of this sort of painting going wrong. When you allow the paint to 'do its thing', you need to be prepared to deal with the consequences, and not allow it to cause you to feel inhibited. If it happens, you could decide to change your design and carry on, working with what you now have in front of you, or start again. Making a tracing gives you the chance to start again with the minimum of effort, or to simply repeat the painting using different colours or brush marks … endless fun! The attitude is almost essential to enjoy applying paint loosely.

Step 2: Apply first place washes.

Step 3: Add more textural marks using masking fluid, then apply bright greens over 'leaf' shapes.

Step 2: To avoid being inhibited by having to paint around the white 'flowers', it is a good idea to mask them out. Do this using a colour shaper and masking fluid.

Also splatter some masking fluid from a toothbrush across the drawn leaves to create marks inspired by highlights.

Next, using unmixed colours, add very wet washes of Winsor blue, Viridian and Permanent rose. Add a few dots of Hansa yellow, inspired by the shards of light.

Allow this layer to dry.

Step 3: Add more masking fluid in small wiggly lines. These lines are inspired by the way light comes through a hedge and catches the edges of leaves.

Throw a few splashes of masking fluid at the paper from the end of a colour shaper or making pen. Again, this is inspired by light coming through the hedge, and it really doesn't matter where it lands.

If you enjoy the more angular shapes created by shards of light, these could be drawn more carefully with masking fluid – be careful not to include too much detail.

When the masking fluid is dry, mix some very bright greens and place them over the leaves that will be slightly more representational.

Step 4: Begin to build up shapes, creating some leaf edges to provide context.

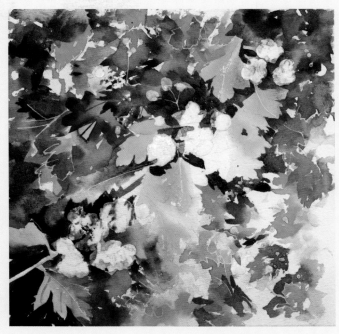

Step 5: Beginning with light and mid tones, begin to build up textural marks and 'leaf' shapes.

Step 4: Add a few yellow-green shapes around the painting, making sure that some edges are left open.

Mix some very dark green, and place them around these central leaves, painting some of the leaf edges negatively.

Step 5: Before beginning the next step, make sure you have plenty of paint mixed up, in a selection of colours made from the paints chosen for the painting. I have used a selection of greens, but also some 'neat' Ultramarine, and the odd touch of red (to complement the greens).

Using the brush marks you chose in your practice session, apply paint to the image. I used a combination of writing shapes, and rolling a size 4 round. Keep changing the colour. Do not forget to wash the brush when changing colour, or you will end up with a mono-tonal, homogenous mess, which will be much flatter and less interesting.

Work across the painting fluidly, sometimes onto dry paper to form found edges, and sometimes into wet paint to create lost edges. Allow yourself to enjoy watching the paint blend and create shapes. Keep an eye on the balance of tone and colour across the image.

Be careful not to completely obliterate the drawn leaves. A few lost edges will not matter, but they are there to provide context for the rest of the mark-making, so it is important to keep some of them.

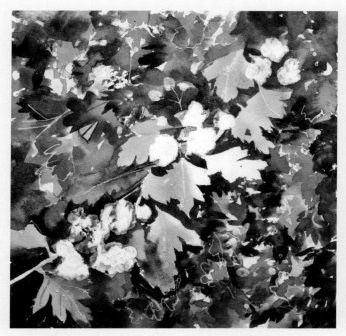

Step 6: Add some strong darks to help the bright colours sing. Remove masking fluid.

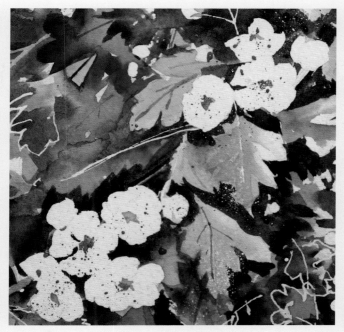

Step 7: Flick red and yellows across the painting.

Step 6: Continue building up layers of 'leaves' until you are happy with the result. Do not be afraid to add some very dark tones as these will make the very bright, vivid colours sing. When you are ready, allow the paint to dry completely and remove the masking fluid.

Step 7: To give a little context, add pale yellow dots to the centre of the flowers. For the same reason, add a few dark lines for veins on a couple of the light green leaves.

Finally, using the toothbrush, splatter some bright rose (a complementary colour) and yellow, aiming at the white flower-like shapes, but not being too bothered if you miss.

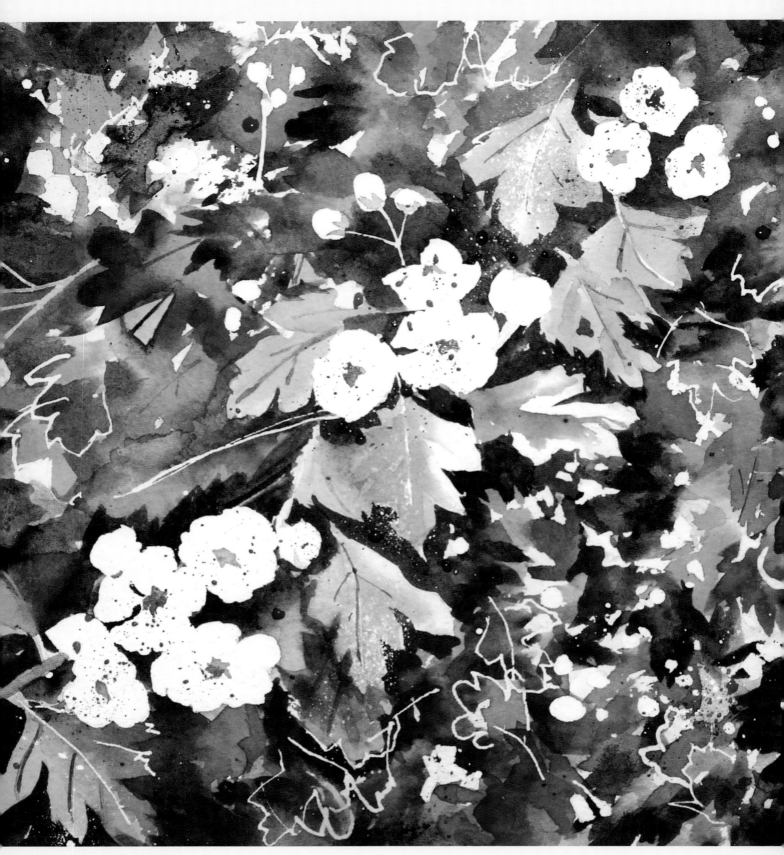

Hawthorn, the finished painting.

A DIFFERENT VIEW POINT

Abstract artists draw inspiration from the world around them, just as any other artists do, but one thing abstract artists are very good at is viewing the world from a slightly different perspective. They have highly developed observational skills, but are also able to use their technical knowledge and imagination to envisage paintings, often recognizing an inspirational subject that others would miss. This can be an unusual viewpoint of an ordinary subject, or making new connections between subject matter and artistic materials to make truly creative images. The project 'Forget-Me-Nots' is an example of one such connection, created by looking at the shadows Forget-Me-Nots cast.

Shadows are inspirational. It is almost as though nature is providing its own abstraction for the artist to work from. To view shadows simply as providing tone that describes form, or to 'ground' a subject to the page, is to miss out on exciting possibilities for abstract florals.

Shadows are almost never what you expect them to be, and even after years of observation, they still produce surprises. They are invariably *not* the shape you would expect them to be. Utterly dependent on the light source, shadow shapes change with the angle of the light. Indoors, moving a light a few millimetres will change the shape of the shadow, not just its position. Outdoors, pretty much anything can happen. It's not just the angle of the sun that matters, a cloud passing over can alter the light intensity enough to change the outline from a crisp, hard edge to a softened, almost lost edge; as it happens, the shadow almost seems to grow even as it fades.

Tonal qualities of shadows vary hugely, due to the distance from the light source, the intensity of the light source, and especially if there are multiple light sources.

Shadows are elusive, there one millisecond, gone the next. That ethereal quality is tantalizing. Catch-me-if-you-can! Capturing shadows is one way of portraying time within a painting, a metaphysical aspiration for a two-dimensional watercolour painting. Flower painting can have more to offer than visually appealing portrayals of beauty.

Shadows are worthy of close observation. While the shape can be a surprise, it is usually close to the object casting it. Flowers (and plants) cast many beautiful shadow shapes, which in bright light closely resemble the shape of the flower. Plants with an open growing habit, or floral arrangements that are not too densely packed, can produce beautiful shadows, with lovely light filled negative shapes. (The light areas are the negative shapes here, a change of mindset might be required.)

PROJECT
Forget-Me-Nots

The inspiration

In *Forget-Me-Nots*, I demonstrate how I use shadows as a basis for abstract florals, laid out as a step-by-step to enable you to follow the method of working and the techniques I use. Unfortunately, it is not possible to provide the shadows in a book, making it difficult for you to copy this image. However, if you have paper and pencils at the ready, next time you see an interesting floral shadow, capture it, then work through the process using your own shapes and colours.

There are other paintings in this book that have been created using the methods described in this project. Although they are much more complicated images, this is because they are built up of more complex drawings and more layers of paint. The techniques used for these paintings are all described in this project.

Developing the idea

Once you have found a suitable shadow to work with, consider how it will sit on a page. Can you arrange it on the paper to produce an interesting image? Is the shadow accessible with paper and pencils?

Note: it is possible to photograph the shadow and trace the shadow, but the results are far less dynamic. The possibilities for overlaying different shadow shapes is reduced to what is contained within the photograph. There is also a possibility of unwittingly being drawn into a compositional layout based on the photograph, rather than exploring a composition made from the shadows first hand.

Information gathering

It is interesting how drawing around the shadow of a flower can increase your level of observation of the flower itself. Drawing around the shadow will lead you to examine the flower itself more closely. Information gathering happens simultaneously with making the image. Look for interesting shapes to draw around as you work.

Designing the painting
Layout
This will develop as you work. Keep design principles in mind. As you assess the drawing, decide whether the positioning of the shadows will provide a focal point, or whether tone of colour can be used instead to lead the eye through the image.

Tone

Similarly, tone will need to be decided upon as you work, again keeping guidelines in mind, and ensuring that it is balanced across the finished image.

Colour

The shadows simply provide the shapes to work to. Colour is completely arbitrary. It depends on how strongly you want to elude to the flowers that cast the shadows.

You could match colours to the plant, or use an interpretation of them based on your favourite paints.

It may be that it was the colour of the flowers that attracted you in the first place, and the shadows have provided you with a motif to incorporate them into a painting.

Alternatively, if the shapes of the shadows are more important to you than the colours of the flowers, you could choose a palette entirely unrelated to the original plant.

Colour was very important to me in this image. A bed of Forget-Me-Nots in my garden was a frothy sea of Cobalt blue, with hints of Lilac, and dictated my colour choice for this painting.

Texture

If the shapes of the shadows are to be maintained in the final image, there is little room for experimental mark-making. However, there is opportunity for allowing marks to develop within the shapes, rather than just colouring them in with flat paint. Cauliflowers, or sprinkling salt into wet paint, can add interest.

Painting the image

Materials

Suggested palette:
- Cobalt blue
- Cobalt violet
- Cobalt turquoise
- New gamboge

Paper:
- Bockingford 300 gsm NOT

Brushes:
- Round, size 2
- Round, size 1

Pencils:
- Choose a grade soft enough to leave marks on the paper with very little pressure which you can see in bright light, but that will leave as little graphite on the paper as possible. As you move randomly around the paper continuing to draw, you do not want to smudge previous marks, or leave excess graphite on the paper to muddy paint. Try a 3B to start.

Other:
- Eraser
- Kitchen roll

Step 1: Draw around the shadows directly onto watercolour paper.

Step 1: The shadows of the Forget-Me-Nots on the paving slabs were delicate, and pretty, and I could see would provide a great opportunity for a painting that would enable me to capture the frothiness of the blue colour. I didn't hesitate to grab a sheet of watercolour paper and a pencil.

With shapes as small as this, I would not need to stretch paper. If your shadows are bigger, you may need to stretch. In this case, be careful that you do not draw your design on the edge of the paper, as it will be lost due to the stretching process. The paper can be stretched with the drawing on it.

Step 2: If the breeze blows the flowers and moves the shadows, just keep drawing.

Step 2: Draw around the shadow shapes. You will have to work quickly outdoors. Even if there are no clouds, the slightest breeze causes flowers to move. These photographs show how the Forget-Me-Nots blew in the breeze – I kept drawing. They repositioned themselves. If they do not, just draw around the shadow again in its new position.

It is important to remember that you are creating a painting. Keep taking the paper away from the shadows to see how the composition is developing. Look at the positions of the shadows on the page, and also consider how you might apply tone and colour to balance the design.

Step 3: I moved the paper several times while making the drawing. The arrangement of shadow outlines on the paper alludes to the frothiness of the bed of Forget-Me-Nots.

Having completed the drawing, it was stuck to a board with masking tape to hold it in place as I painted.

Look closely at the drawing that has developed. There will be some obvious flower shapes, other shapes will be formed by the overlaps and negative spaces. Try to look at each shape as a shape in its own right, rather than a representation of the flower. Adjust by drawing more shapes, or even rubbing some out, if necessary, to create a pleasing arrangement on the paper.

Step 4: I began this painting by filling in three obvious Forget-Me-Not flowers with Cobalt blue. This was primarily to help me focus on achieving a balance and colour across the image.

Step 3: Move the paper several times to overlap the shadow outlines. Look carefully at the drawing that has developed. Adjust it if necessary.

Step 4: Begin to add colour. Choose shapes that will help you orientate your eye.

Step 5: Working evenly across the image, continue to add colour.

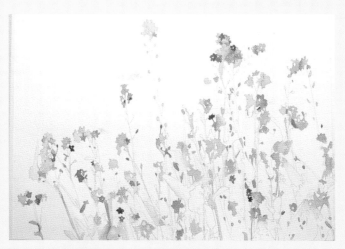

Step 6: In a similar way, introduce Cobalt violet.

Step 5: I continued with the neat Cobalt blue, filling in some flower shapes, but also any others that appealed to elicit the feeling of the tiny dots of blue across the bed of Forget-Me-Nots in the garden.

Notice some of the shapes were shadows of stems, some shadows on leaves and some the negative spaces within the drawing.

Throughout this painting, keep stepping back to assess the image, being ready to make adjustments as necessary.

Step 6: Next, working with the Cobalt violet, I added some dots of colour, again randomly over the page.

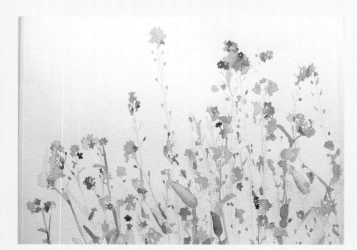

Step 7: Next introduce the greens, keeping the colours harmonious.

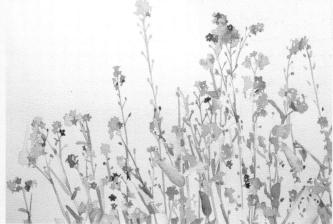

Step 8: To balance random marks with the more obvious flower shapes, paint in some stem shapes.

Step 7: I followed this with a range of greens made with a three-way mix of Cobalt blue, Cobalt turquoise and New gamboge.

I wanted to maintain the gentle blues of the flowers, so I kept the yellow to a minimum to keep the colour range more harmonious.

Step 8: Happy for a strong allusion to the flowers in this painting, I painted in some of the stems with a lilac grey mix. Note that I used the shapes on the page. I did not want to be drawn right back to the figurative by painting stems traceable from base to tip.

I also applied the grey to some of the other shapes in the image.

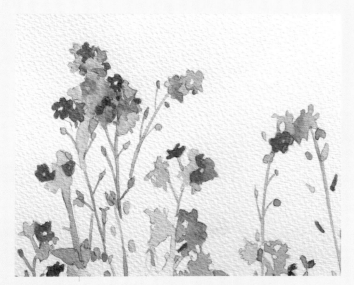

Step 9: I took time to step back again. Having placed the colour to my satisfaction across the image, I worked back into the painting to adjust the tones, particularly in the shadows of the petals.

Step 9: Step back, assess, and adjust tones where necessary.

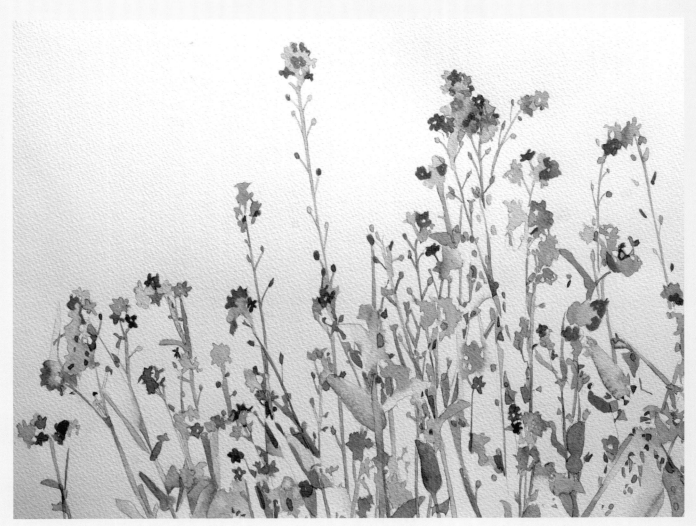

Forget-Me-Nots, the finished image.

Hydrangea anachronistii.

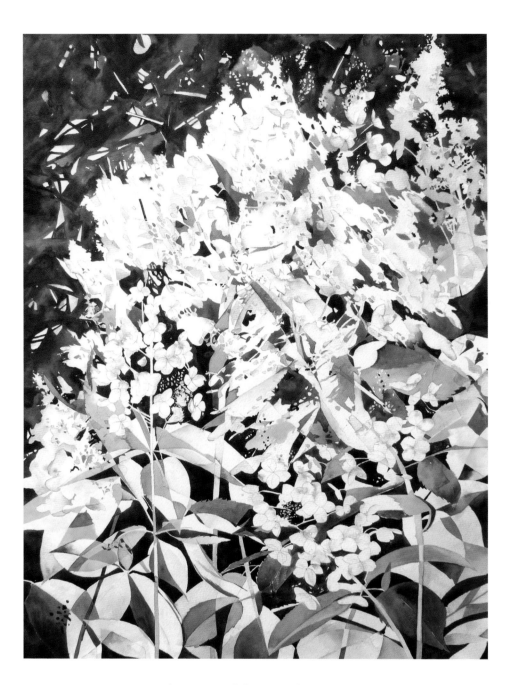

Hydrangea anachronistii

The method of creating an abstract painting in the project 'Forget-Me-Nots' requires a thorough understanding of how to design a painting. Learning to balance shapes, tone, colour and texture as you work rather than before you start painting is something that comes through practice and experience. One of the more difficult skills to acquire is to learn to take your time, to stand back and assess the painting in its various stages before continuing.

The painting *Hydrangea anachronistii* was painted over a number of months. It began with drawing around the shadows of the fresh flowers. At this stage, an observational drawing of a single flower head was added on the left of the image, and colour swatches made from the fresh flowers.

The flowers were left to dry over winter. In the spring, the dried flowers were used to create more shadows, this time obliquely, and from a number of light sources. Eventually the shapes were painted, over several days. The inspiration for the colours was taken from (though not matching) the initial colour swatches, emphasizing the pale hues against the rich darkness of the hedge that was behind the flowering bush as I had seen it the previous summer.

Further information

Paint colours

Colour is such a subjective choice, and very personal. The lists here are suggestions, that will give a very good starting point and give a suitable range of colours for flower painters.

Beginners basic palette

Alizarin crimson
Quinacridone red
Permanent rose
New gamboge (or New gamboge hue)
Lemon yellow
Cobalt blue
Ultramarine blue
Sap green (Daler Rowney)
Dioxazine purple (available as Permanent mauve by Daler Rowney, or Windsor violet by Winsor and Newton)
Burnt sienna

Further reading

Simblett, Sarah. *Botany for the Artist: An Inspirational Guide to Drawing Plants.* Dorling Kindersley

Martin, Rosie and Thurston, Meriel. *Botanical Illustration Course.* Batsford

Marsh, Jean and Greenaway, Kate. *The Language of Flowers.* MacDonald and Jane's

Videos

Siân has made numerous tuitional videos with Art Tutor. Her videos include a course on painting flowers in watercolour, and basic watercolour techniques.

Art Tutor is an online website dedicated to a very high standard of art tuition across all media.
www.arttutor.co.uk

Suppliers

Jackson's Art Supplies
1 Farleigh Place
London
N16 7SX
www.jacksonart.co.uk

Ken Bromley Art Supplies
Unit 13 Lodge Bank Estate
Crown Lane
Horwich
Bolton
BL6 5HY
www.artsupplies.co.uk

Information on copyright

https://www.gov.uk/copyright/overview

A basic palette for beginners interested in painting flowers. The colours are (top to bottom) Alizarin crimson, Quinacridone red, Permanent rose, New gamboge, Lemon yellow, Cobalt blue, Ultramarine blue, Sap green (Daler Rowney), Permanent mauve (Daler Rowney), Burnt sienna (Daler Rowney).

Index